The Dining Room

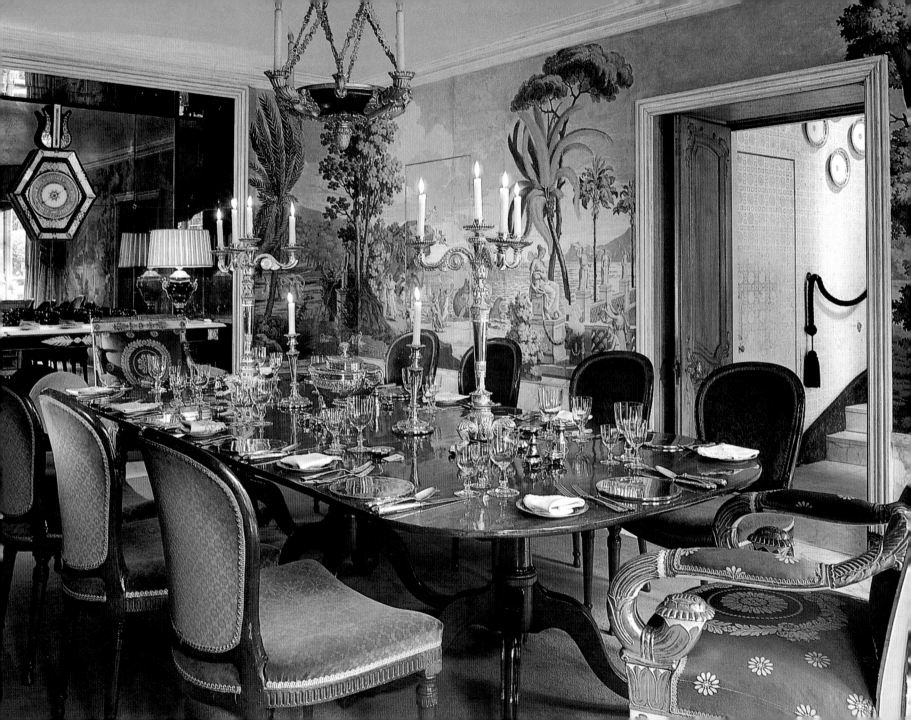

D I A N E B E R G E R

The Dining Room

P H O T O G R A P H S B Y F R I T Z V O N D E R S C H U L E N B U R G

A B B E V I L L E P R E S S • P U B L I S H E R S • N E W Y O R K • L O N D O N • P A R I S

Jacket front: An open-air dining room overlooking the Bosporus in Istanbul (see page 136)

Jacket back: A romantic dining room in Barbados (see pages 70 and 71)

Frontispiece: An eighteenth-century panoramic paper covers the walls of this London dining room (see page 50)

Contents page, clockwise from top: A pedestal bowl from the Heraldic Service in the dining room at Pavlovsk Palace in Russia (see page 39); All the tableware in this kitchen was found at flea markets (see page 96); A dining table designed by David Linley (see page 45); Detail of a table set for an intimate dinner in a trellised gazebo (see page 131).

Page 6: The library at Chilston Park makes a warm, inviting ambience for dining.

EDITOR: Jacqueline Decter
DESIGNER: Molly Shields
PRODUCTION EDITOR: Abigail Asher
PRODUCTION MANAGER: Simone René

Photography credits:
page 9: Trustees of Wedgwood Museum, Barlaston, Stoke-on-Trent, Staffordshire, England
page 10: ©The British Museum, Photographic Service Department, London
page 12: Source unknown
page 15: Country Life Picture Library, London
page 85: ©Pascal Chevallier; courtesy of TOP Photo Agency, Paris

Library of Congress Cataloging-in-Publication Data

Berger, Diane.
The dining room / Diane Berger ; photographs by Fritz von der Schulenburg.
p. cm.
Includes bibliographical references and index.
ISBN 1-55859-555-4
1. Dining rooms. 2. Interior decoration. I. Von der Schulenburg, Fritz. II. Title.
NK2117.D5B47 1993
747.7'6--dc20 93-28141
CIP

To the memory of my mother, who taught me what style was all about, and to my husband for all his support and his love of special meals in special places.

> *Though she would not for the world have owned it to her parents, Undine was disappointed in the Fairford dinner.*
> *The house to begin with, was small and rather shabby. There was no gilding, no lavish diffusion of light. . . .*
> *The dinner too was disappointing. Undine was too young to take note of culinary details, but she had expected to view the company through a bower of orchids and eat pretty-colored entrées in ruffled papers. Instead, there was only a low center-dish of ferns, and plain roasted and broiled meat that one could recognize. . . . With all the hints in the Sunday papers, she thought it dull of Mrs. Fairford not to have picked up something newer; and as the evening progressed she began to suspect that it wasn't a real "dinner party," and that they had just asked her in to share what they had when they were alone.*
> —Edith Wharton,
> *The Custom of the Country,* 1913

We all harbor great expectations that not only dinner parties but all our meals will be special. This book is dedicated to creating wonderful environments that will make any meal an unforgettable experience.

Contents

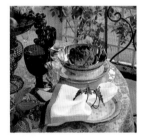

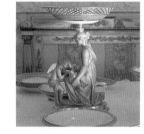

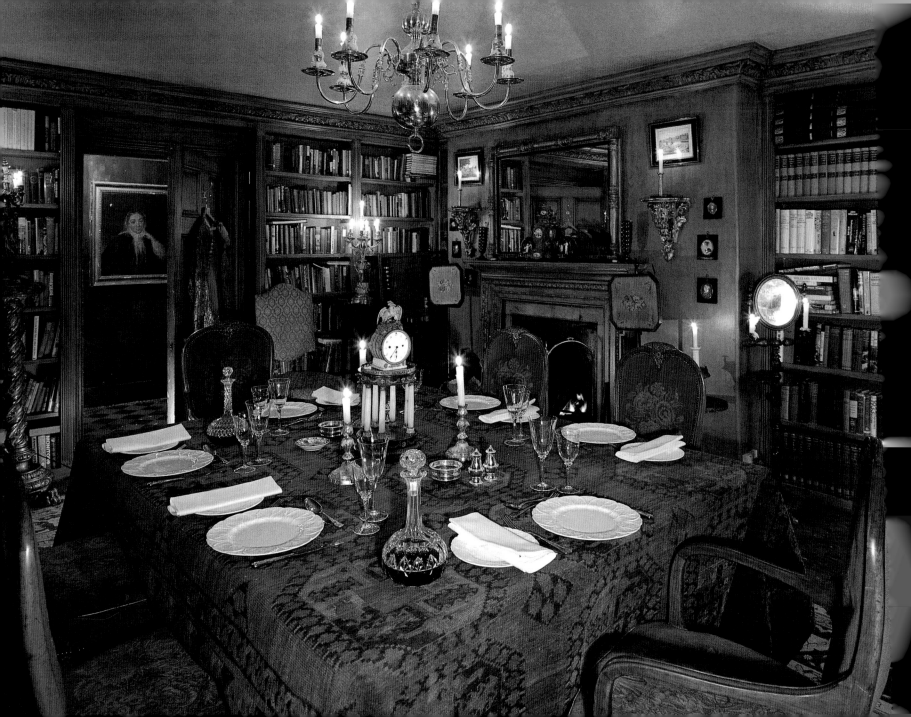

Introduction

"The hour of dinner has been pronounced by Dr. Johnson to be, in civilized life, the most important hour of the twenty four," observed a nineteenth-century writer, and to this day there are few activities in daily life that are as cherished and esteemed as dining. The act of meal taking is special for many reasons. It is imbued with ritual, tradition, and celebration. It is sensual and dramatic, comforting and nurturing. It is romantic, exotic, mysterious, and magical. An activity so obviously special deserves its own space, a haven where mood reigns supreme and fantasy is allowed to take flight. For New York interior designer John Saladino, the dining room is perhaps "the only place in our lives where we still have a sense of ceremony." To London interior designer Nicholas Haslam, it is the soul of the house.

Luscious food presented with flair in delectable surroundings delights our vision as well as our senses of taste and smell. Indeed, the visual memory of an extraordinary meal remains in our minds long after the food is cleared away. In the late twentieth century, when the dining room in the strict sense--a room devoted exclusively to eating--has become somewhat of a luxury, the term is more reflective of a state of mind than of a fixed architectural space. But whatever shape it takes, the dining room should be alluring and seductive, tempting us to indulge in a simple meal or a lavish feast, to linger, to share, and to leave satiated, pampered, and fulfilled. Whether it is the cosseting intimacy of a chintz-filled country-cottage kitchen, the grand formality of an elegant and stately dining room, the sweeping majesty of a vaulted Roman palazzo, the secret pleasure of a tray straddled across a canopy bed, the cool sleekness of a New York terrace, the romance of a garden pavilion, the warmth of a paneled library with a roaring fire, or the sultry laziness of a seaside picnic in late summer, wonderful settings enhance great dining experiences.

Dining is inherently theatrical. The decor of the dining room is the mise-en-scène, the stage setting, for the presentation of the food. The creation of that mise-en-scène through wall, floor, and window treatments should dazzle the senses and whet the appetite. Table settings and the array of functional equipment used to serve the meal are the props. Just by changing setting and props, one can achieve strikingly different dramatic effects or make the mundane special. Simply by draping a casual cloth over a plywood table, dimming the lights, and lighting a candle, we can turn even a Chinese take-out meal into a sublime experience.

The pages that follow will treat you to a whole repertoire of wonderful feasting places, from traditional dining rooms to a wide range of alternative venues, indoors and out, and show you how to transform the dining space of your choice from the ordinary into pure magic. With a little imagination, you can create your dream dining room, whatever your taste, lifestyle, or budget.

The sources of inspiration for decorating the dining room are endless, and it can be daunting, when faced with four blank walls, to know where and how to begin. Although there are many ways to put the process in motion, a brief look at history is a natural starting place. As we trace the evolution of dining traditions and room decoration, we can

see that history, indeed, repeats itself and that old ideas are continuously being reinterpreted, restyled, and revitalized.

The eighteenth century gave pride of place to the dining room and, as a result, to the very act of meal taking; it was during this period that the tradition of a room set aside only for eating became established. The eighteenth century also bore witness to the birth of the place setting as we know it. Prior to that time, most people, except for the aristocracy, shared one-pot meals with communal utensils. But soon commercialization took hold, and a burgeoning marketplace flooded with a great variety of irresistible tableware came within reach of the middle class for the first time. The ceramics manufacturer Josiah Wedgwood was a pivotal figure in this process, revolutionizing the marketing of dinnerware. When launching a new design, Wedgwood first sought a royal or aristocratic endorsement, which he knew would filter down the social scale and create a surefire demand for his wares among a middle-class clientele eager to be au courant with the latest fashion. A prolific designer, he also broke down the distinction between what he called "useful" and "ornamental" wares. The concept that functional objects can also be decorative is still a basic tenet of table settings today. He often produced highly fanciful shapes, such as cauliflower teapots, and unusual patterns, such as tortoiseshell. As soon as one design became de rigueur, he quickly introduced another. It was also during the eighteenth century that a taste for matched sets of dinnerware took hold.

By the late eighteenth century, a formula for dining room decoration had become nearly set. Furniture designers such as Hepplewhite and Sheraton popularized it through the publication of pattern books. By the time Robert Adam wrote his *Works in Architecture* in 1773, the basic room scheme included sets of tables--making it possible to seat various numbers of guests--chairs, and a sideboard or side table for serving. Adam also offered some helpful hints for decorating the dining room, such as not covering walls with expensive textiles that would retain the smell of food. But he looked beyond the utilitarian demands of dining to what he felt was the underlying essence of the dining experience, "The eating rooms are considered as the apartments of conversation in which we are to pass a great part of our time." To many people today this is still at dining's very core.

The decoration of the dining room is no longer so formulaic. In order to navigate through the maze of possibilities, we may follow Adam's lead and look to the heart of the dining experience itself for a design source. After identifying the venue in which you wish to dine, ask yourself some basic questions about the mood and ambience you want to create and go from there. For instance, do you want it to be exotic, magical, dramatic, rustic, cool and sleek, warm and cozy, formal, or informal? There are countless places to look for inspiration, including unforgettable dining experiences while traveling, a literary description of a dinner that enticed you, a favorite film set, period rooms in historic houses and museums, and antique pattern books, to name only a few.

Pattern books, paintings, prints, and old photographs can be "decoded" to reveal a wealth of how-to information, from ways of treating walls, floors, and windows, to usage of furniture and tableware in styles as varied as the Renaissance and Art Deco, to hanging pictures in an authentic manner. For example, Henry Sargent's famous painting *The Dinner Party* (c. 1821) reveals such details as wine carafes placed directly on the polished surface of a mahogany pedestal table, the location of the sideboard, the use of a wall-to-wall patterned carpet, and so on. The work of nineteenth-century watercolorist Mary Ellen Best shows us tables set with Staffordshire ware and rustic dressers in country kitchens filled with all sorts of cooking equipment. When asked what his ultimate dining fantasy is, New York interior designer David Easton immediately conjured up the image of a favorite photograph, Horst's portrait of Edith Sitwell reclining in bed, attended by Indian servants—a rich visual evocation of Raj style. Henri Matisse's bold use of pattern

and color in *Harmony in Red* (1908) provides ideas for splashing walls, floors, and tables with dramatic designs. Or you might be inspired by the profusion of variously shaped glassware, bottles, and simple wooden chairs in Pierre Auguste Renoir's *The Boating Party* (1881).

Period styles are very evocative of mood because once you are familiar with them they transport you back to another era. Ideas for period styles can be garnered from books or by visiting design and decorative arts collections in museums. A faithful reconstruction of a period room conveys a sense of tradition and ceremony, but it need not be copied slavishly. Use a period style as a springboard for your own ideas and interpretations. Or focus on a single element that suggests the atmosphere of the period without costing a fortune. For instance, you can approximate the look of an English Chippendale interior simply by making paneling out of an inexpensive synthetic material, such as medium-density fiberboard (MDF) or chipboard, and painting it in any number of ways, including wood-graining and marbleizing, to give it the feeling of a centuries-old patina. Architectural detail can be added by painting false picture-frame molding. You can also create the illusion of panels by pasting wallpaper borders on the walls. Or you can find old paneling by searching through architectural salvage depots (page 110).

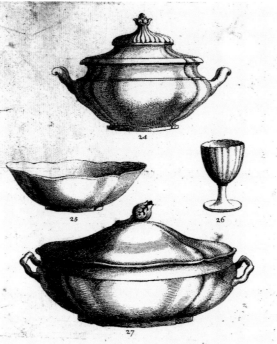

*P*LATE 7 FROM JOSIAH WEDGWOOD'S 1774 QUEEN'S WARE CATALOG. WEDGWOOD WAS NOT ONLY A PROLIFIC DESIGNER OF CERAMICS BUT ALSO A PIONEER IN THE MARKETING OF TABLEWARE.

You can also achieve a period feel at a reasonable cost by investing in one important piece of antique furniture, such as a table, that will act as the focal point of the room, and pair it with a far less expensive set of comfortable contemporary upholstered chairs. Or do the opposite, and combine a set of period chairs with an ordinary plywood table covered with a cloth.

Mixing and matching antique furniture is a fun and affordable way of creating period style. For example, single chairs, or groups of three or four, are always less expensive than sets of eight or more, which command premium prices. You can experiment with mixing different chairs that share a general theme. For instance, you might consider starting a collection of Sheraton chairs, all of which have painted shield backs but with various decorative motifs. Some may sport Prince of Wales feathers, others may feature flowers. The impact will be similar to that of a collection of paintings. Anna Fendi has successfully combined two completely different sets of period chairs in her Roman dining room, each set lined up on one side of her long rectangular table (page 38). Remember, too, that any chair can be copied. When the owner of the kitchen on page 96 could not resist a provincial Georgian chair, she had the others reproduced.

If you love period styles but the authentic pieces exceed your budget, look for a style that is currently undervalued or simply less expensive,

9

such as seventeenth-century turned furniture. You can still find some Biedermeier and Art Deco pieces at good prices, or you might consider the vintage chic of aluminum diner furniture from the 1940s and 1950s. You can create your own variation on a period theme, such as using a pair of antique stone garden ornaments as a base for a glass-topped table.

When creating a period interior, let one object or group of objects inspire you, and use it as the foundation on which to build a decorative scheme. For instance, when the owner of the dining room on page 32 fell in love with a splendid set of Hepplewhite chairs with their original blue and yellow paint, she let them dictate the wall color. A deep rich blue was taken from the decoration of the back splats and applied to the walls by dragging the paint in thin layers to enhance the period feel. The inspiration flowed from there, including the start of a collection of antique cobalt-blue glassware and lots of nineteenth-century blue-and-white Staffordshire ware plates and tureens of various sizes and shapes. Any object in the room can provide an excellent color source, such as a collection of ruby-red pressed wine glasses or a set of spongeware.

Remember that period style does not have to be formal. For example, you may want to re-create the cozy, rustic charm of a colonial tavern, as fashion designer Bill Blass has done (page 86), or by pairing Windsor chairs painted in different colors with a gateleg table. Both

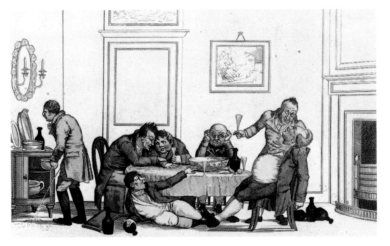

L'Après-Dinée des Anglais, ENGRAVING, C. 1814. THIS PICTURE POKES FUN AT THE ENGLISH TRADITION OF WOMEN WITHDRAWING AFTER DINNER, LEAVING THE MEN TO THEIR OWN DEVICES.

Biedermeier, with its curvaceous treatment of polished blond woods, and Art Deco, with its sleek ocean-liner chic, have an almost contemporary simplicity. The warmth of rural France can be captured by combining whimsically painted rush-seated farm chairs with a provincial armoire. Just by draping a table with a quilt, filling country baskets with dried flowers, and hanging folk-art paintings on the walls, you can create the feel of an early American cottage. To simulate the delicate, cool interiors of nineteenth-century Scandinavia, cover the walls with a bold striped wallpaper, paint the floor a pale gray-white, stencil it with a decorative border, and fill the room with painted neoclassical furniture.

Antique textiles can also lend enormous atmosphere and character to the dining room. They often turn up in flea markets and country auction houses at reasonable prices, especially if they are fragments. Used as table coverings, they can impart a period feeling to a nondescript table. London picture dealer Stephanie Hoppen drapes the dining table in her New York drawing room with a nineteenth-century paisley shawl. A panel of eighteenth-century French toile de Jouy will set off country faience dinnerware beautifully. Or consider an eighteenth-century crewelwork panel paired with pearl ware. Victorian embroidered white linens are readily available and make ethereal table coverings.

Tea towels are fun to collect and can be used as napkins. If you are lucky enough to find ones embroidered with unusual monograms or with laundry-identification numbers, you can be sure they will generate conversation among your guests while lending great style to your table. Roger Banks-Pye's enormous collection of blue-and-white tea towels and checked gingham napkins, almost all of which he bought one at a time, inspired the decoration of his breakfast room (pages 88–89).

In addition to period styles, national, regional, and ethnic styles offer a wealth of design ideas for color schemes and furnishings. To give the room a bright, exuberant look, try a Caribbean-style palette of shocking pink, brilliant yellow, or sea-foam green (page 30). If you prefer an earthier ambience, consider a Santa Fe–style mixture of terra-cotta and blue, and decorate the room with local baskets and ceramics. To re-create the homey rusticity of a lodge in the Adirondacks, combine bent-twig furniture with quilts (page 74) or faded chintz.

The contemporary styles you can use to create a starker, more pared-down look are too numerous to list here. There is an enormous amount of imaginative and whimsical furniture being produced today, such as Philippe Starck's witty version of a traditional café chair, which comes in lots of colors, or the sculptural creations of André Dubreuil. A simple metal chair can be dressed up by tying a rope tassel or a sleek, oversized metallic bow to the back where it meets the seat.

Throughout history, travel has been a rich source of both culinary and design ideas. In 1784 Abigail Adams was enormously impressed by a dinner she attended in London and wrote unabashedly, "I am in love with the London stile of entertaining company." I often reminisce about a wonderful country lunch in Provence, in the courtyard of a château similar to Vignelaure (page 73), where the afternoon sunlight peeking through the surrounding foliage dappled the brilliantly patterned tablecloth as it rustled in the breeze. A glazed-crockery olive pot bursting with sunflowers sat in the center of the table, its rich yellow echoing the chunky octagonal painted earthenware plates with their simple beaded borders. Luscious local wine was poured from earthenware jugs into heavy, roughly blown green glass goblets. Glistening spiced olives piled high in painted faience bowls provided the prelude to a hearty daube dished out of eighteenth-century tureens covered with naive figures. The sensual delights of such dining experiences need not remain mere memories. You can achieve similar effects at home simply by adorning your table with the same kind of fabric and crockery.

Nor will I ever forget my first meal in a turn-of-the-century French bistro, with its leather banquettes, rattan chairs, and crisp white paper tablecloths. Now the mere sight of a café chair or heavy green bistro ware with its gilded borders conjures up the salty taste of *pommes frites* and the heady smell of Dijon mustard. French restaurant tableware and accessories are widely available and can help you create your own bistro chic at home.

There are many imaginative uses of paint and fabric that allow you to transform ordinary furniture into a decorative tour de force. For example, look in secondhand and antique shops for pieces with decorative potential but in less than pristine condition. You can give new life to an Edwardian table with a frieze of bows and swags by painting it with a faux finish. A basic table can be made special by painting a trompe l'oeil mural or a favorite still life of food and flowers on it or by covering it with a decoupage of prints or floral and geometric motifs. A plywood table can be dressed up by wrapping it in fabric. For a more festive look, tie the fabric in knots, bows, or rosettes at the corners, or hang tassels on it. To change the mood, simply change the fabric.

Creative uses of fabric can also transform chairs. Consider covering ordinary folding or director's chairs in loose slipcovers, which are easily removed for cleaning or whenever you want to change the look. They can be prints or solids, monogrammed, piped, trimmed, tied with bows and gently ruffled for a period look, or boxy and unstructured for a more

contemporary feeling. Fashion designer Bill Blass has revived the eighteenth-century practice of covering expensive upholstered and leather chairs with slipcovers (page 113). Tom Parr of Colefax and Fowler is especially fond of loose covers, not only because of their practicality but also because fabric lends a cozy air to a room and is an excellent way of introducing pattern.

Interesting wall decor can convert a nondescript dining room into an enchanting space. In the eighteenth century, one of the most popular wall treatments was to create a "print room" by pasting a collection of decorative prints onto stippled walls, framing them with wallpaper borders, and linking them with ornamental devices such as chains, rings, lions' heads, or ribbons. Today the print room is back in fashion. Available in do-it-yourself kits, it is a relatively inexpensive way of turning a dining room into a personal art gallery. Prints are easy to find, and there is no end of appropriate themes to choose from, including silver or porcelain designs taken from pattern books, scenes of dining and feasting, architectural renderings, vintage menus or wine lists, and portraits (page 116). Inexpensive reproductions can be tinted by dipping them in tea for an old world feeling. Wallpaper facsimiles of print rooms were fashionable in the eighteenth century and are also available today. For a Palm Beach dining room interior, designer

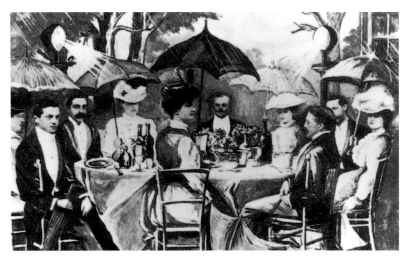

A TEA PARTY AT ELVEDEN HALL, SUFFOLK, ENGLAND, C. 1910. EVIDENTLY NOT EVEN INCLEMENT WEATHER COULD DISSUADE THIS COMPANY FROM ENJOYING THE PLEASURES OF DINING ALFRESCO.

Bunny Williams used the print-room technique in an innovative way, pasting a series of hand-colored porcelain designs on the wall and interspersing them with trompe l'oeil versions (page 53).

Another fashionable eighteenth-century wall covering that is particularly effective in the dining room is panoramic wallpaper. The visual stories these mural-like papers tell delight the eye and obviate the need for pictures on the walls. One of the original producers of panoramic wallpapers, Zuber of Paris, continues to manufacture a wide range of them.

Of course, dining room walls can be the perfect place to showcase treasured paintings, drawings, or prints. They draw guests' attention, providing a pleasant diversion during the course of a meal.

Like wallpaper, specialist paint finishes aid in the creation of mood and atmosphere. Using a simple stone-blocking technique, for instance, you can achieve looks as diverse as a Roman palazzo, a Tuscan farmhouse, or an English country manor. Dragging, ragging, sponging, and marbleizing all add depth and visual interest to otherwise plain walls. A trompe l'oeil mural of an outdoor scene will transform your dining room into a "room with a view." If the room has great architectural features, highlight them with color. If not, you can create the illusion of architectural splendor with paint, including faux columns, cornices, and boiserie.

12

Walls covered with fabric have a soft, inviting effect. Don't be afraid to use a large-scale overall pattern even in a small space; the look will be dramatic. Small patterns create subtle backdrops for collections of ceramics or glass. Experiment with the wide range of fabrics based on print rooms and trompe l'oeil ceramics, such as Jane Churchill's witty rendering of nineteenth-century platters and Pierre Frey's fanciful teacup design inspired by a Minton pattern book.

Although almost any floor covering is appropriate to a dining room, you may want to turn to certain historic treatments for inspiration, such as covering the floor with a cloth that has a geometric or floral motif painted on it, or painting a trompe l'oeil carpet design directly onto the floor (page 96).

When deciding on the window treatment for your dining room, ask yourself the following questions: Do you want to draw attention to the windows? How much light do you want to let in? To what extent is privacy a factor? Elaborately draped fabric will feature the windows, soften the space, and provide privacy. If privacy is not an issue, you may opt to ornament the windows with a simple gauzy swag, allowing in maximum light during the day. You might try reviving the eighteenth-century custom of using shutters carved with a ribbon-and-festoon decoration that is revealed when the shutters are closed. Inexpensive decorative plaster ornaments can be pasted on wood and painted to create the effect of the cupboard doors seen on page 110.

Table settings are the pièce de résistance of dining room decoration. A wonderful way to accumulate tableware is to comb antique shops, flea markets, and auction houses wherever you live or travel. The quest itself is fascinating and fun. One can spend endless happy hours foraging through Bermondsey Market and the stands at Portobello Road in London, the Marché aux Puces in Paris, the L'Isle sur la Sorgue Market in Provence, the souks of the Middle East and North Africa, and the farmers' markets and flea markets all over America.

When setting the table, feel free to mix and match styles, colors, and media. Not only will this approach give your table a unique personal touch, but it will never fail to stimulate conversation about the various pieces' history and provenance. Stephanie Hoppen mixes reproductions of Catherine the Great's famous ribbon-bordered dinner service with other pieces from her vast collection of period china and colored glass (page 107). Designer Rupert Cavendish combines Art Deco silver and glass with a contemporary dinner service by Susie Cooper (page 43).

Anne Hardy, an editor of British *House & Garden*, favors the concept of "layering" a table; as the setting for each course is removed, another layer is revealed. The foundation layer is likely to be presentation plates of silver, glass, china, pewter, wood, or painted metal. The kitchen table on page 96, set with inexpensive industrial copper presentation plates, contemporary handmade puddle-shaped dishes and matching bowls, Wedgwood plates from the 1860s with leaf motifs and basketweave borders, an assortment of antique and reproduction majolica decorated with flowers, and contemporary glasses inspired by a Byzantine design with jewel-like stems of colored beads, is the ultimate in flea-market chic. As a rule of thumb, when shopping for tableware don't be concerned about acquiring complete services for eight or twelve. Smaller sets are easier to find and less expensive.

Different styles of tableware tend to suit different moods and types of food. French country faience is ideal for a rustic outdoor lunch; nineteenth-century transfer-printed wares with their romantic scenes lend a Victorian mood to Sunday dinner; the bright colors and geometric shapes of Fiesta ware provide the perfect backdrop for simple grilled vegetables; mid-nineteenth-century emerald-green Wedgwood sets off dessert elegantly; luminous nineteenth-century lusterware is resplendent in candlelight; twentieth-century basket-shaped majolica suggests the pleasures of a turn-of-the-century picnic; creamware with its milky opacity conjures up the spirit of the eighteenth century; Chinese Export

porcelain emblazoned with family crests makes us dream of its original owners; and nineteenth-century botanical plates have the freshness and charm of a period conservatory.

The dining room is a natural showcase for collections, and any objects related to food preparation or service can form the basis of a decorative collection. It is surprising to discover how ornamental many functional things are, including cobalt-blue mineral-water bottles; new or vintage biscuit tins; Italian olive-oil cans; pasta boxes; mason jars; French wire egg baskets; Shaker, Indian, or other woven baskets; twisted mahogany candlesticks; ceramic and silver teapots; cookie jars in the shape of figures and animals; gleaming silver meat covers; wine coasters and caddies; pot lids; and Bakelite toasters. Many people enjoy collecting specific types of ceramics, such as Chelsea porcelain, annular ware, spongeware, flow blue, agate ware, mocha ware, transfer prints, and so on. Even herbs look great when massed together, and you can snip off sprigs whenever needed (page 101).

I like to think of cutlery as the jewelry—whether real or costume—with which we adorn the table. If you keep an open mind and don't insist on buying large sets, you can find small quantities of all sorts of interesting flatware, such as eighteenth-century pistol-handled knives, two-pronged metal forks with dyed-green ivory handles, or George III spoons with deep bowls monogrammed on the outside. When you set the table, turn these over to reveal the monogram.

Although period or reproduction silver can be very elegant in settings as varied as a traditional dining room or a high-tech loft, there are all sorts of inexpensive alternatives that, like faux baubles, add a touch of sparkle and humor to the table. Brightly colored melamine or plastic flatware, replicas of French bistro cutlery, faux-marble finishes, and knives and forks whose handles are shaped like twigs are just a few. Contemporary designers such as Elsa Peretti have created fluid, sculptural forms resembling molten silver.

When searching for tableware, remember that things do not have to be what they appear; you can give objects found in a flea market a new life either by using them for a purpose different from the one originally intended or by renovating them with paint and other methods. Soup tureens are very versatile; use them for serving berries or bread, or for flowers. Patty pans, originally used for baking savory pastries, make wonderful butter dishes. You can reclaim an old tin milk jug by painting it and applying decoupage prints, flowers, or miniature portraits. Use the same techniques to decorate variously shaped trays, which can be used instead of silver trays for serving drinks.

You might be surprised to learn how easy it is to design your own plates. In many cities you can find ceramicists who will paint your own design onto an ordinary plate, revive a historic design, or create a transfer print for you. Consulting period manufacturers' catalogs or books on antique china will give you lots of ideas. Or you can have plates hand painted with your monogram and a border of your choosing. Kits for painting your own are also available.

If your taste tends toward the contemporary, let the dinnerware add color, shape, and a sculptural quality to your table. You may want to indulge in a wide range of fanciful designs, such as dinner plates in the shape of flower petals, service plates resembling gilded stars, or glass platters with faux-jewelled borders, to name just a few possibilities.

Now that you have accumulated all of these collections, what do you do with them? Storage is a key consideration in decorating your dining room. Undoubtedly there will be some objects you will want to display, and others you would prefer to conceal. There are all sorts of ways to create attractive storage space that will complement your decor. You can disguise cupboard doors by painting them with faux paneling or a trompe l'oeil picture, by gluing prints to them, or by hanging a series of framed pictures on them, linked perhaps with ribbons or rings. You can also hide them behind faux books (page 110). Bill Blass has converted a

pair of classical columns into decorative storage spaces (page 113). In his Victorian sitting room, Christophe Gollut has hidden an entire miniature kitchen behind false doors hung floor to ceiling with pictures (page 115). Open pantry shelves filled with collections of drinking glasses, carafes, dinnerware, wine baskets, or linens can become the decorative focus of the room. Groups of objects tend to have greater impact than single pieces; clutter can be a virtue. Open shelving is available in a wide variety of styles, from rustic painted wood to high-tech steel. Country dressers look great when filled to bursting with kitchen and dining accoutrements (page 88). Period chests provide ample storage space and add character to the room. They can be painted any way you like and fitted with pull-out shirt drawers to maximize capacity. You can also conceal storage space with decorative screens, such as the one made out of a collection of English paintings that hides the wine racks in the dining room on page 41.

Nothing is more alluring on a splendid spring or summer day than dining alfresco. This is perhaps the ultimate dining fantasy. The charm of a natural setting has been enticing diners for centuries. Follies—delightful garden buildings often designed specifically for dining or tea drinking—were all the rage in the eighteenth century. Typically, they were modeled on exotic architectural forms, such as classical ruins, Egyptian temples, or Chinese pagodas.

Mr. Richard Edgcumbe (afterwards 1st Lord Edgecumbe) entertaining his guests in front of the Garden House (folly). From a drawing by T. Badeslade, 1735.

You can capture the enchanting ambience of a folly by erecting a gazebo or garden pavilion (pages 128, 129, and 131), available in a wide range of prefabricated forms at reasonable prices. Conservatories make ideal dining rooms in which to enjoy the out of doors year round. Terraces, porches, and even a shady spot on the grass are all inviting, romantic places to dine, and the decor is supplied by the best designer of them all—Mother Nature. But indoors you can re-create even the pleasures of a seaside picnic—the roar of the ocean and the feeling of sand in your toes— by decorating a table with shells and serving the food on glazed sand-colored terra-cotta plates.

To increase your flexibility so that you can turn dining into a movable feast at whim, it helps to have a set of portable round folding tables or a collection of removable trays on folding stands, such as mahogany butler's trays, rattan campaign trays, or a set of painted tole trays in different sizes. Inexpensive metal or wood folding tables are indispensable too.

All of us have our own personal fantasy about the most special place to dine. While writing this book, I spoke with many interior designers and asked them to describe their ideal dining room. Their responses varied widely, but all agreed that whatever the space in which we dine, it should be a refuge from the trials and tribulations of daily life; it should be intimate, cozy, and romantic; and above all it should possess an indefinable magic.

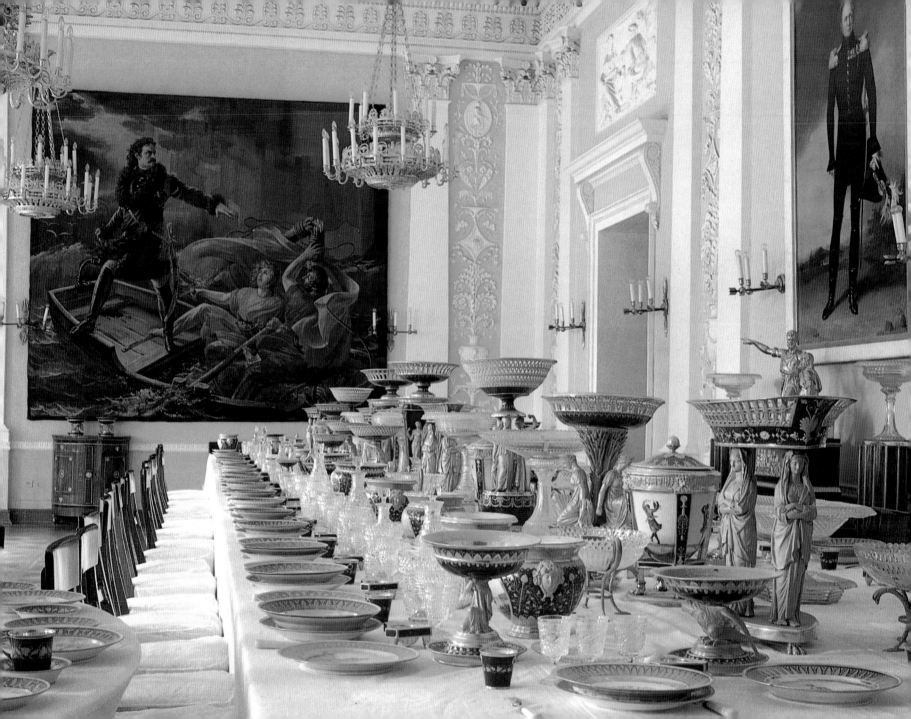

Grand and Stately

DINING IN ARCHITECTURAL SPLENDOR

Architecture on a grand scale sets an elegant and stately mood for dining. The character and often imposing air of the formal dining rooms featured in this chapter have been achieved through a combination of large proportions and dramatic architectural elements, including arches, elaborate cornices, engaged or freestanding columns, paneled walls, decorated ceilings, fireplaces, and sumptuous stucco wall decoration. Such rooms tend to be found in stately English and American country houses as well as in the palaces of Europe, but many of their architectural motifs can be re-created anywhere. The effect an architectural element can have varies greatly, depending on the spatial and stylistic contexts in which it is used; it may retain a period feel or take on a contemporary look. Details rich in historical association can evoke a wide range of moods. For example, a pair of Ionic columns used to differentiate the dining space in an ultramodern SoHo loft may suggest the exoticism of a meal at the foot of a classical Greek ruin or the formality of a Sunday lunch in a Palladian villa. No matter what the setting, architectural detail imparts a sense of import and splendor to dining, imbuing it with a feeling of elegance and tradition and setting it apart from the more mundane routines of daily life.

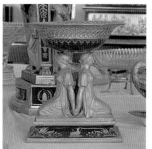

The rooms pictured here provide a visual encyclopedia of architectural ideas that can be reconstructed or reinterpreted in any setting. There are several ways to achieve great architectural effects. The rich repositories of salvage dealers, auction houses, and antique shops offer no end of treasures. In addition, virtually any architectural motif, such as the dazzling faux-mosaic and gilded ceiling in the dining room at Fighine Castle (pages 24 and 25) or the splendid marble columns in Spencer House (page 22), can be achieved through trompe l'oeil. Paneling, such as that on page 20, can be constructed from synthetic materials at reasonable prices. It can also be simulated with specialist paint finishes (page 31) or simply by forming picture-frame moldings out of wallpaper borders.

Whatever style or mood you wish to achieve, from traditional to high camp, the use of architectural elements is an excellent way to add great character and visual interest to the most ordinary dining space. Although the grand and magnificent rooms that follow may seem to call for a formal feast, even the simplest meal would take on an aura of magic in such splendid surroundings.

Pages 16 and 17

MON PLAISIR, A BANQUETING PAVILION AT PETERHOF PALACE NEAR ST. PETERSBURG, RUSSIA, IS AN ARCHITECTURAL TOUR DE FORCE, FEATURING ELABORATE CORNICING, FLUTED PILASTERS, AND ORNAMENTAL OVERDOORS HIGHLIGHTED IN CRISP WHITE PAINT AGAINST A PALE YELLOW BACKGROUND. THE GILDED AND ENAMELED SERVICE, PRODUCED BY THE ST. PETERSBURG PORCELAIN FACTORY, IS A FINE EXAMPLE OF RUSSIAN NEOCLASSICAL STYLE. *(Left and right)*

18

HUNTING PAVILIONS SUCH AS THAT OF THE CHÂTEAU DE BEAUREGARD IN THE LOIRE VALLEY WERE MAGICAL PLACES TO DINE. BUILT DURING THE RENAISSANCE, THE DINING ROOM IS A POTPOURRI OF ARCHITECTURAL DETAIL, INCLUDING ELABORATE STRAP WORK USED TO ARTICULATE THE WALL AND FRAME AN OVERSIZED OIL PAINTING. THE EFFECT OF THIS ORNAMENTATION CAN BE SIMULATED ON ANY WALL BY USING FAUX FINISHES SUCH AS STONE BLOCKING.

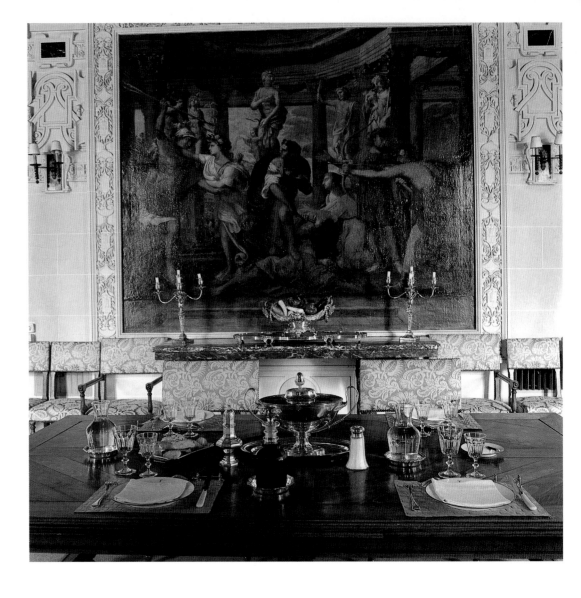

The massive stone fireplace in the dining room at Beauregard reads like an encyclopedia of Renaissance ornament. A heraldic crest framed by a cartouche dominates the overmantel, and among its other decorative motifs are two columnar supports topped by classical heads. By decoding the architectural elements in a room such as this, you can amass a treasure trove of ideas.

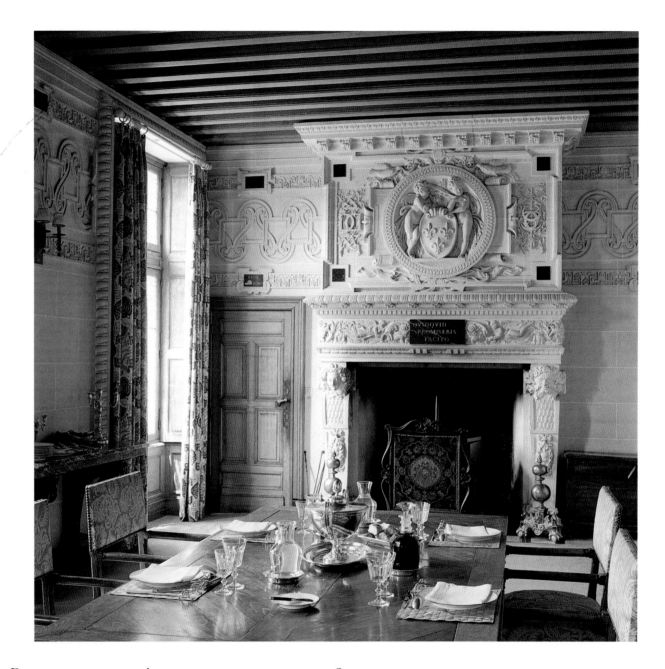

DINING IN ARCHITECTURAL SPLENDOR

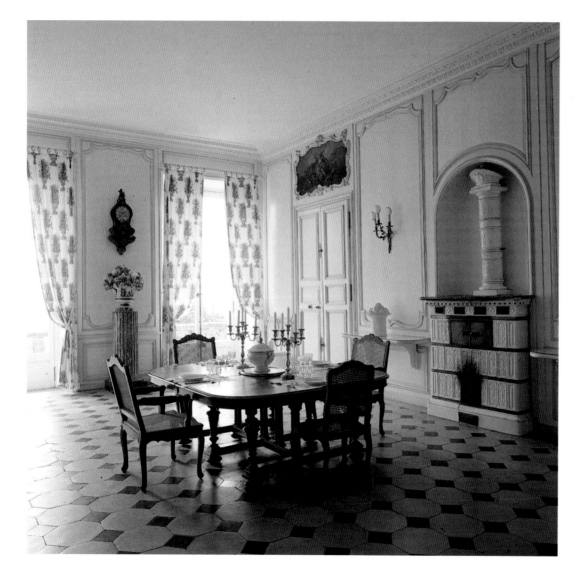

Painted paneling such as that at the château de Montmirail near Le Mans adds character and Old World charm to any dining room. You can achieve the same effect by installing real period paneling or by constructing it out of a synthetic material and painting it. The decoration that frames the panels can be simulated through trompe l'oeil techniques or by applying plaster ornaments. The overdoor painting accentuates the height of the room. (Left)

Arches lend an elegant sweeping line to any wall. Low shelves on brackets not only provide a place to display a collection of white porcelain but also function as convenient serving stations. (Below)

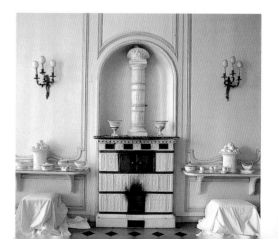

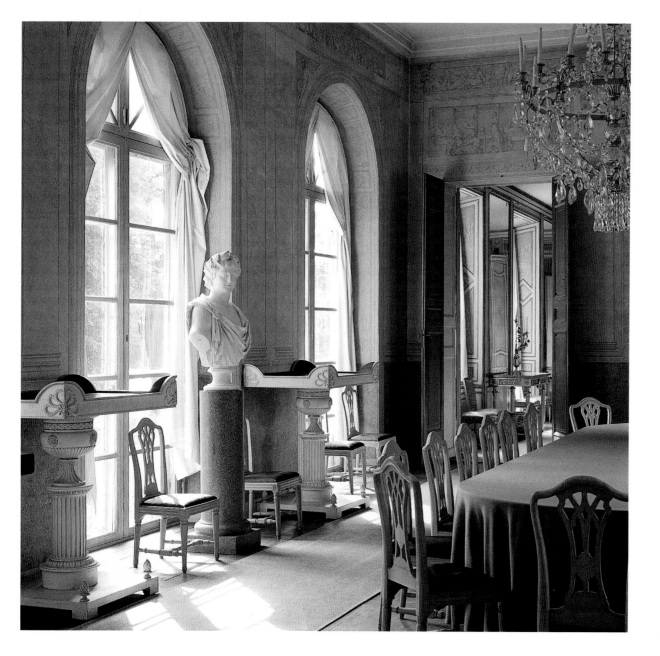

\mathcal{T}HE ETHEREAL FEELING OF
THE DINING ROOM AT THE
HAGA PAVILION IN SWEDEN IS
CREATED BY ITS HIGH CEILING
COMBINED WITH A SERIES OF
ARCHED FRENCH DOORS.
DOORS SUCH AS THESE
ARE WIDELY AVAILABLE IN
PREFABRICATED FORM. THE
WHITE-PAINTED CHAIRS IN
LATE CHIPPENDALE STYLE
ARE ALSO AVAILABLE IN
REPRODUCTION. EVEN THE
NEOCLASSICAL SERVING TABLES,
WHICH ARE ESSENTIALLY
DEEP-BORDERED TRAYS
MOUNTED ON COLUMNAR
BASES, ARE ARCHITECTURALLY
INSPIRED.

21

THE NATURALNESS OF THESE FLOWER
ARRANGEMENTS SOFTENS THE FORMALITY
OF THE DINING ROOM AT SPENCER HOUSE
IN LONDON. *(Above)*

ELEMENTS OF THE GRAND ARCHITECT-
URAL ORNAMENTATION OF THE SPENCER
HOUSE DINING ROOM, RESTORED BY DAVID
MLINARIC, CAN BE RE-CREATED ON A MUCH
MORE MODEST SCALE. TO DECORATE YOUR
CEILING IN A SIMILAR FASHION, YOU CAN
USE EITHER PLASTER AND WOOD TO
ACHIEVE THE RELIEF, OR PAINT THE DESIGN
AND PUNCTUATE IT WITH FAUX-GILDED
ROSETTES. SIMILAR CORNICES AND FESTOON
FRIEZES CAN ALSO BE REPRODUCED IN
PAINT. COLUMNS CAN BE BOUGHT AT
ARCHITECTURAL SALVAGE CENTERS AND
MARBLEIZED. *(Right)*

22

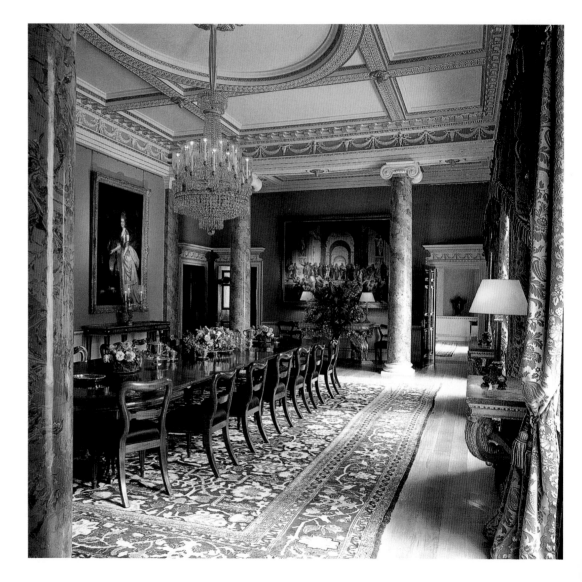

When fourteenth-century Blairquhan Castle in Scotland was redesigned by William Burn in 1798, many of its Gothic elements were retained. The dining room is approached through one of a pair of arched wooden doors crowned by a pair of pointed Gothic arches that terminate in basket finials. One of the great achievements of Gothic style, the pointed arch has countless applications, from framing a doorway to being incorporated into a cornice frieze or wall mural.

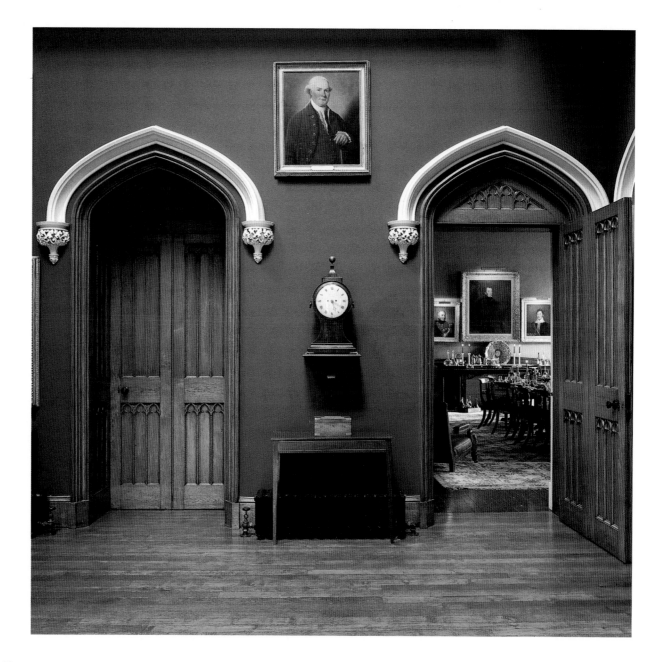

DINING IN ARCHITECTURAL SPLENDOR

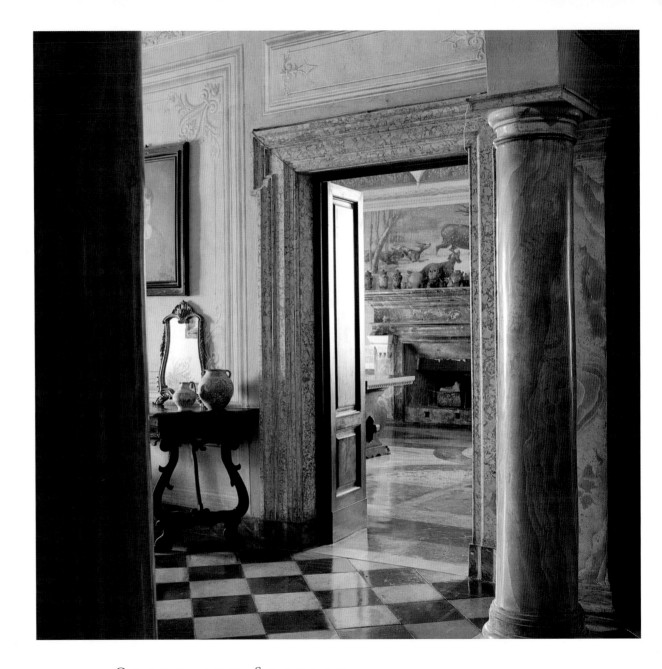

The regal entrance to the dining room at Fighine Castle in Tuscany combines genuine architectural elements, such as the door case and column, with trompe l'oeil effects. The grisaillelike stucco decoration on the walls and the marble of the column and door frame are all faux.

GRAND AND STATELY

\mathscr{I}N THE FIGHINE CASTLE DINING ROOM
ITSELF, DRAMATIC ARCHITECTURAL DETAILS
AND AN ELABORATE USE OF PAINT TECH-
NIQUES TRANSLATE INTO SHEER MAGIC.
THE CEILING AND PENDENTIVES HAVE BEEN
PAINTED TO SIMULATE A SHIMMERING
MOSAIC. ABOVE A FRIEZE OF SWAGS AND
FESTOONS, ROUNDED ARCHES FRAME A
SERIES OF PAINTED LANDSCAPE PANELS.
(Above and right)

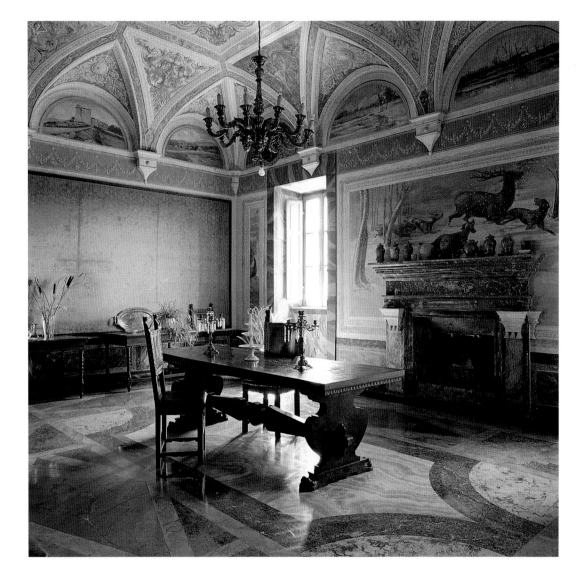

25

THE HALL LEADING TO THE
DINING ROOM AT
MANDERSTON, IN ENGLAND, IS
A TREASURE TROVE OF GRAND
ARCHITECTURAL ELEMENTS.
WALLS ARE PUNCTUATED WITH
ARCHES AND COLUMNS,
EMBELLISHED WITH ELABORATE
STUCCO DECORATION, AND
FRAMED WITH SWAGS AND
FESTOONS. THE FESTOON THAT
CROWNS THE CIRCULAR
ORNAMENT ON THE LEFT-HAND
WALL IS A PARTICULARLY
EFFECTIVE DECORATIVE
ELEMENT. EASILY RE-CREATED
EITHER IN PLASTER OR PAINT,
IT CAN SERVE TO HIGHLIGHT A
PAINTING OR SIMPLY TO ADORN
A PLAIN WALL.

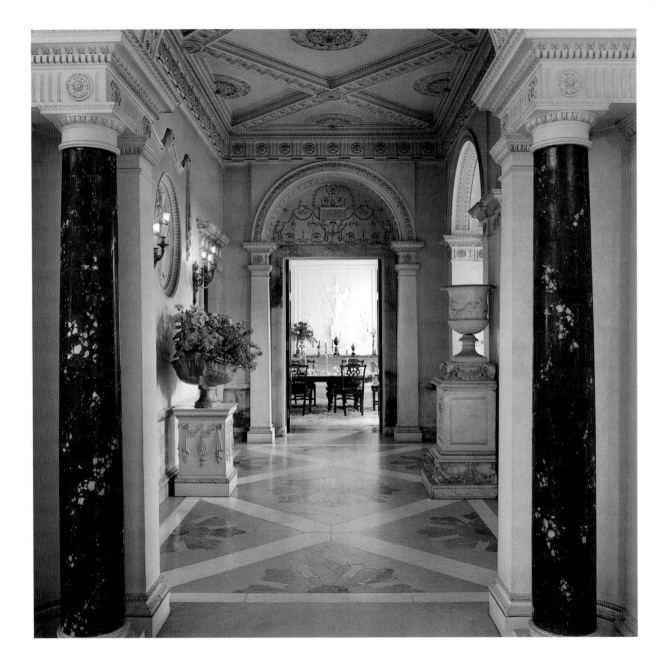

GRAND AND STATELY

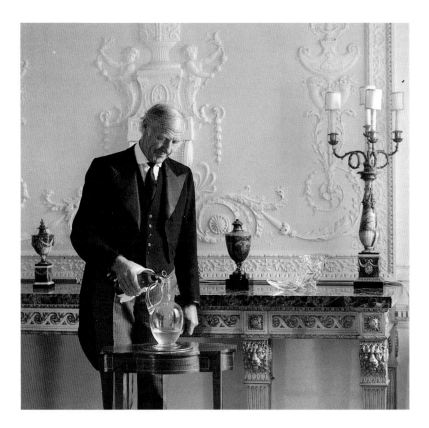

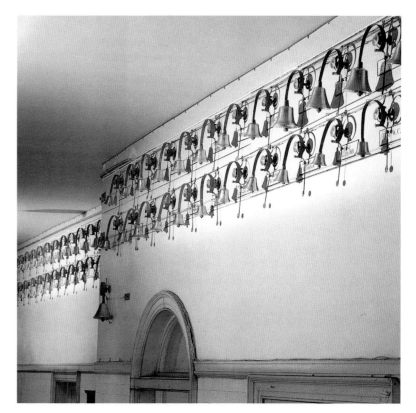

*T*HE FIFTY-SIX BELLS IN THE CORRIDOR OUTSIDE THE BASEMENT KITCHEN AT MANDERSTON, EACH WITH A DIFFERENT SOUND, MAY NO LONGER SUMMON LIVERIED FOOTMEN OR ANNOUNCE MEALS, BUT THEY ARE RICHLY EVOCATIVE OF THAT BYGONE ERA AND HIGHLY DECORATIVE. *(Below)*

*A*LTHOUGH BUILT IN THE TWENTIETH CENTURY, MANDERSTON WAS INSPIRED BY THE GREAT COUNTRY HOUSES OF EIGHTEENTH-CENTURY ARCHITECT ROBERT ADAM. THE INTRICATE PLASTER RELIEF ON THE WALL IS PARTICULARLY REMINISCENT OF ADAM'S DECORATIVE STYLE. ONE CONTEMPORARY OF HIS DESCRIBED SUCH ORNAMENTATION AS "SNIPPETS OF EMBROIDERY"; ANOTHER, AS "MODELS FOR THE TWELFTH-NIGHT DECORATION OF A PASTRY COOK." THE WINE TABLE, SPECIALLY DESIGNED FOR DECANTING, CAN BE DRAWN UP NEXT TO THE DINING TABLE WHEN THE WINE IS READY TO BE SERVED. *(Above)*

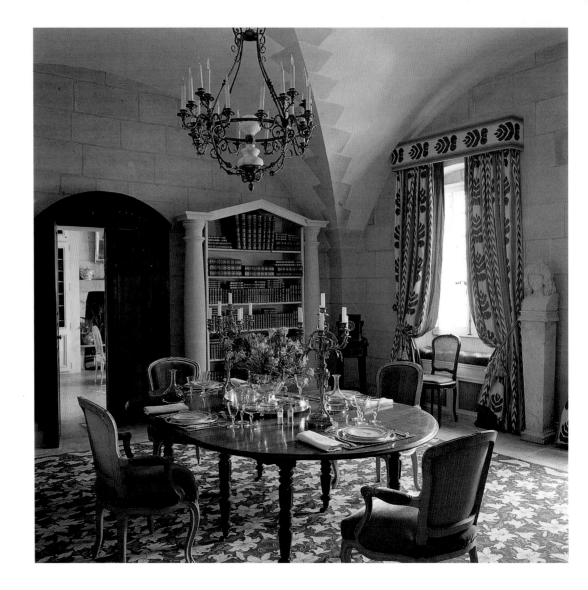

At Le Grand Launay, a moated seventeenth-century château in the Loire Valley, architectural elements lend the dining room the ambience of a centuries-old library. Even the bookcase, with its pedimented roof and columnar supports, was inspired by an architectural model.

GRAND AND STATELY

In the dining room of the Gothick Villa in London, rich red walls are crowned by a Gothic frieze, which is echoed in the gilded window pelmets, the pointed arch of the mantelpiece mirror, and the door. Gothic-inspired motifs are even incorporated into the carpet design. Period pattern books are an excellent source of ideas for such architectural motifs, which can either be simulated in paint or purchased ready made.

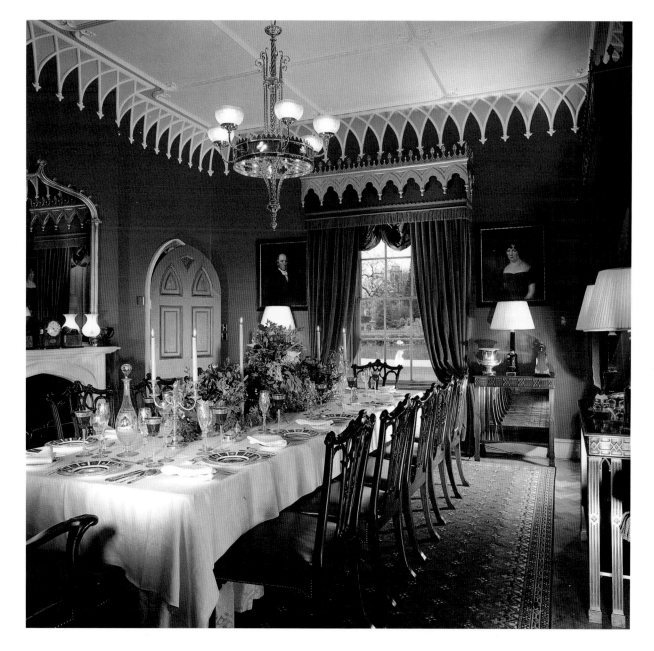

DINING IN ARCHITECTURAL SPLENDOR

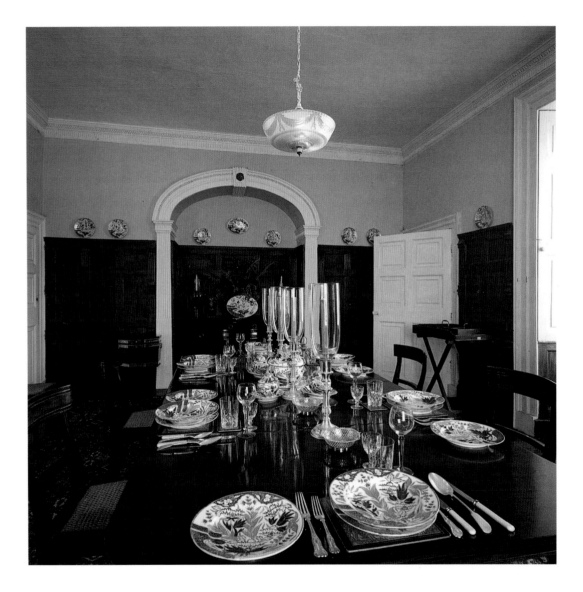

30

\mathcal{A}N IMPOSING ARCH, PANELED DOORS, AND PANELED WINDOW FRAMES IMPART SIMPLE BUT STRIKING ELEGANCE TO THIS BARBADOS DINING ROOM. THE BUTLER'S TRAY, WHICH CAN BE REMOVED FROM ITS STAND FOR SERVING, FUNCTIONS AS A TEMPORARY SIDEBOARD. IN TRUE CARIBBEAN FASHION, THE WALLS ARE PAINTED A REFRESHING SEA-FOAM GREEN.

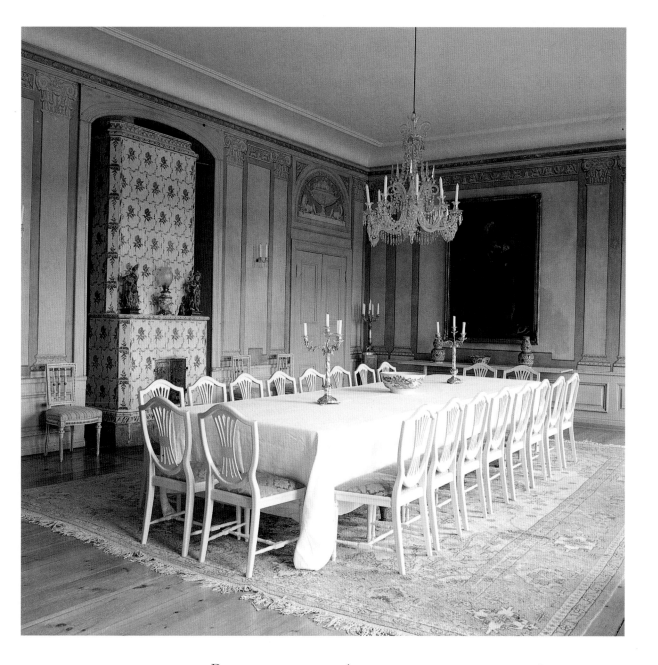

THE DINING ROOM AT
HYLINGE, WITH ITS PANELING
AT THE BASEBOARD LEVEL,
TROMPE L'OEIL DOUBLE
CORINTHIAN COLUMNS, CLAS-
SICAL OVERDOOR DECORATION,
AND DELICATE FRIEZE IS A
STUDY IN THE SWEDISH
INTERPRETATION OF THE
NEOCLASSICAL STYLE. ALL IN
SOFT SHADES OF BLUE AND
WHITE, THE ROOM LOOKS LIKE
THE ARCHITECTURAL
EQUIVALENT OF WEDGWOOD'S
NEOCLASSICAL CERAMICS.

DINING IN ARCHITECTURAL SPLENDOR

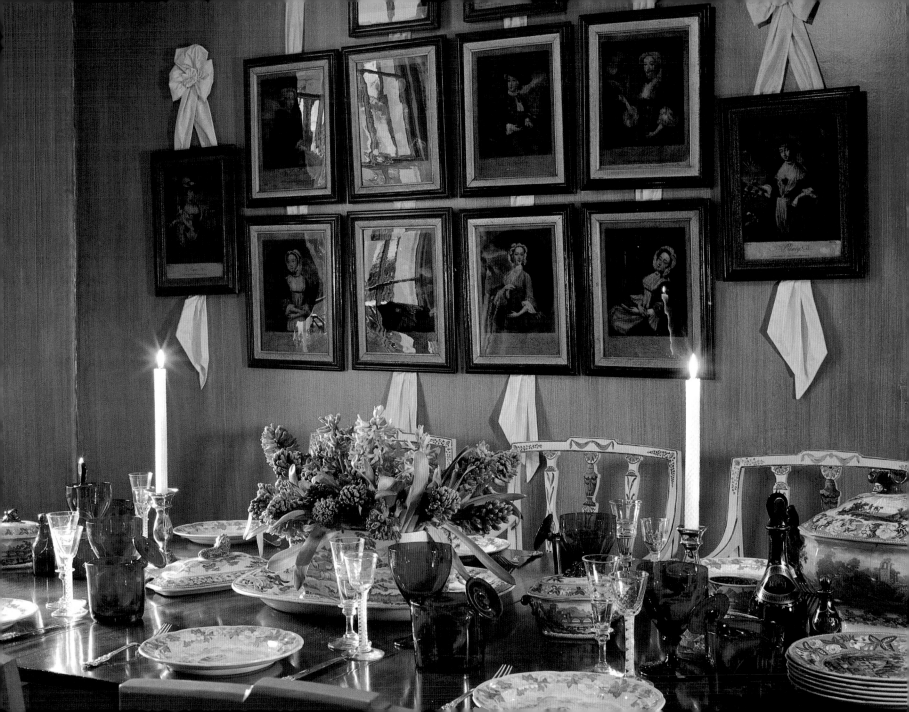

Form and Function

A Feast for the Collector

The collector's spirit lurks somewhere in all of us, and the dining room is the perfect place to let it come to the fore. Thinking about tableware and decorative objects in terms of building a collection can transform an ordinary task into an adventure. The first step in forming a collection of any kind is to identify a unifying theme, such as a period, style, color scheme, type of object, or function. Part of the fun of collecting is discovering the history and special qualities of an object, as well as the social circumstances in which it was created. Each piece will reveal a story, an anecdote, a bit of intrigue, an insight into another era. The objects you collect need not be grand; anything whose design enchants you, whether it is dainty Sèvres porcelain, hardy English ironstone, vintage tins, mustard crocks, rainbow-colored Bakelite cutlery, Chinese vegetable steamers, or neon-bright espresso makers, is a bona fide collectible.

Simply by focusing on a color scheme, such as blue and white, you can build collections as varied as eighteenth-century salt-glazed stoneware, Chinese Export porcelain, shell-edged pearl ware, nineteenth-century transfer-printed ware, unornamented creamware, Chinese porcelain, broadly striped and boldly lettered willowware, azure-blue Provençal earthenware, and so on. Or you may wish to focus on a particular style of ceramics, such as agate, Whieldon, mocha, or biscuit ware. You may choose to concentrate on the products of a single region or manufacturer, such as the faience of Moustiers or the porcelain of Spode, Minton, Wedgwood, or Royal Doulton. You can collect a particular type of object, such as teapots, ranging from Wedgwood's fanciful cauliflower ware, to neoclassical jasperware or basalt black, to Clarice Cliff's amusing "Eight O'Clock" tea set in the shape of an alarm clock, to the delightful Staffordshire ware fashioned to look like houses and castles, to the clean lines of Art Deco silver.

The pleasure of it all is in mixing and matching the pieces of your collection. In the dining room on the facing page, for instance, the table is set with a collection of blue-and-white Staffordshire plates, all with different scenes, which work together because they have similar borders and coloration.

The theme of table-top collections can extend to the entire room. For example, you can enhance the decorative impact of a set of botanical-motif porcelain by hanging a set of botanical prints on the walls. Or combine china depicting scenes of dining and tea drinking with paintings or prints of similar subjects. The dining room is a wonderful venue for displaying a collection of pictures, such as equestrian paintings (page 41), portraits (page 38), a series of prints (page 44), and vintage photographs of restaurants, picnics, or grande soirées. Whatever your collecting interest, learning to look at ordinary objects for their decorative potential is the key.

Pages 32 and 33

Tiny blue vases on the backs of a set of eighteenth-century painted chairs inspired the wall color of this London dining room. A collection of eighteenth-century British portraits on glass hang from taffeta ribbons, as was the period fashion. Blue and white is the theme of the owner's eclectic tableware collection. The plates are nineteenth-century Staffordshire ware, each printed with a different pastoral scene. A set of cobalt-blue wine rinsers unlocks the mystery of the eighteenth-century custom of rinsing the glass before each change of wine. Patty pans have been given a new life as butter dishes, and wine is poured from antique decanters that once housed "Holland" and "Rum." *(Left and right)*

At Stanway, a seventeenth-century house in the Gloucestershire, England, countryside, an eighteenth-century marble-topped serving table displays a collection of porcelain tureen lids. The painting conjures up rural gentry life in the era when these charming objects were produced.

34

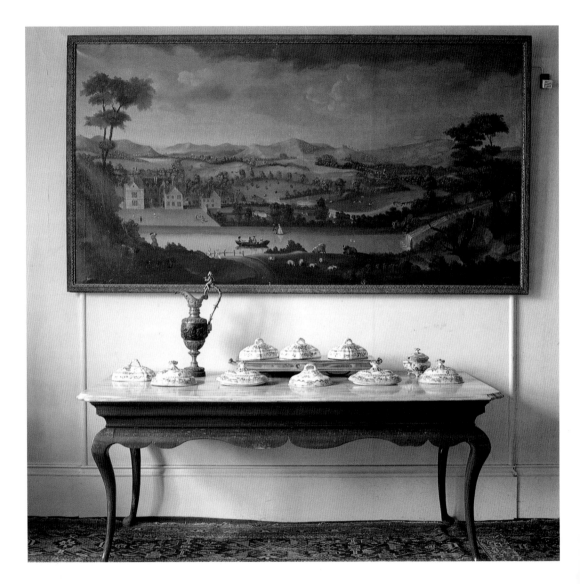

FORM AND FUNCTION

London art dealer Stephanie Hoppen is a passionate collector, and her dining room is filled with pieces from her extensive collections of period glass, napkin rings, antique Chinese and English porcelain, vintage lace tablecloths, and, of course, wonderful paintings.

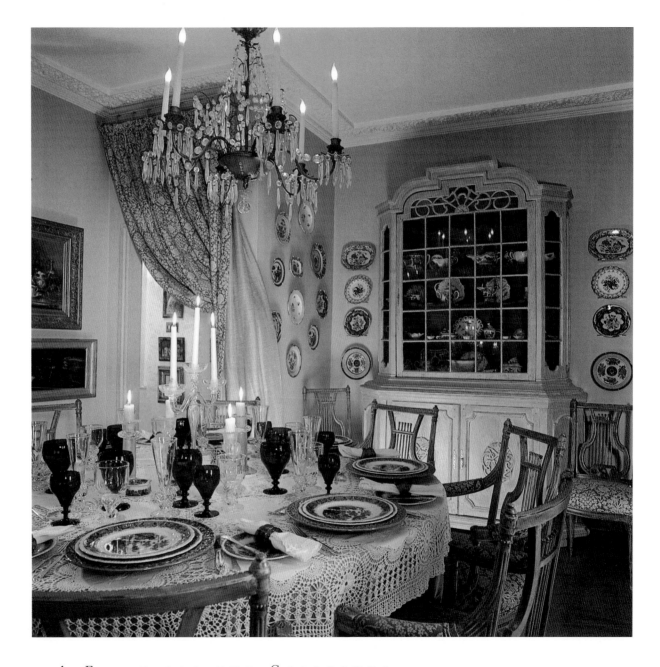

A FEAST FOR THE COLLECTOR

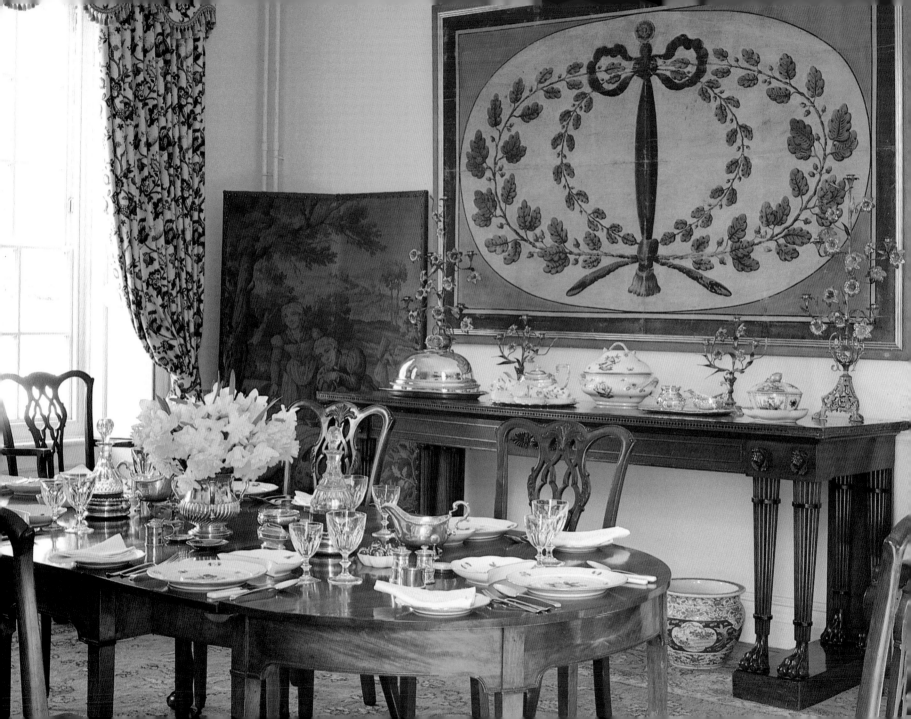

The dining room in this English country house designed by Lutyens reveals much about how furniture and object collections evolve over time. A set of carved Chippendale chairs is paired with an eighteenth-century table and an early nineteenth-century sideboard, which displays a collection of silver and porcelain serving dishes and French bronze candlesticks. A design for an Aubusson carpet hangs above the sideboard. *(Facing page)*

The spirit of the ocean liner *Normandie* inspired this Art Deco dining room in a New York City loft. The sideboard, designed by Ruhlmann in the 1930s, is the perfect place to display a collection of glass vases from the period. The Puiforcat cutlery and candelabra date from the same era. The paneling was designed to capture the decorative essence of the great age of ocean liner travel. *(Right)*

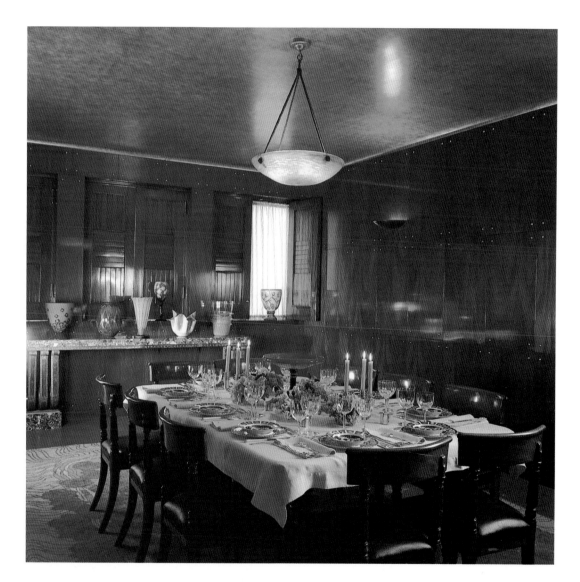

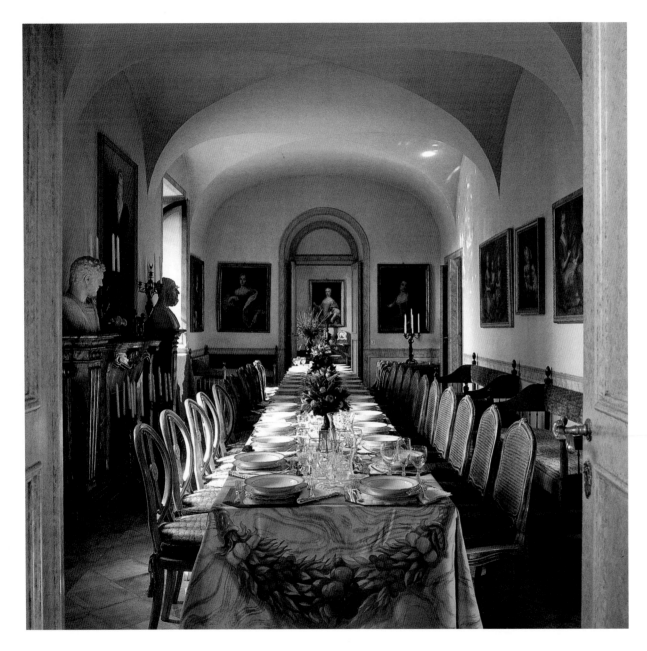

In Anna Fendi's centuries-old Roman palazzo, the warm yellow stucco walls of the dining room are lined with a collection of portraits. Two different but complementary sets of chairs face each other on either side of the table.

FORM AND FUNCTION

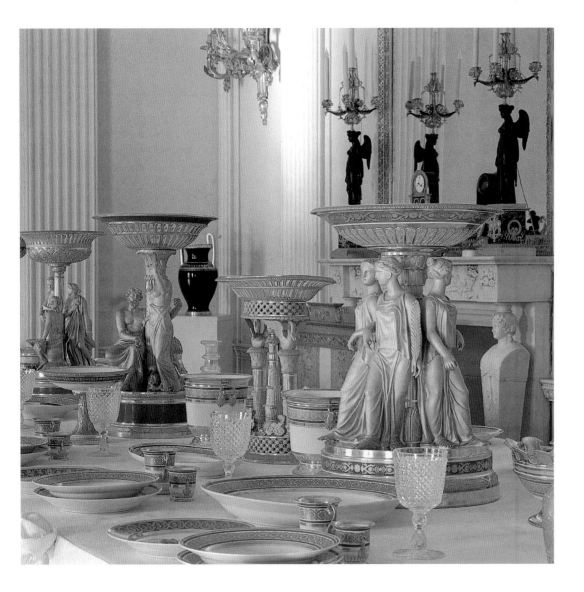

In the dining room at Pavlovsk—the neoclassical jewel of Russian palaces, designed by architect Charles Cameron—the table is set with the glittering Heraldic Service. *(Left)*

One of the many extraordinary gilded pedestal bowls of the Heraldic Service, depicting Venus and Cupid. Gilding has a dazzling effect on any table setting, and even a single gilded object, such as a bowl or candlestick, helps create a magical ambience. *(Below)*

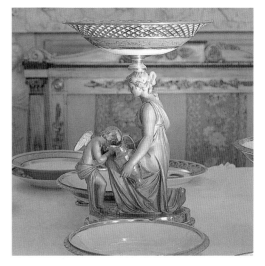

The dining room at Charleton, an early eighteenth-century laird's house in Scotland, is a treasure trove of collections. According to family records, the Italian baroque door case that frames the fireplace was bought by the ancestors of the current owner on the advice of the artist John Singer Sargent. The collection of landscapes and portrait paintings date from the seventeenth century to the present. They vary in size from the monumental portraits flanking the door to the charming pair of ovals next to the window. In the evening, the room is lit by twenty-two wall sconces, copies of an original in the Wallace Collection in London.

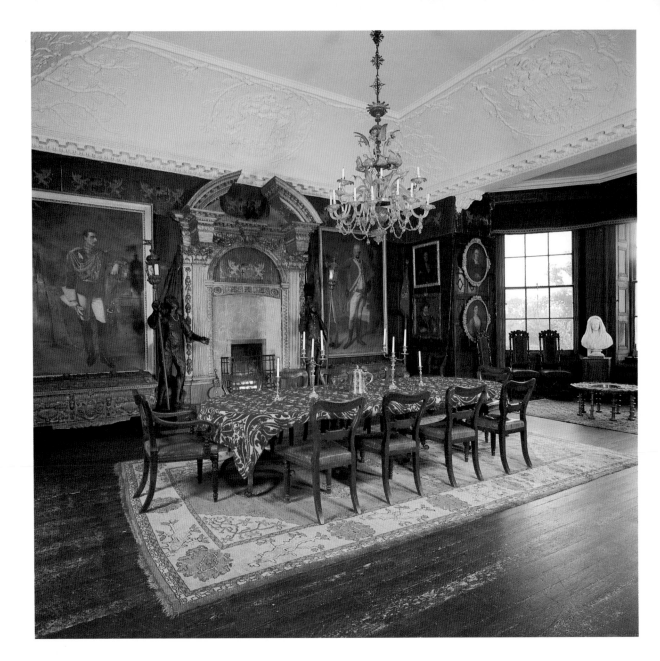

FORM AND FUNCTION

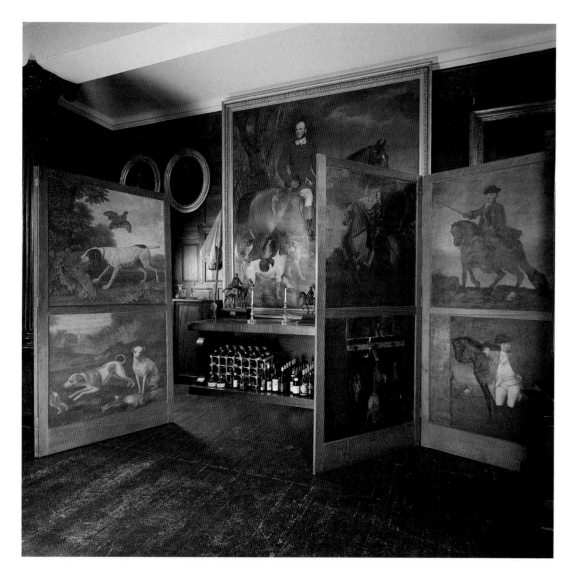

\mathcal{A}T ONE END OF THE ROOM, A
COLLECTION OF EQUESTRIAN, LANDSCAPE,
AND ANIMAL PAINTINGS HAS BEEN CLEVERLY
TRANSFORMED INTO A SCREEN, WHICH NOT
ONLY HAS GREAT DECORATIVE IMPACT BUT
ALSO SERVES TO CONCEAL WINE STORAGE.

A COLLECTION OF
BLUE-AND-WHITE NINE-
TEENTH-CENTURY PORCELAIN
TRANSPORTS THE SPIRIT OF
OLD ENGLAND TO THIS DINING
ROOM IN SPAIN. BEAUTIFULLY
DISPLAYED ALONG WITH
PERIOD GLASS, SILVER-LIDDED
MEAT PLATTERS, SILVER
CANDLESTICKS, AND ANTIQUE
WINE DECANTERS ON SIMPLE
OPEN SHELVING, THIS COLLEC-
TION ILLUSTRATES HOW
TABLEWARE CAN FUNCTION AS
THE DECORATIVE FOCUS
OF A ROOM.

42

FORM AND FUNCTION

On Rupert Cavendish's Art Deco dining table, his collection of Art Deco wares, including a Baccarat decanter and a set of French flatware, impart a period feel to a dinner service by Susie Cooper.

A Feast for the Collector

An array of eigh-
teenth- and nineteenth-
century prints, including
landscapes, botanicals, and
portraits, covers the walls
of London print dealer
Julia Boston's cozy dining
room, creating a gallery-
like effect.

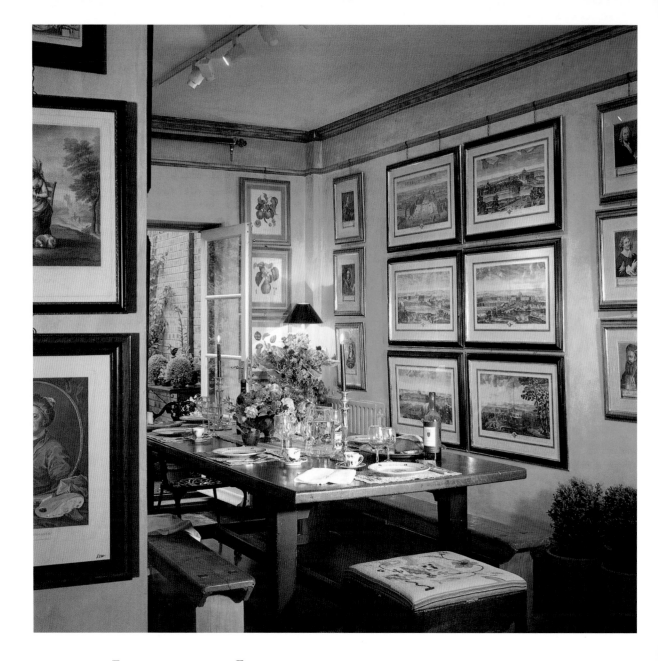

FORM AND FUNCTION

45

*L*ONDON FURNITUREMAKER DAVID LINLEY'S COLLECTION OF CHINA
WAS INSPIRED BY HIS FURNITURE DESIGNS, WHICH UPDATE THE
NEOCLASSICAL TRADITION OF CONTRASTING LIGHT AND DARK AND
CREATING GEOMETRIC FORMS THROUGH WOODEN INLAY. *(Below)*

*T*HIS GROUPING OF WOODEN CANDLESTICKS ON A SIDE TABLE, ALL
DESIGNED BY DAVID LINLEY, ILLUSTRATES THE DECORATIVE IMPACT
THAT THE MASSING OF OBJECTS CAN HAVE. *(Above)*

\mathcal{S}ILVER SALT CELLARS, COASTERS,
SHELL-SHAPED ASHTRAYS, SALT SHAKERS,
AND PEPPER MILLS ADD A FESTIVE TOUCH
TO A DINING ROOM TABLE DESIGNED BY
LONDON FASHION DESIGNER ANOUSKA
HEMPEL. *(Above)*

\mathcal{T}HE ROOM'S LUSH GREEN WALLS PROVIDE
A SOFT BACKGROUND FOR AN ECLECTIC
ARRAY OF PAINTINGS AND ECHO THE GREEN
CANDLESTICKS, THE EMERALD-GREEN WINE
GLASSES, AND THE CENTERPIECE, A
COLLECTION OF DARK GREEN GLASS BALLS
PILED HIGH IN A SILVER BOWL. *(Right)*

46

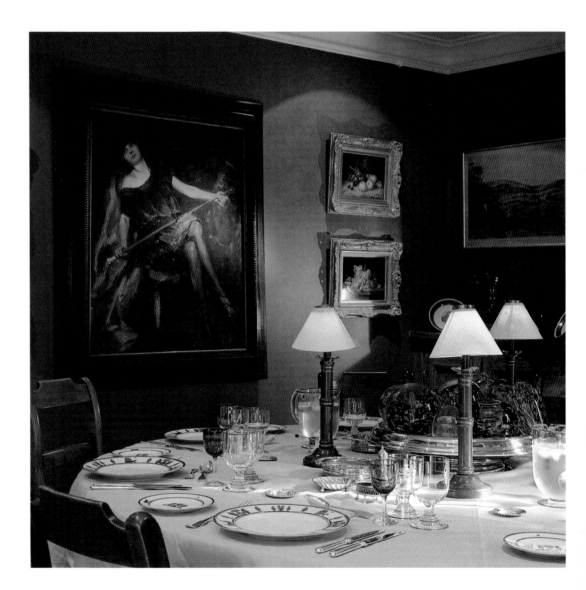

FORM AND FUNCTION

This London dining room owes its elegance to the tasteful display of treasured possessions collected over time: the triple-shield-back neoclassical chairs, the paintings and sculptures, and the decorative ornaments, including the ebony candlesticks on the table and the freestanding candelabra in the corner.

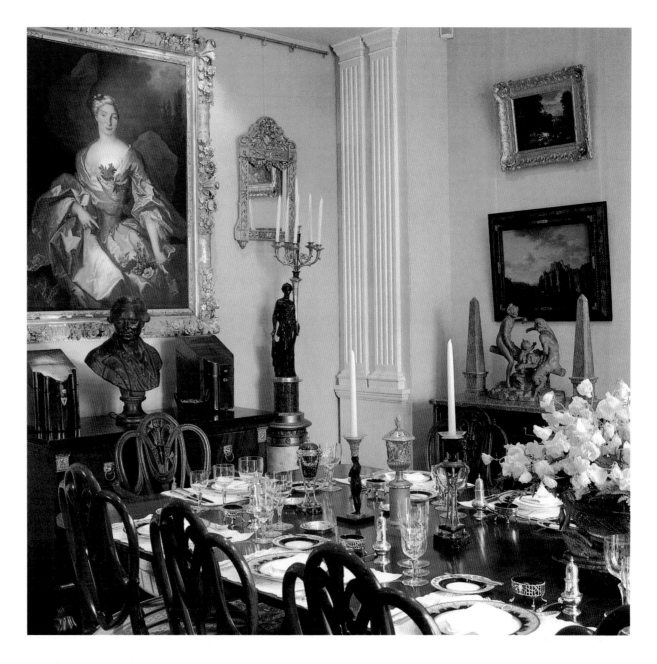

47

A FEAST FOR THE COLLECTOR

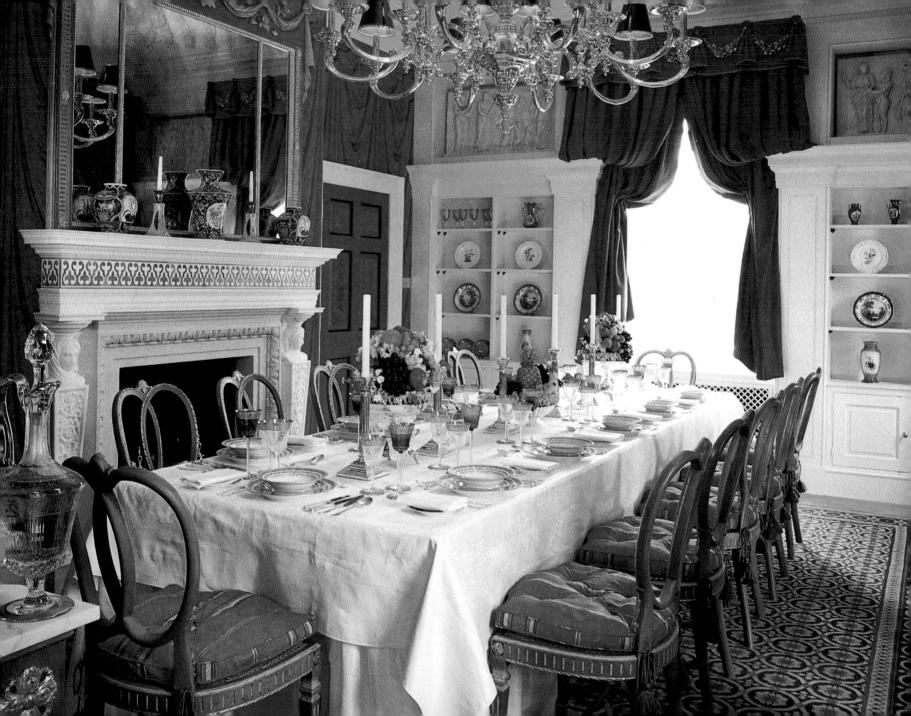

Room with a View

TEMPTING WALL TREATMENTS

Dining rooms with a view have always had an irresistible charm. In restaurants we covet the table at the water's edge or the one with a panorama as far as the eye can see. You need not have your own seaside setting or a pavilion in the midst of a wild and romantic garden to enjoy the pleasures of a view while dining. In fact, you do not even have to have a window! Simply by painting a trompe l'oeil mural on the walls or covering them with one of the many trompe l'oeil wallpapers on the market, you can transform even a small dark space into a room with a captivating and beguiling view. The illusion of any natural setting—an Italianate garden with majestic cypress and fruit trees, for example, or an English garden path lined with a profusion of flowers, or even a rugged Maine seascape—can be created indoors and savored all year round.

The tradition of this type of wall treatment dates back to the eighteenth and nineteenth centuries, when the taste for painted, panoramic murals that told an allegorical story became so widespread that French wallpaper manufacturers began to produce ready-made facsimiles. Papers such as those on pages 50 and 52 were all the rage, appearing in the most fashionable houses. Not only were these panoramic wallpapers extremely decorative, they were also visually entertaining. Another pop-

ular style of trompe l'oeil wallpaper mimicked the fashion for draping expensive fabric on the walls. Papers such as the one on the facing page, a reproduction of a period design, were often paired with lacy borders. Yet another wall treatment that was popular in the eighteenth century was the print room. By pasting prints on the walls, outlining them with wallpaper borders to give the illusion of picture frames, and then linking them with such decorative devices as chains, ribbons, bows, or animal heads simulating brass rings, one could create the illusion of a museum gallery. This decorative technique can be re-created today, easily and inexpensively, by using reproduction prints and ready-made borders.

Walls with diverting views are particularly appropriate for dining rooms, where people tend to be seated in one place for several hours. They not only enliven the room but also give the impression of transporting it in space and time. The concept does not have to be interpreted literally, however. All of the dining rooms on the following pages have a "view," some of which are created through illusionistic effects, but others through the use of a bold overall pattern, whether on fabric or wallpaper or applied directly to the walls with paint.

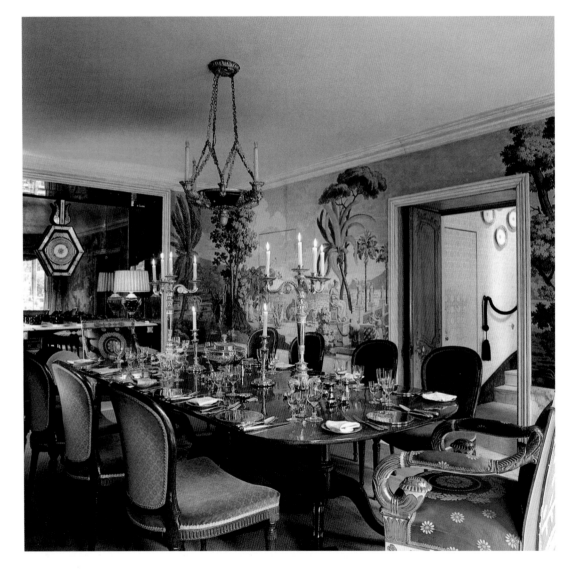

Pages 48 and 49
THE WALLS OF THE VENETO VILLA IN
LONDON ARE COVERED WITH A RICH RED
HAND-PAINTED WALLPAPER THAT
SIMULATES THE LUXURIOUS DRAPING OF A
SUMPTUOUS FABRIC. SUCH PAPERS WERE ALL
THE RAGE IN THE LATE EIGHTEENTH AND
EARLY NINETEENTH CENTURIES. THIS ONE
IS A REPRODUCTION BY ZUBER.
(Left and right)

THIS LONDON DINING ROOM FEATURES
AN ORIGINAL EIGHTEENTH-CENTURY
PANORAMIC WALLPAPER, "JOURNEYS OF
TELEMACHUS," BY DUFOUR. *(Left)* BELOW
THE WALLPAPER, FAUX-MARBLE FINISHES
CREATE THE ILLUSION OF A DADO AND
BASEBOARD. *(Above)*

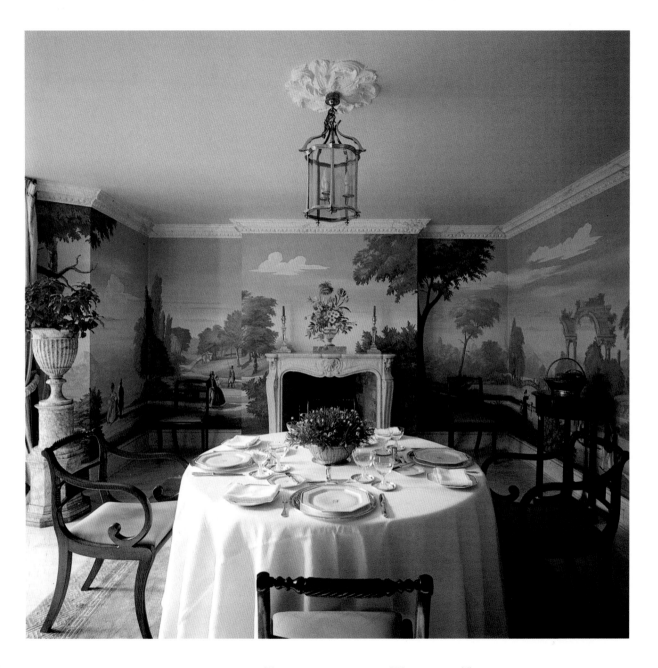

Period panoramic wallpapers created the effect of expensive painted murals but at prices that the then-burgeoning middle class could afford. In this London dining room interior designer Christophe Gollut has done just the opposite. Using original panoramic wallpaper designs as his inspiration, he has painted a trompe l'oeil pastoral landscape on the walls. A brilliant piece of deception, even the urn of flowers above the mantelpiece is an illusion.

TEMPTING WALL TREATMENTS

THE WALLS OF THIS
ELEGANT DINING ROOM ARE
COVERED IN THE FRENCH
PANORAMIC WALLPAPER
"HINDOUSTAN." THE
EXOTICISM OF THE SCENE IS
ENHANCED BY THE GILDED
FLORAL AND STARLIKE MOTIFS
ON THE DARK WOOD PANELING.

52

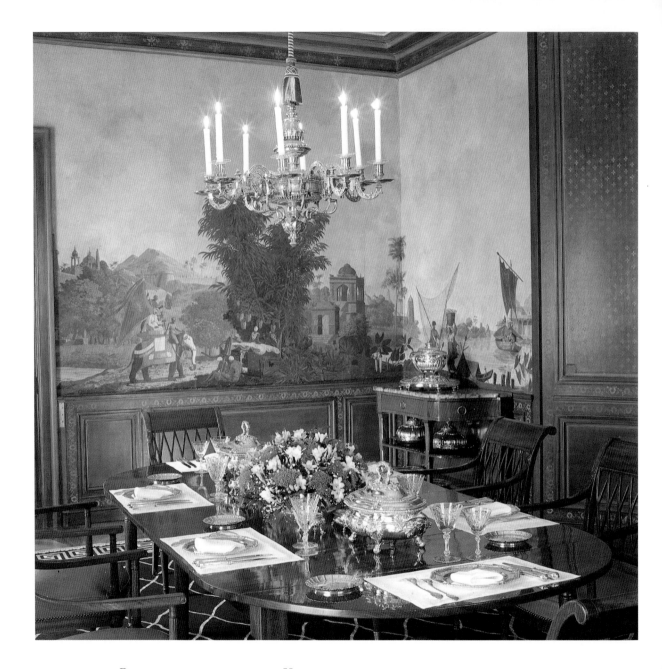

ROOM WITH A VIEW

IN THIS ENCHANTING DINING ROOM,
AMERICAN INTERIOR DESIGNER BUNNY
WILLIAMS HAS PULLED OFF AN
ILLUSIONISTIC TOUR DE FORCE. NONE OF
THE PORCELAIN PLATES AND URNS ON THE
WALLS IS REAL. SOME ARE PATTERN-BOOK
DESIGNS THAT HAVE BEEN CUT OUT AND
PASTED ON THE WALL. OTHERS ARE
TROMPE L'OEIL DESIGNS PAINTED DIRECTLY
ON THE WALL. *(Right)*

IN THE DINING ROOM OF A LONDON
HOUSE THAT WAS FORMERLY AN INN WHERE
ARCHITECT CHRISTOPHER WREN ONCE
LIVED, A MASTERFUL TROMPE L'OEIL ARTIST
HAS TRANSFORMED THE FLAT WALLS INTO
WEATHERED STONE, COMPLETE WITH
ARCHED NICHES. *(Below)*

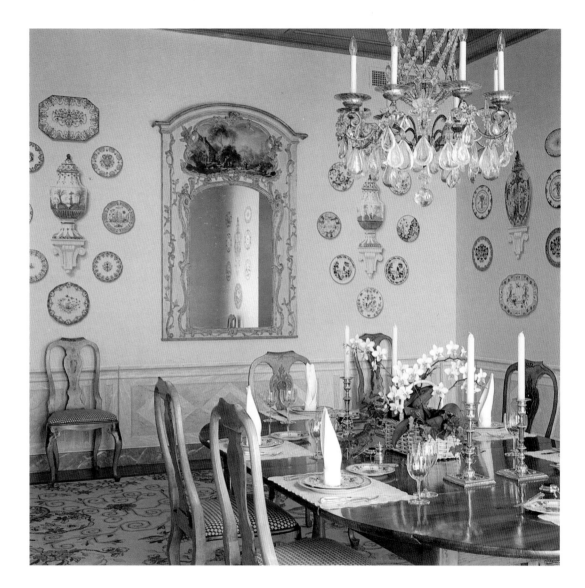

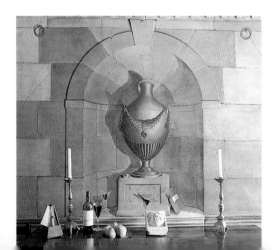

53

TEMPTING WALL TREATMENTS

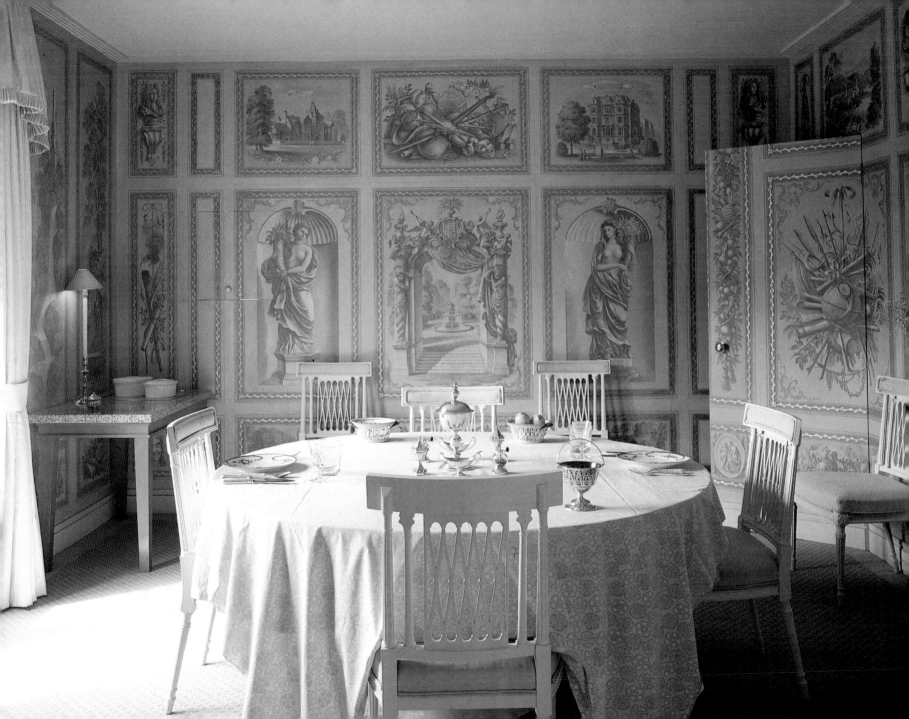

In interior designer David Hicks's dining room in the English countryside, the walls are covered with grisaille-painted panels originally commissioned for Lady Mountbatten at Broadlands and inherited by Lady Pamela Hicks. Although the panels are executed in paint, the effect resembles that of a print room. Even the door leading to the kitchen has been covered with the paneling, making it almost indistinguishable when closed. The removable panels have followed the Hicks family from house to house. *(Facing page)*

The panel over the fireplace depicts Broadlands, the Mountbatten family seat. The surrounding panels of classical figures and trophies reflect Lady Mountbatten's personal interests, such as gardening and music. When the wall treatment is this elaborate, virtually no other decoration is needed. *(Right)*

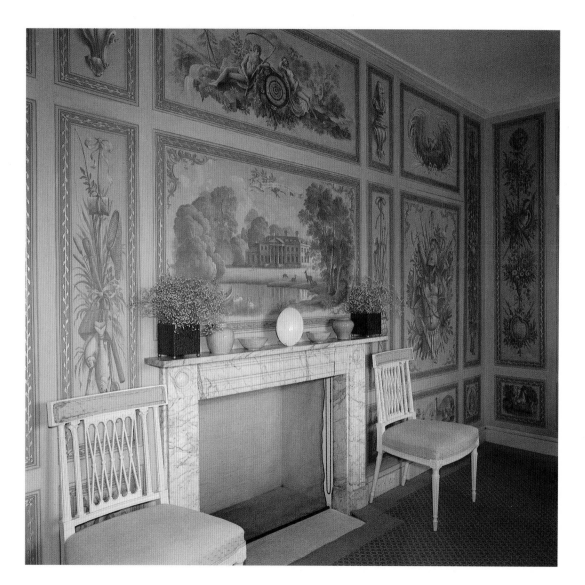

TEMPTING WALL TREATMENTS

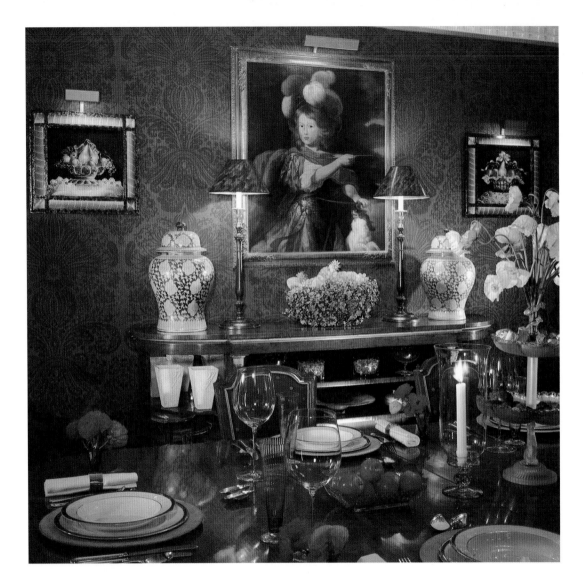

56

\mathcal{I}N THIS DINING ROOM DESIGNED BY
DAVID HICKS INTERNATIONAL, PATTERN
AND COLOR JOIN FORCES TO ACHIEVE A
DRAMATIC YET WARM AMBIENCE. THE
RUSTY-RED WALLPAPER WITH ITS LARGE-
SCALE DAMASK PATTERN BEAUTIFULLY
COMPLEMENTS A SEVENTEENTH-CENTURY
PORTRAIT OF A YOUNG GENTLEMAN AND
THE STILL LIFES THAT FLANK IT.

ROOM WITH A VIEW

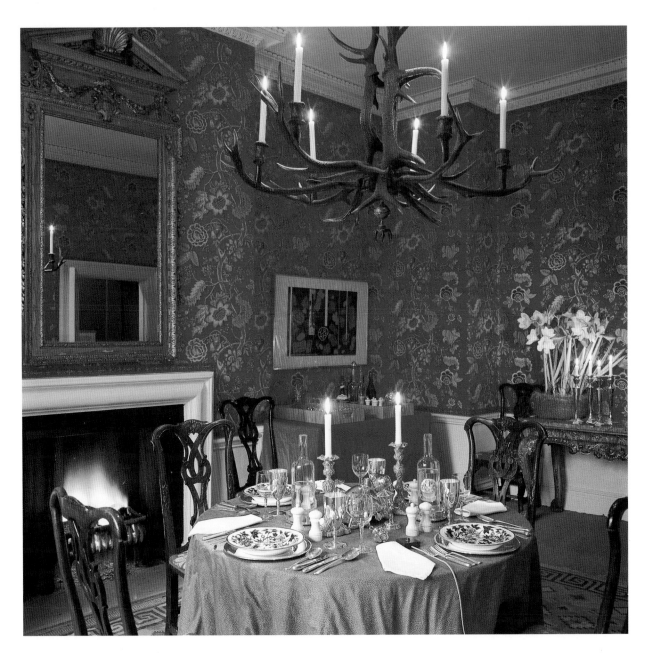

A BOLDLY COLORED AND PATTERNED FLORAL WALLPAPER ADDS GREAT DYNAMISM TO MARGUERITE LITTMAN'S LONDON DINING ROOM. THE FLOWERS' SINUOUS STEMS ECHO THE GRACEFUL LINES OF THE CHAIRS AND THE ANTLER CHANDELIER.

57

TEMPTING WALL TREATMENTS

THE DELICATE GOLD SILK
DAMASK THAT COVERS THE
WALLS OF THE TEA ROOM AT
MANDERSTON IS PERFECTLY IN
KEEPING WITH THE ROOM'S
CHINOISERIE DECOR. THE
COLOR AND SHEEN OF THE
FABRIC ENHANCE THE GILDING
ON THE CHINESE-STYLE
CHIPPENDALE CHAIRS, THE
CHINOISERIE LACQUER
CABINET, THE SIDE TABLES,
THE SCREEN, AND THE
PORCELAIN COLLECTION. THE
ROOM ATTESTS TO THE PASSION
FOR ALL THINGS ORIENTAL
THAT SURROUNDED THE
RITUAL OF TEA DRINKING IN
EIGHTEENTH-CENTURY
ENGLAND.

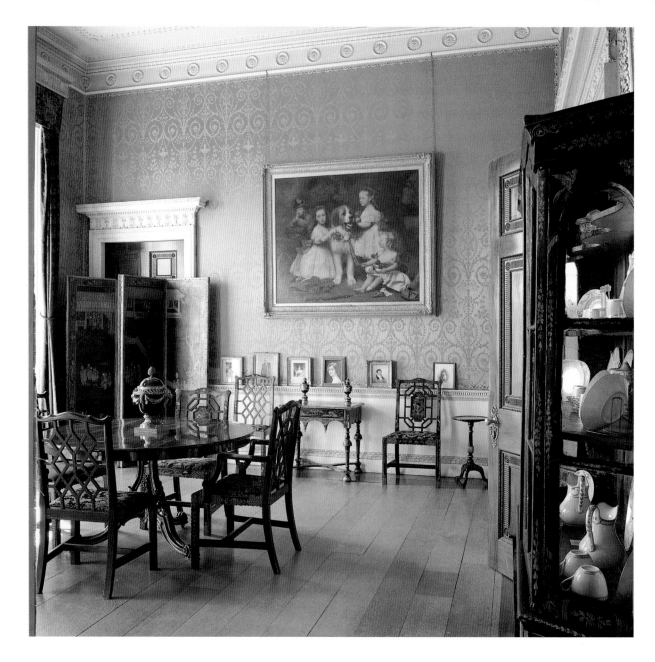

ROOM WITH A VIEW

In this Brussels dining room, designed by the late Laura Ashley, a large Old Master painting is both accentuated and balanced by the damask-printed cotton wall covering.

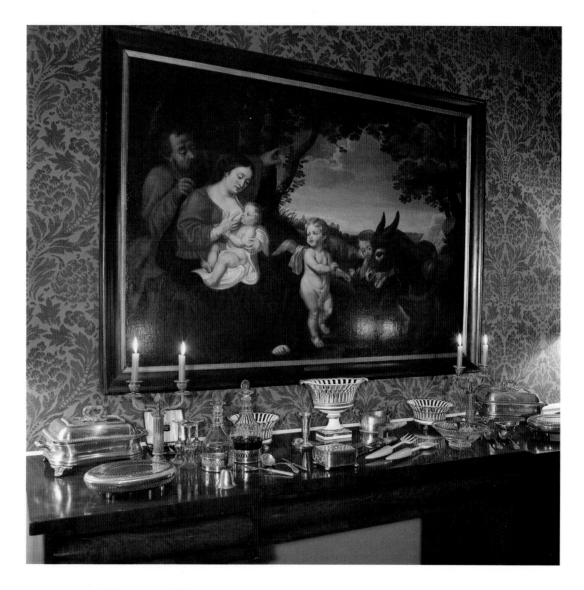

59

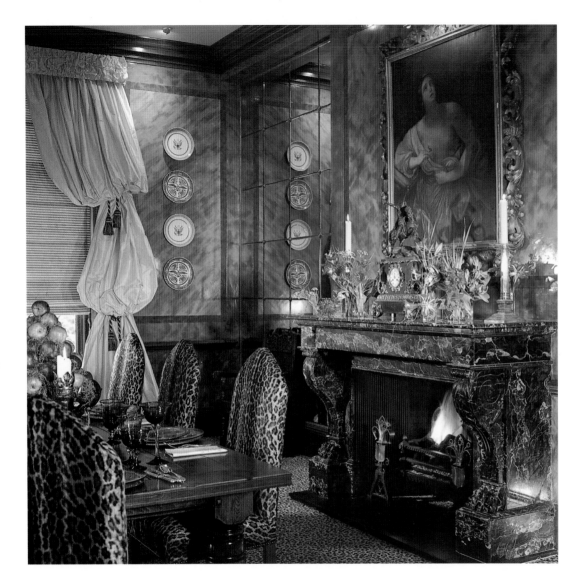

\mathcal{L}ONDON INTERIOR DESIGNER JOANNA
WOOD HAS TAKEN A NO-HOLDS-BARRED
APPROACH TO COMBINING COLOR, PATTERN,
AND TEXTURE IN THIS DINING ROOM.
TAKING HER CUE FROM THE BOLD AND SAV-
AGE BEAUTY OF JUNGLE ANIMALS, SHE HAS
GIVEN THE WALLS A TORTOISESHELL FINISH
AND COVERED FLOOR AND CHAIRS IN A
FAUX-LEOPARD PRINT. *(Left and facing page)*

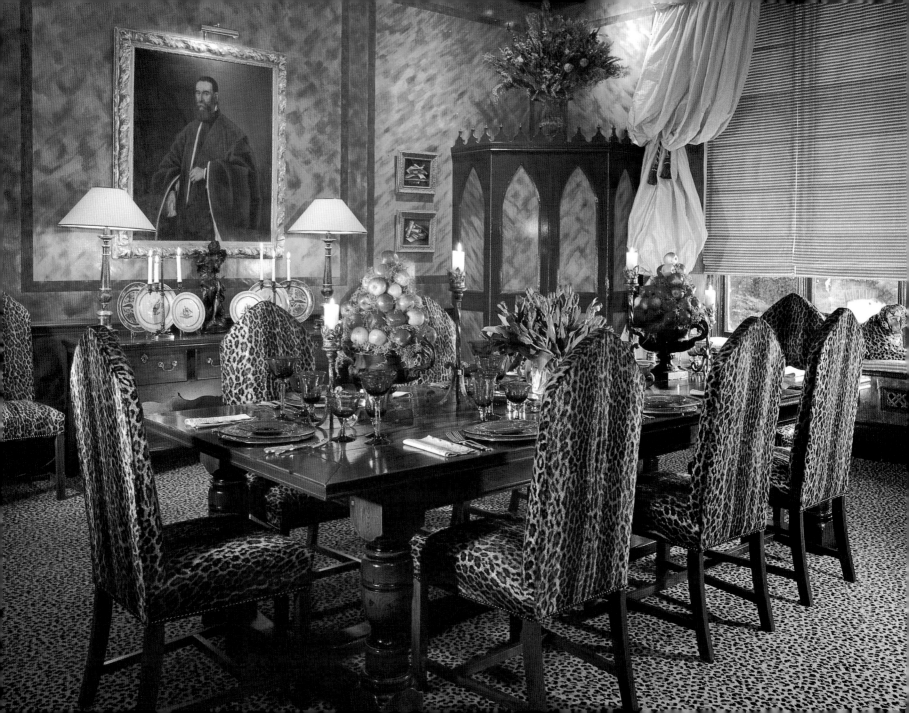

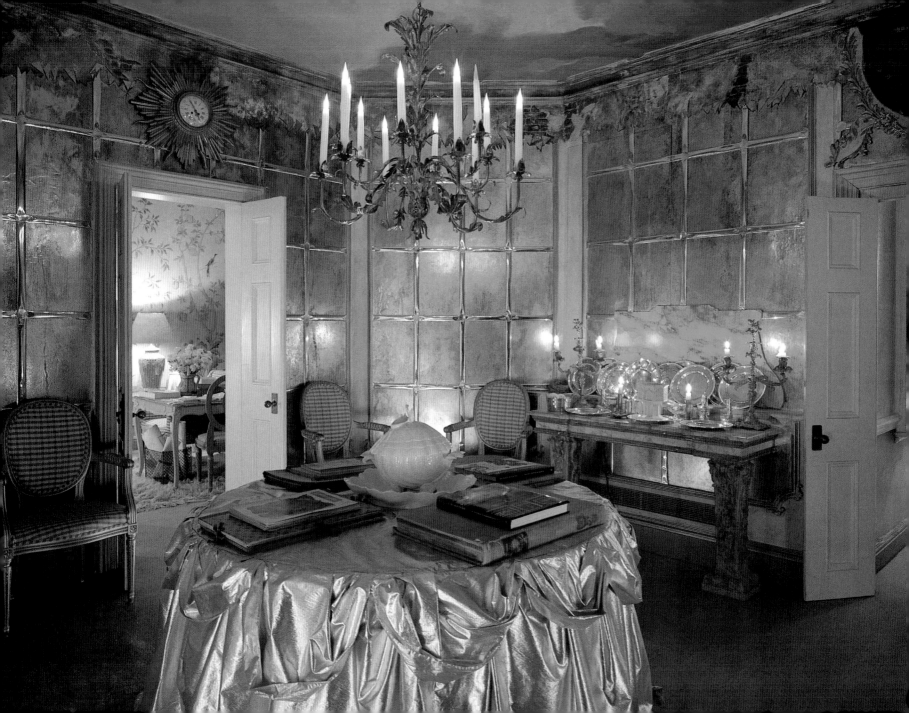

Romantic Fantasy

DECORATIVE CONFECTIONS

Fantasy has been associated with dining at least since the bacchanalia of Roman times. In the courts of medieval and Renaissance Europe, the meal was a veritable pageant, full of pomp and circumstance. Opulently dressed servants bore fanciful food creations on silver and gold trays; elaborate sugar sculptures in the shapes of classical temples, obelisks, or formal gardens graced tables; and, as though attending a spectacle, invited guests looked on as the king dined. Only after he had finished were they entitled to eat. During the eighteenth century, as sugar became a less expensive commodity, the penchant for decorating tables with ethereal sugar sculptures grew. By the early nineteenth century, they were de rigueur. Harrison Gray Otis, a Washingtonian, impressed by a sugar sculpture he saw at a dinner party at the French Ministry, observed, "The cloud cap'd towers and gorgeous palaces of white Sugar, and . . . all the paper columns and castles in the air . . . escaped without sap or assault." Most people were too struck by the beauty of these grand concoctions to eat them.

The desire to dine in a romantic fantasy setting is just as strong today as in centuries past, and the rooms on the following pages suggest just a few of the many ways you can transform an ordinary space into a magical world. Fashion designer Valentino, for instance, gave his

Roman dining room the exotic look of a Moroccan tent by covering the walls with trompe l'oeil tenting and draping the windows with gauzy white curtains (page 66). A similar effect can be achieved by draping ceilings and walls in fabric or by using a tent-motif wallpaper. But your fantasy dining room may not be exotic at all; you may simply desire an atmosphere different from your daily experience. For example, if you long for the warmth and coziness of a country dining room but live in the middle of New York City, you might consider countrifying your dining space by adding distressed ceiling beams, acquiring some rustic furniture, and using lots of well-worn chintz.

Inspired by both a haunting ancient ruin and certain baroque and rococo palaces, interior designer Nicholas Haslam converted the hallway of his London flat into a shimmering, otherworldly dining space, using such inexpensive materials as aluminum foil and bricks. Topped by a trompe l'oeil ceiling of a moody evening sky, the room is mesmerizing in candlelight (facing page). Recessed niches holding classical statues and surrounded by shell-encrusted decoration turn a Barbados dining room into sheer magic when bathed in either sunlight or candlelight (pages 70 and 71).

63

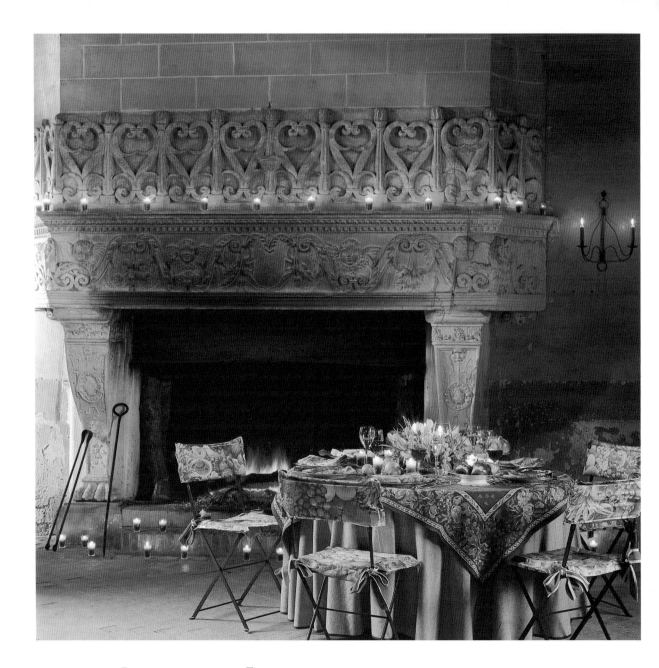

Pages 62 and 63

Ｉnspired both by the desire to dine under the stars in a crumbling ruin and by the dazzling mirrored halls of the great baroque and rococo palaces of Europe, London interior designer Nicholas Haslam transformed his ordinary, box-shaped hallway into this magical dining room. The "mirrored" walls are in fact aluminum foil divided into panels with reflective tracing bars and glazed to achieve a soft patina. The chandelier seems to be floating in the trompe l'oeil evening sky.
(Left and right)

ROMANTIC FANTASY

\mathcal{A}T THE MAGNIFICENT HÔTEL DU MARC IN REIMS, FRANCE, WHICH HAS BEEN HOME TO THE CLICQUOT FAMILY SINCE THE EARLY NINETEENTH CENTURY, THE INGREDIENTS FOR A MAGICAL, INTIMATE DINNER FOR FOUR ARE A FESTIVELY SET TABLE PULLED UP TO THE MASSIVE, INTRICATELY CARVED STONE FIREPLACE, A DANCING FIRE, AND CANDLES EVERYWHERE. FLORAL-PRINT CUSHIONS AND SLIPCOVERS TURN BASIC METAL FOLDING CHAIRS INTO DECORATIVE, COMFORTABLE SEATING. *(Facing page)*

\mathcal{L}OTS OF FLICKERING VOTIVE CANDLES AND FRESH FLOWERS, COMBINED WITH A BOLDLY PATTERNED FLORAL CLOTH, EXERCISE THEIR POWERS OF ENCHANTMENT OVER THIS FESTIVE YET COZY DINNER TABLE AT THE HÔTEL DU MARC. *(Right)*

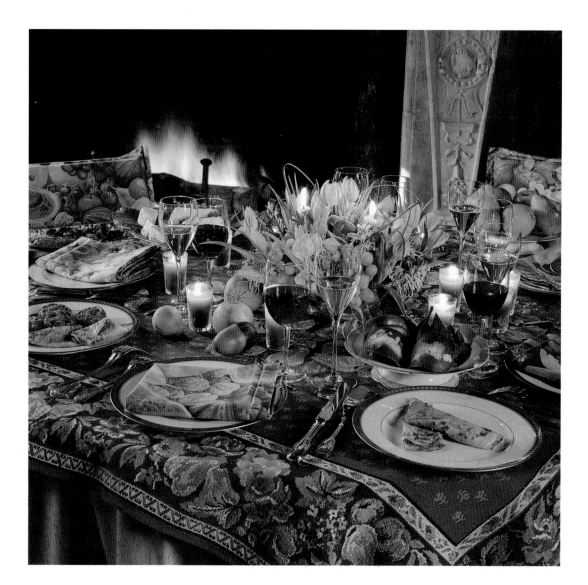

DECORATIVE CONFECTIONS

In the dining room of fashion designer Valentino's Roman palazzo, the trompe l'oeil tenting, gauzy curtains accented with tassels, and furnishings all capture the exotic allure of Morocco.

ROMANTIC FANTASY

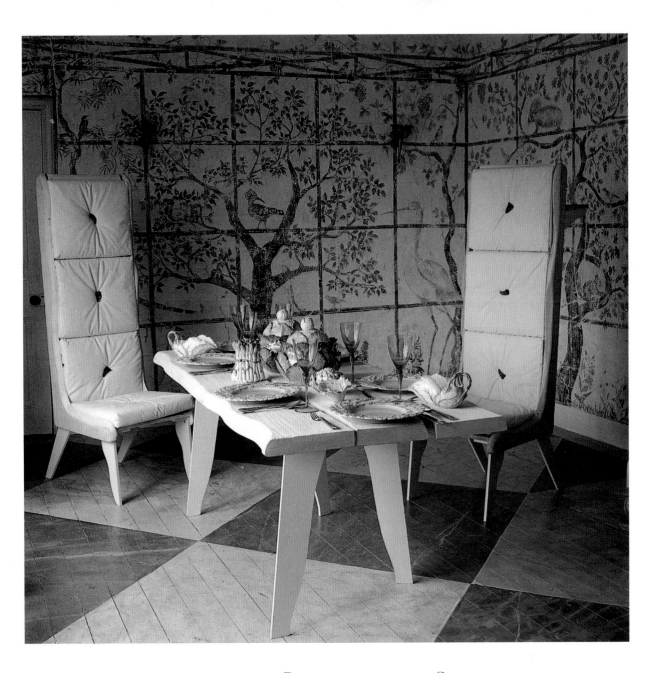

Inspired by the fresco tradition of both ancient and Renaissance Rome, interior designer Christopher Nevile transformed the walls of an English country house dining room into a garden fantasy. The garden theme extends from walls to table top, where a pair of artichoke-shaped tureens, gravy boats in the shape of shells, and asparagus and cabbage dishes serve both functional and decorative purposes.

With its gilded arabesque decoration and mirrors that reflect the flickering light of ornate candelabras, the entrance to Sir Nicholas Fairbairn's dining room in Scotland is a glittering prelude to the elegantly set table beyond.

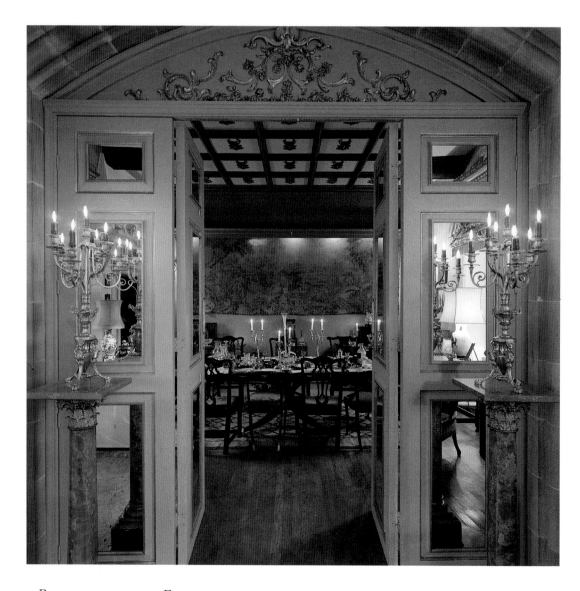

ROMANTIC FANTASY

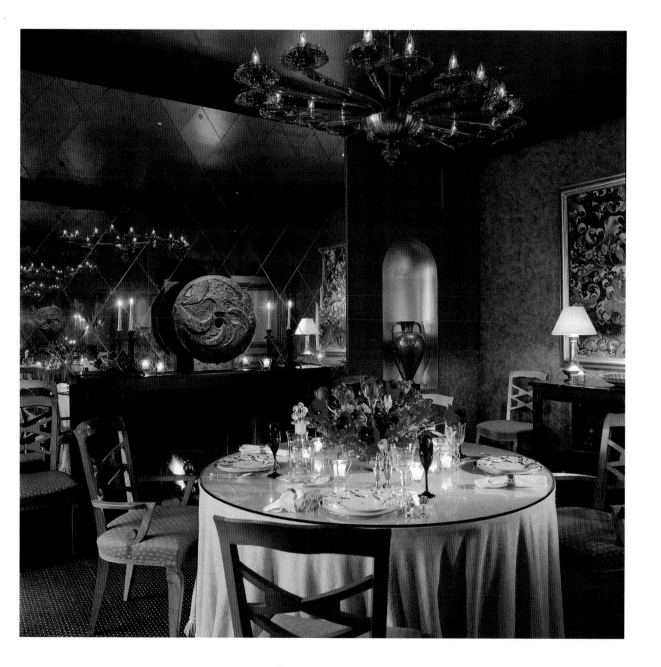

In this New York dining room, designed by Brian Murphy of Parish-Hadley, a 1920s Venetian glass chandelier is reflected ad infinitum in facing mirrored walls, creating a galaxy of twinkling lights. In their glow, the ceiling and wall niches, which are painted in Chinese silver, take on a veneer of burnished gold. The inspiration for the room's unusual color scheme was the Aubusson cartoon that hangs over the side table on the right.

69

DECORATIVE CONFECTIONS

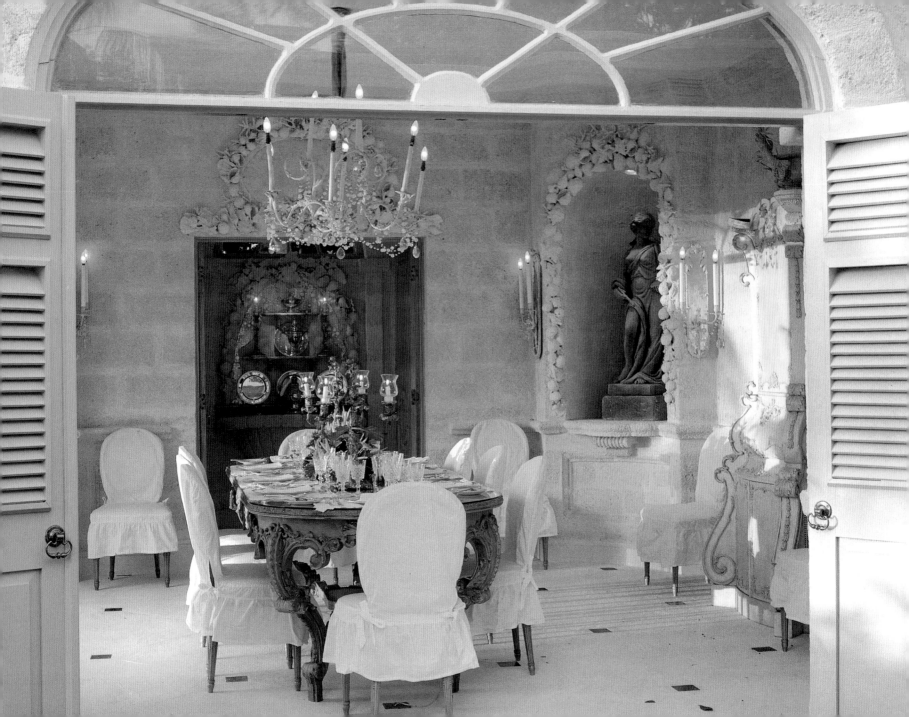

This dining room in Barbados, designed by Nicholas Haslam, is resplendent in both sunlight and candlelight. Recessed niches, whimsically ornamented with shells and coral, are a rococo fantasy. All the furniture, which was designed specially for the room, is equally fanciful, including the painted storage cupboard, whose voluptuous lines were inspired by a baroque original. The crisp white cotton slipcovers on the chairs are coolly inviting. *(Facing page and right)*

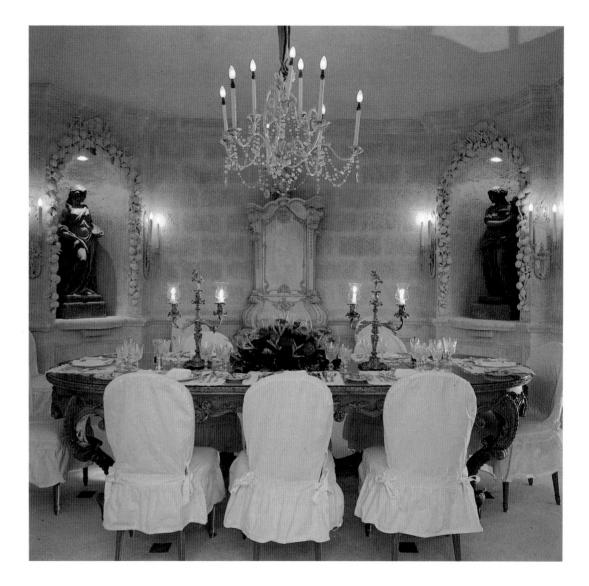

DECORATIVE CONFECTIONS

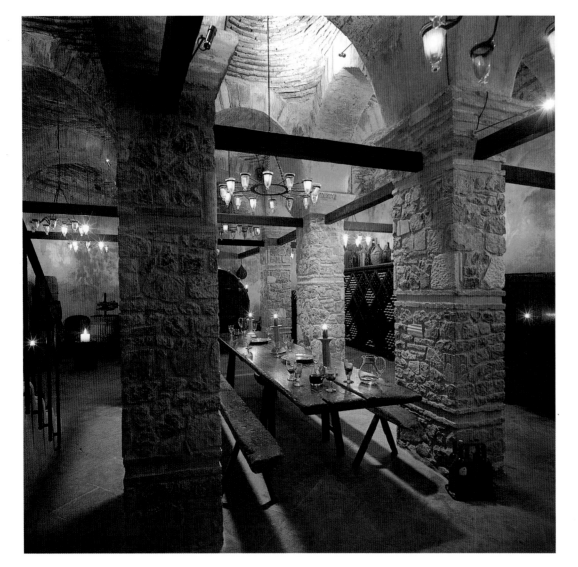

THIS ROMANTIC WINE CELLAR BENEATH THE BUSTLING STREETS OF ISTANBUL IS A FAVORITE PLACE TO ENTERTAIN. THE ROUGH-HEWN STONE WALLS AND PILLARS TAKE ON A WARM, INVITING GLOW IN CANDLELIGHT. AN OLD WINE PRESS AND A FASCINATING COLLECTION OF WINE BOTTLES AND JUGS ARE ALL THAT IS NEEDED IN THE WAY OF DECORATION.

ROMANTIC FANTASY

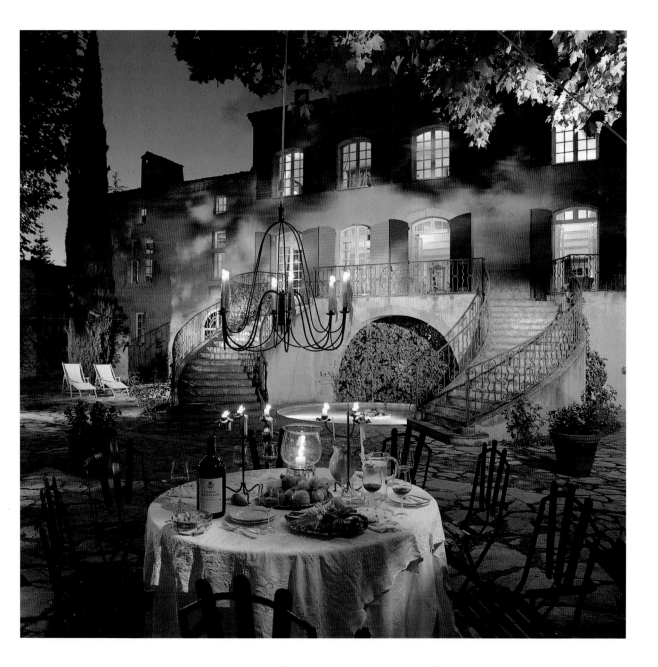

\mathcal{F}EW EXPERIENCES COULD
BE MORE ENCHANTING THAN
DINING IN THE COURTYARD OF
THE CHÂTEAU DE VIGNELAURE
IN PROVENCE ON A SUMMER
EVENING. THE LIGHT FROM
THE CHÂTEAU'S WINDOWS AND
FROM THE CHANDELIER
WHIMSICALLY SUSPENDED
FROM AN OVERHANGING TREE
CREATES A MAGICAL AMBIENCE
FOR A DINNER OF DELICIOUS
PROVENÇAL FARE, WASHED
DOWN WITH THE CHÂTEAU'S
OWN WINE.

DECORATIVE CONFECTIONS

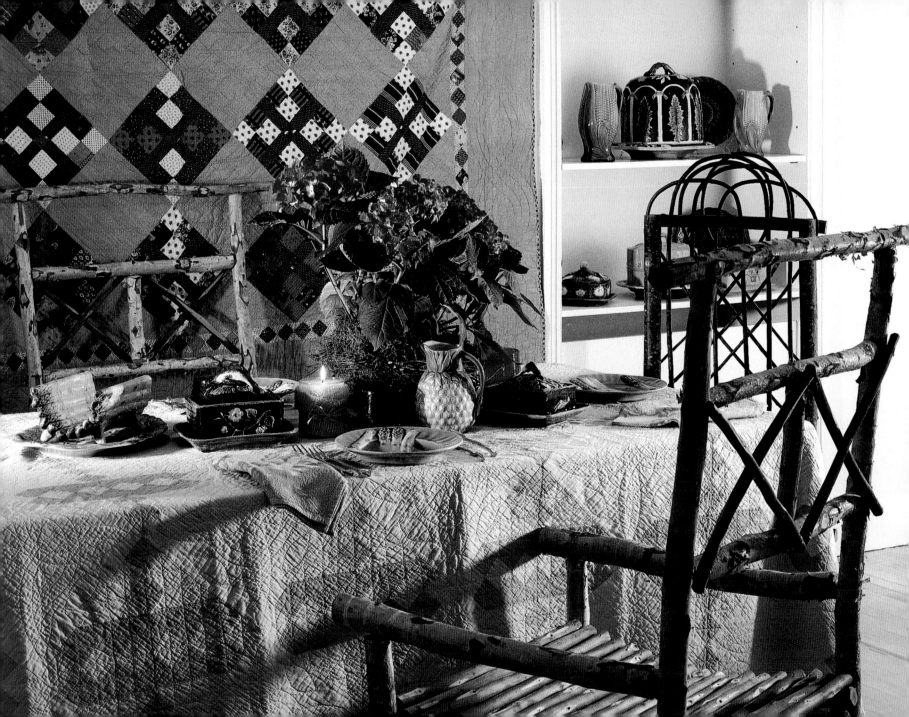

Simple Pleasures

COUNTRY DINING

"Ah! There is nothing like staying at home for real comfort!" wrote Jane Austen in *Emma.* And as for dining, there is nothing more relaxing and rejuvenating than simple, homey interiors and table settings. Rustic styles, harking back to a less complicated, gentler existence, exude tradition and continuity, nostalgia and warmth.

If your dream dining room is a country idyll, there is a wide range of styles to choose from. Every region has its own indigenous vocabulary of rustic furniture, tableware, and decorating techniques: rural America's quilts, folk art, and stenciled floors; the clay pots and glazed earthenware of the hill towns along the Mediterranean; arcadian England's ubiquitous faded chintz and rough-hewn dressers; French provincial painted, rush-seated, ladder-back chairs and carved armoires; and the delicate painted palette of Swedish farmhouses.

Whether antique or new, country furnishings can be incorporated into today's interiors in all sorts of ways to evoke the pleasures of a simpler, less hectic time. There are any number of chairs and other types of seating that will infuse a room with a rugged, earthy mood, such as Windsor chairs, in painted or natural wood, combined with settees or benches (page 86); American country chairs decorated with naive motifs or Provençal-style chairs with painted slatted backs; or Adirondack-style chairs made from bent twigs (facing page) or wide planks of weathered wood. Pair any of these with a classic gateleg, trestle, or farmhouse slab table, which can even be painted with folk motifs. Fill a rough-hewn oak or pine dresser with pewter plates or color-wash one with a distressed finish to display a collection of simple painted pottery (page 78). Cover the walls with vertical wainscoting or whitewashed barn siding (pages 80 and 81). Stencil walls and floors with a naive border or leave the floor boards bare and add a needlework or hooked rug. Grain-paint doors with exaggerated brushstrokes for a less formal feeling. Use a French armoire for storage or conceal recessed cupboards behind armoire doors. Install well-worn cottage doors to cut the newness of modern construction. Cover the table with an antique American quilt or an English patchwork chintz, checked gingham, or striped homespun cloth (page 85). Set the table with handmade ceramics, such as sponge-ware, slipware, glazed earthenware, the faience of Moustiers and Quimper, or Italian crockery with a basket-weave pattern or animal-painted borders. Start a collection of baskets, antique and new, in all shapes and sizes. They can be used for everything from serving bread to storing wine bottles to holding cutlery for a buffet dinner. Hang them from the ceiling, group them in a corner, or display them on open shelving when not in use. Hammered tin and painted tole can be pressed into service as anything from serving trays to candle shades. Finally, try hanging lots of dried herbs from the ceiling to add a heady kitchen-garden scent to the rustic charms of your country dining room.

Pages 74 and 75

\mathcal{A}DIRONDACK-STYLE TWIG CHAIRS, PATCHWORK QUILTS, AND A WHIMSICAL COLLECTION OF NINETEENTH-CENTURY ENGLISH MAJOLICA SHAPED AS VEGETABLES AND FRUITS ALL LEND THIS TINY DINING ROOM A RUSTIC CHARM. THE COUNTRY FEELING EXTENDS EVEN TO THE TWIG-SHAPED CUTLERY. *(Left and right)*

\mathcal{P}ERIOD PROVINCIAL FURNITURE, INCLUDING EIGHTEENTH-CENTURY CHAIRS AND A SEVENTEENTH-CENTURY CHEST THAT DOUBLES AS A SIDEBOARD, PERFECTLY SUITS THE RUSTIC FLAVOR OF THIS DINING ROOM IN RURAL SCOTLAND. LARGE FRAMED PANELS OF EARLY EIGHTEENTH-CENTURY CREWELWORK ADD A FEELING OF WARMTH TO THE ROOM.

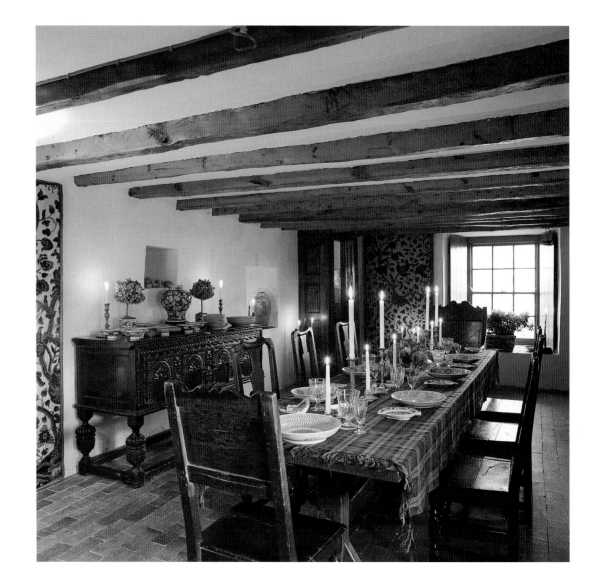

CHEERFUL CHINTZ
CURTAINS, CREAM WALLPAPER
WITH A RIBBONLIKE STRIPE,
AND FLORAL-PATTERNED
STRIPED CUSHIONS COUNTER-
BALANCE THE HEAVY, DARK
FURNITURE AND CEILING BEAMS
IN THIS COUNTRY KITCHEN.
AN ECLECTIC COLLECTION OF
PLATES AND SERVING PLATTERS
ON THE WALLS ADDS A FESTIVE
TOUCH. THE DISH TOWELS
ARRAYED ON A FREESTANDING
RACK AND THE CANISTERS AND
MUGS ALIGNED ON A SHELF
OVER THE COUNTER DEMON-
STRATE HOW DECORATIVE
BASIC KITCHEN OBJECTS
CAN BE.

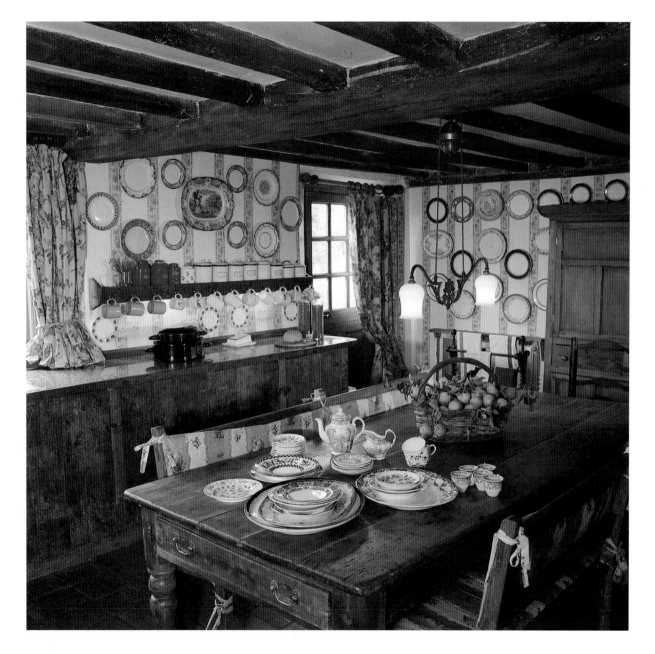

COUNTRY DINING

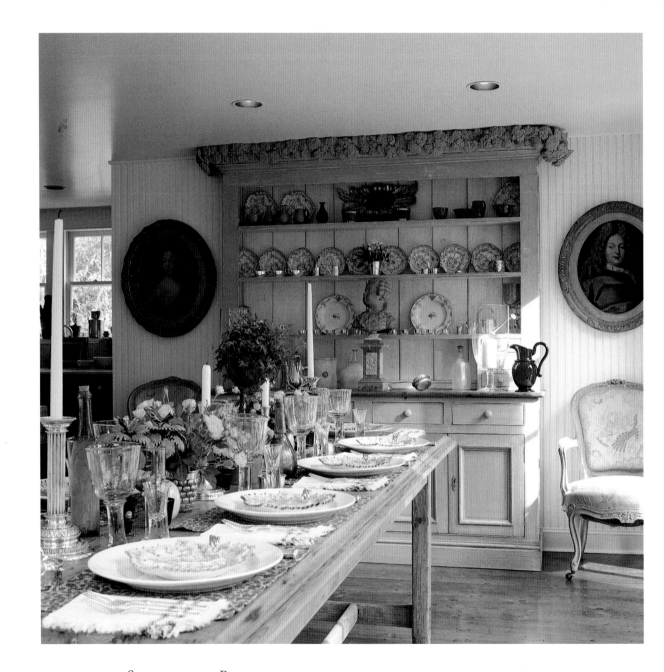

In the relaxed country atmosphere of this Long Island cottage dining room, Scandinavia meets America. A distressed painted dresser, inspired by rural Scandinavian design and topped by a crown of dried flowers, houses a diverse assortment of ceramics and silver. A pair of period portraits in oval frames hangs above painted continental armchairs.

78

\mathcal{L}EAF-SHAPED PLATES, SYLVAN-GREEN GLASSES, BAMBOO-SHAPED CUTLERY, BUNCHES OF GARDEN-FRESH FLOWERS, AND A SMALL TOPIARY TREE BRING THE OUTDOORS RIGHT ONTO THE TABLETOP. HAND-BLOWN BLUE GLASS BOTTLES CONTAINING LEMON-FLAVORED VODKA ARE READY TO BE UNCORKED FOR A RUSSIAN-STYLE MEAL. *(Right)*

\mathcal{O}PEN SHELVING IN A COUNTRY DINING ROOM OR KITCHEN PERMITS DECORATIVE DISPLAY OF—AND EASY ACCESS TO—SUCH ESSENTIALS AS THESE VINTAGE 1940S CANISTERS OR THIS COLLECTION OF TWENTIETH-CENTURY PLASTIC ICE BUCKETS, WHICH CAN ALSO BE USED AS WINE BUCKETS OR TO HOLD NAPKINS OR CUTLERY FOR BUFFET ENTERTAINING. *(Below)*

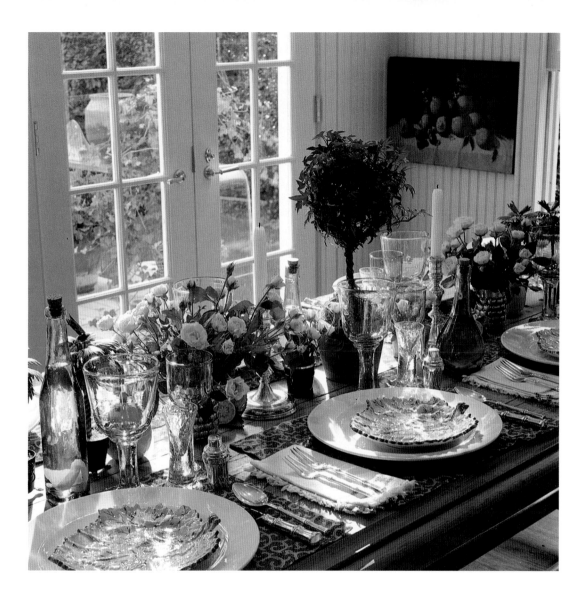

79

COUNTRY DINING

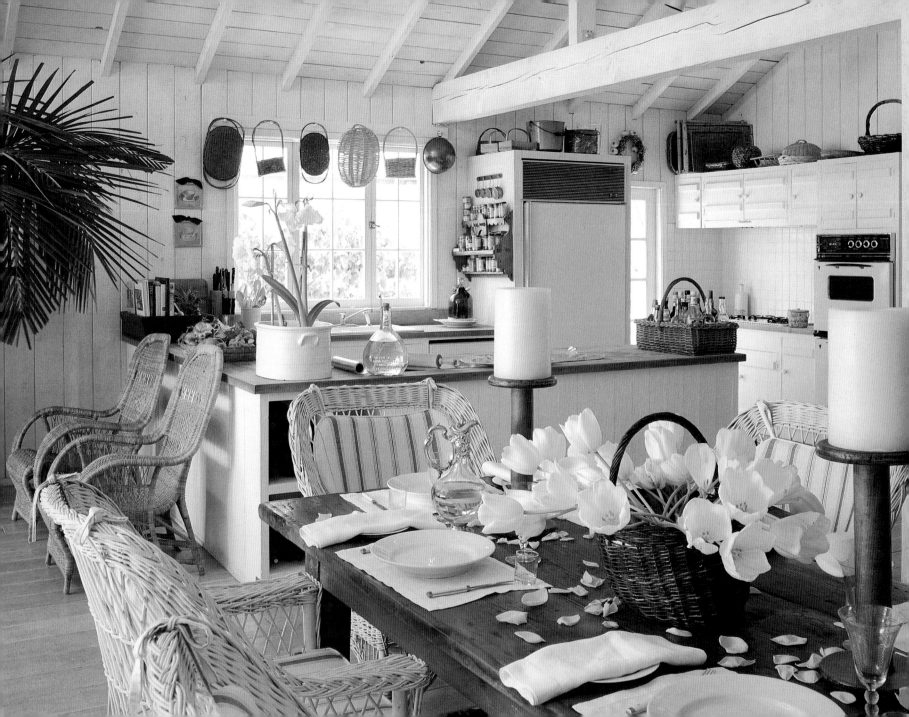

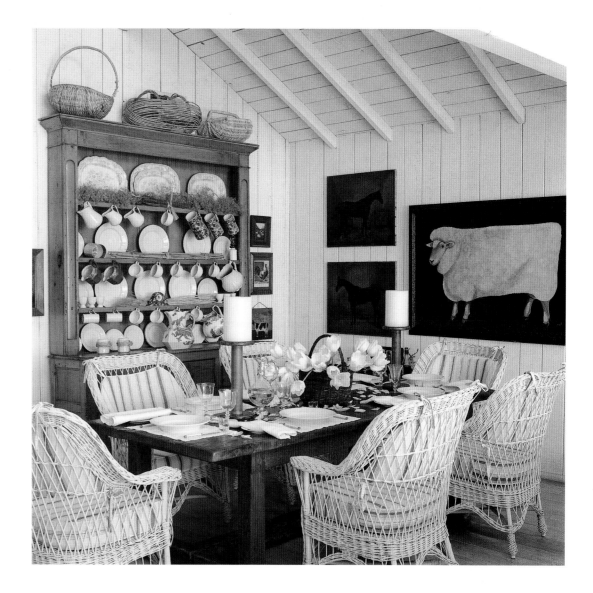

WHITEWASHED WALLS AND CEILING,
PAINTED AND NATURAL RATTAN CHAIRS,
SIMPLE WHITE CROCKERY, AND BASKETS
GALORE ALL JOIN FORCES TO CREATE AN
ELEGANT BUT CASUAL MOOD IN THE DINING
AREA OF THIS CALIFORNIA BEACH HOUSE.
EVERY DETAIL, INCLUDING THE OVERSIZED
WHITE CANDLES ON WOODEN PEDESTALS
AND THE BASKET OF WHITE TULIPS, EXUDES
CLEAN, BACK-TO-BASICS STYLE.
(Facing page)

A STRIPPED-PINE WELSH DRESSER
FILLED WITH BLUE AND WHITE CROCKERY
AND A COLLECTION OF PRIMITIVE ANIMAL
PAINTINGS GIVE THIS CORNER OF THE
BEACH HOUSE A COUNTRY REDUX FEEL.
(Right)

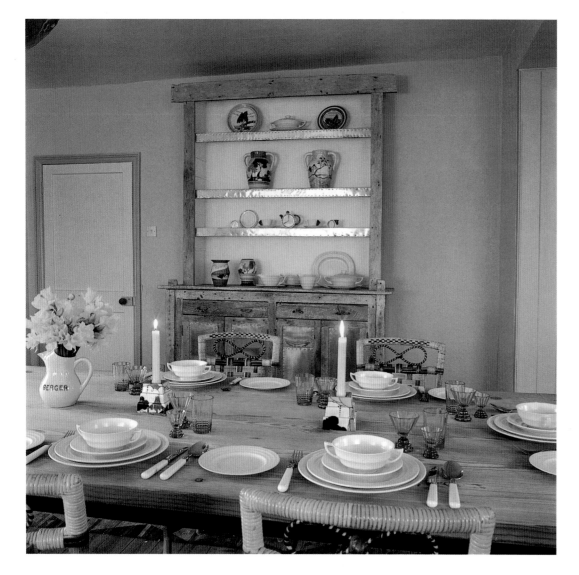

\mathcal{T}HE STOVE IN CHRISTOPHER NEVILE'S COUNTRY KITCHEN IS CLEVERLY HOUSED IN A SANTE FE–INSPIRED CUPBOARD. FOR EASY ACCESS, FREQUENTLY USED INGREDIENTS ARE STORED ON THE WINDOWSILL IN A COLLECTION OF BOLDLY LABELED YELLOW-AND-WHITE WILLOWWARE CONTAINERS. *(Above)*

\mathcal{S}EVERAL OF NEVILE'S FAVORITE DESIGN THEMES ARE INCORPORATED IN HIS KITCHEN. THE COLORS DERIVE FROM SUCH DIVERSE SOURCES AS SANTA FE STYLE, THE PALETTE OF CARL LARSSON, AND MONET'S KITCHEN AT GIVERNY. HIS PASSION FOR TWENTIETH-CENTURY CERAMICS AND GLASS IS SEEN IN THE COLLECTION OF CLARICE CLIFF POTTERY ON THE DRESSER AND IN THE 1940S ANNULAR WARE AND ART DECO GLASSES ON THE TABLE. *(Left)*

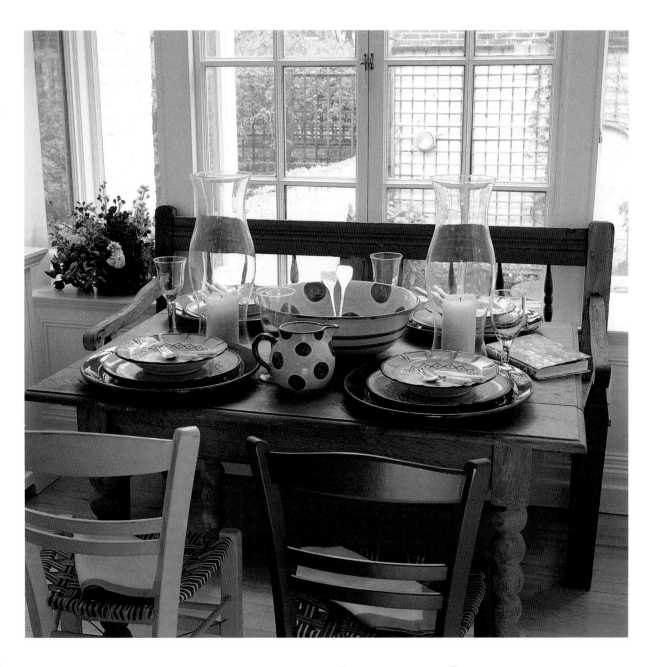

THIS ALCOVE IN A LONDON
HOUSE HAS THE RUSTIC
CHARACTER OF A DINING ROOM
IN A MEDITERRANEAN HILL
TOWN, THANKS TO A
RECLAIMED PINE BENCH AND A
TABLE WITH ECCENTRICALLY
TWISTED LEGS—BOTH OF
WHICH HAVE BEEN TREATED
WITH A SERIES OF PAINT
GLAZES TO CREATE A
DISTRESSED LOOK—AND A PAIR
OF COLORFULLY PAINTED
GREEK CHAIRS WITH
WOVEN-PLASTIC SEATS. THE
TABLE IS SET WITH BRIGHTLY
PAINTED ITALIAN CROCKERY IN
ANTICIPATION OF A HEARTY
PASTA LUNCH.

83

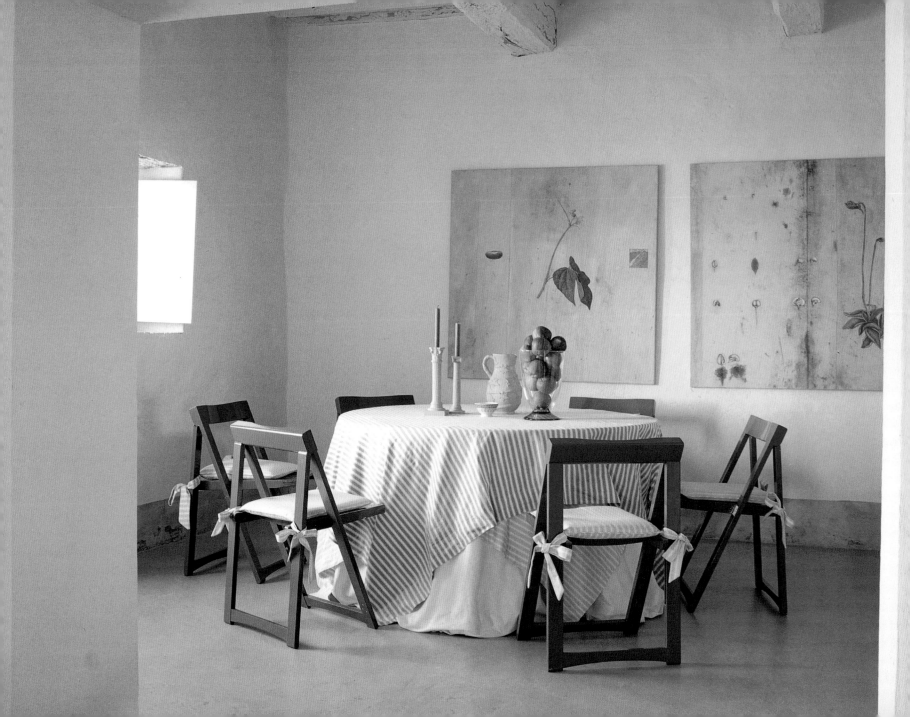

The appeal of this dining room in the Tuscan countryside is its refreshing simplicity. The only frills are the jaunty bows that secure cushions to the folding chairs, the draping of three cloths over the table, and the modern botanical paintings on the otherwise bare walls. *(Facing page)*

A reclaimed garden bench, a patchwork quilt, ruffled cushions, simple wooden shelves, and a pastel palette combine to make Ellen O'Neill's unassuming Long Island cottage kitchen irresistibly inviting. *(Right)*

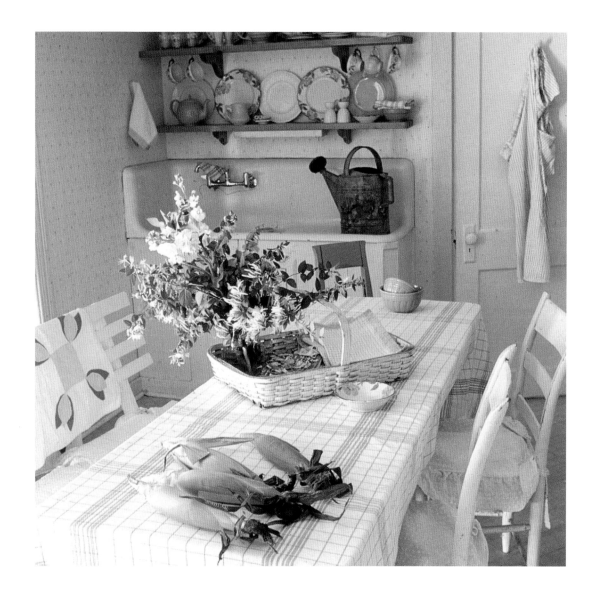

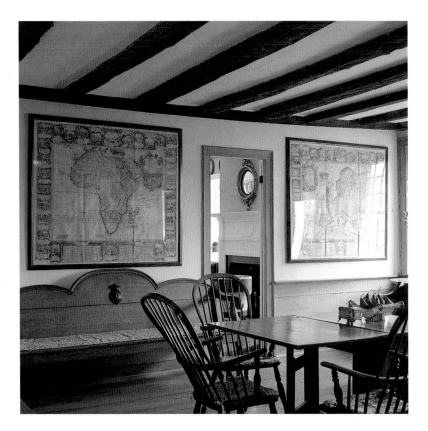

THE LARGE HEARTH WITH STRIPPED-PINE SURROUND IS THE FOCAL POINT OF THE DINING ROOM, WHICH IS EQUIPPED TO ACCOMMODATE QUITE A LARGE NUMBER OF GUESTS. THE GATELEG TABLE CAN BE OPENED TO ITS MAXIMUM SIZE, AND ADDITIONAL SEATING IS PROVIDED BY A PAIR OF PROVINCIAL BENCHES, WHOSE BOLDLY SCALLOPED BACKS COMPLEMENT THE CURVES OF THE WINDSOR CHAIRS. *(Below)*

WITH ITS WINDSOR CHAIRS AND TABLE, WOOD PANELING BELOW THE CHAIR RAIL, AND BARE FLOORBOARDS, THE DINING ROOM IN FASHION DESIGNER BILL BLASS'S EIGHTEENTH-CENTURY COUNTRY HOUSE IN CONNECTICUT, ORIGINALLY A TAVERN, HAS RETAINED ITS COLONIAL FLAVOR. *(Above)*

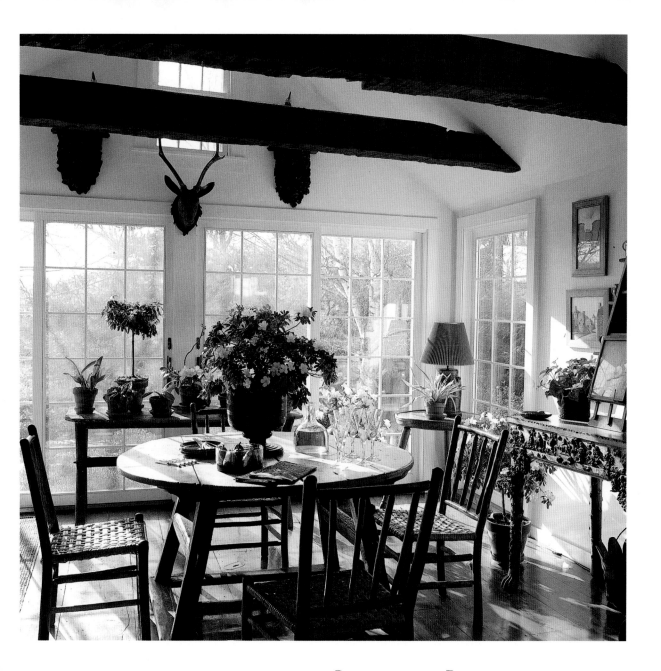

\mathcal{W}ITH THE SUN POURING
THROUGH THE WALL OF
WINDOWS, BILL BLASS'S
"MORNING ROOM" IS AN
IDYLLIC SETTING FOR
BREAKFAST. THE STURDY
ROUND TRESTLE TABLE AND
SIMPLE CHAIRS WITH
WOVEN-CANE SEATS HAVE
THE SAME RUSTIC CHARM AS
THE ROUGH-HEWN CEILING
BEAMS.

87

COUNTRY DINING

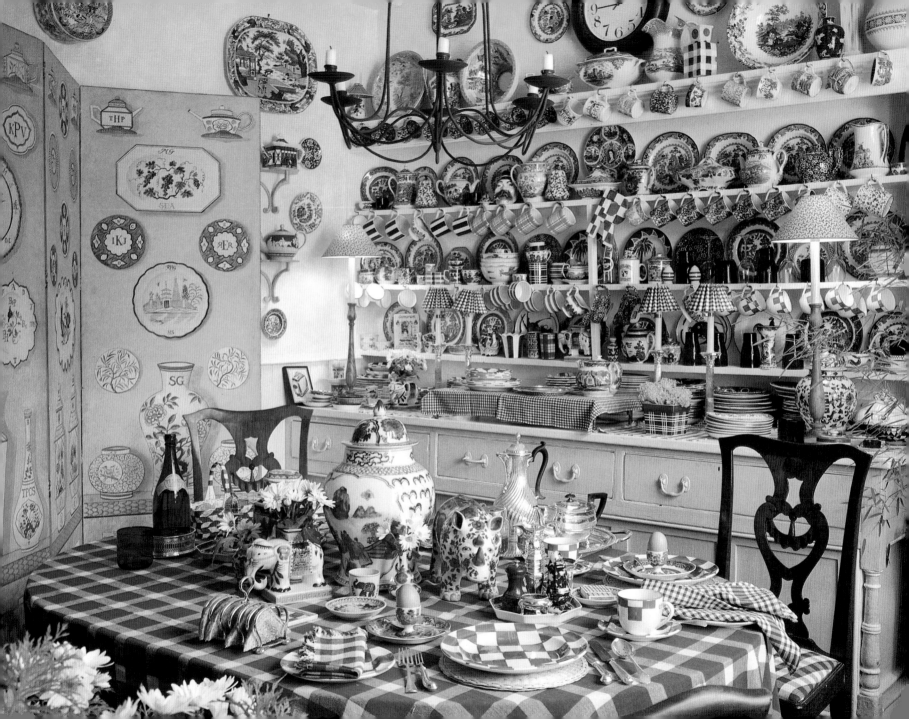

Back to Basics

KITCHEN STYLE

The architect Le Corbusier once wrote, "Decorative art is equipment . . . beautiful equipment." Although he was referring to decorative art in the broad sense, his statement is particularly apt for kitchen design. The kitchen is distinguished from other rooms in the house by the fact that its decorative scheme must address a host of functional demands and incorporate a seemingly endless variety of equipment, gadgets, foodstuffs, and so on. Just as in the dining room, the range of looks you can create in the kitchen is extensive, from the rustic ambience of a Tuscan farmhouse to the industrial-strength chic of the professional cook. But no matter which mood you wish to create, the first step is to decide how much visual emphasis to give to the kitchen's inherent functionalism—whether to highlight it for a high-tech look that bespeaks efficiency like the exposed inner workings of a finely crafted clock, or to evoke the romantic flavor of the past by hiding the practical elements "behind closed doors." You can achieve the glamorous sleek look favored by master chefs by installing professional equipment, such as a steel-and-glass refrigerator, which reveals a glimpse of the food stored inside, and a restaurant stove and sink, and also by hanging masses of metal cookware from ceiling racks (page 102). If, however, you long for the cozy, back-to-basics intimacy of a rural setting, consider designing an "unfitted" kitchen, using freestanding furniture, either reclaimed or specially designed, to display or conceal equipment. In the country kitchen on page 82, inspired by the

clear strong colors of Santa Fe and the early twentieth-century designs of the Swedish painter Carl Larsson, all the furniture is freestanding, each piece showcasing a collection of decorative ceramics, which are used on a regular basis. In the kitchen on page 96, an early nineteenth-century cupboard was converted into a pantry, an unsightly refrigerator and dishwasher were hidden behind faux-paneled doors, and even the exhaust fan was concealed beneath an arched overdoor found at architectural salvage.

Whichever look you want your kitchen to have, open shelving provides economical, easily accessible storage for everyday essentials, which can lend great panache to the room. Baskets of fresh fruits and vegetables; bottles stuffed with marinated olives, sun-dried tomatoes, or dried mushrooms; tins of coffee or tea with decorative hand-written labels; jam jars with whimsically ruffled Provençal lids; bunches of herbs tied with raffia ribbon; oil and vinegar bottles, whether left plain, painted, or even gilded; mustard crocks with wax seals; vintage and contemporary biscuit and cookie tins; copper pots and pans; wooden spoons and utensils amassed in crockery jars; Chinese vegetable steamers; antique rattan picnic carafes; French bistro ware lettered with everything from *café au lait* to *chocolat chaud;* Bakelite and steel toasters; postmodern teapots in neon-colored metal; streamlined cappuccino machines; and simple stove-top espresso pots are just a few examples of the everyday *batterie de cuisine* that have enormous decorative potential.

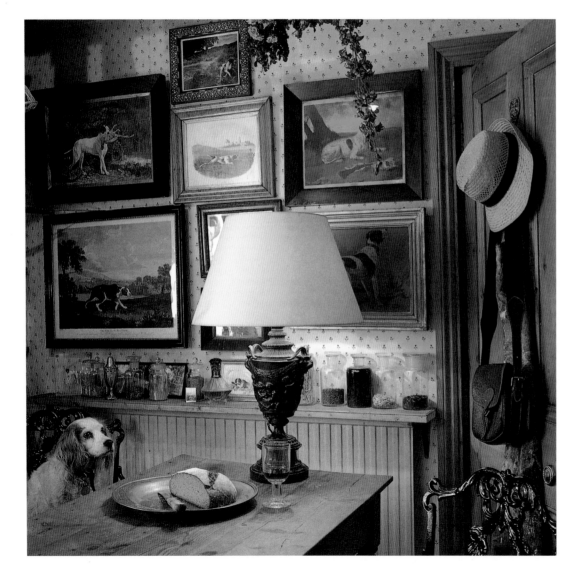

Pages 88 and 89

In interior designer Roger Banks-Pye's artfully cluttered kitchen, an enormous reclaimed dresser is just big enough to display his vast collection of Staffordshire ware, which has inspired the trompe l'oeil decoration on the screen. *(Left)* The room's color scheme is picked up in the tea towels that hang festively above an antique cast-iron stove, which is used for storage. *(Right)*

Scrubbed wooden surfaces, a delicate sprig-patterned wallpaper, and a grouping of rustic animal paintings and prints give this London kitchen a warm, rustic look.

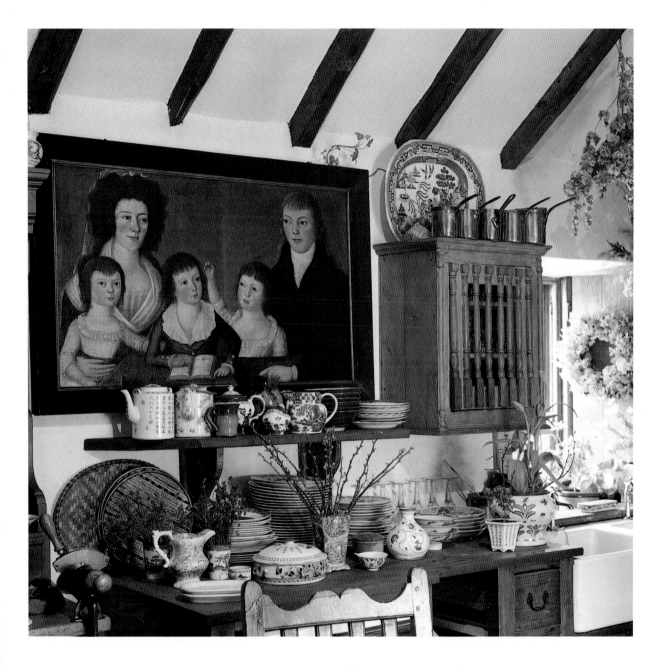

A LARGE EIGHTEENTH-
CENTURY FAMILY PORTRAIT
AND A WOODEN DESK THAT
SERVES AS A SIDEBOARD ADD
GREAT PERSONALITY TO THIS
KITCHEN IN SCOTLAND.

KITCHEN STYLE

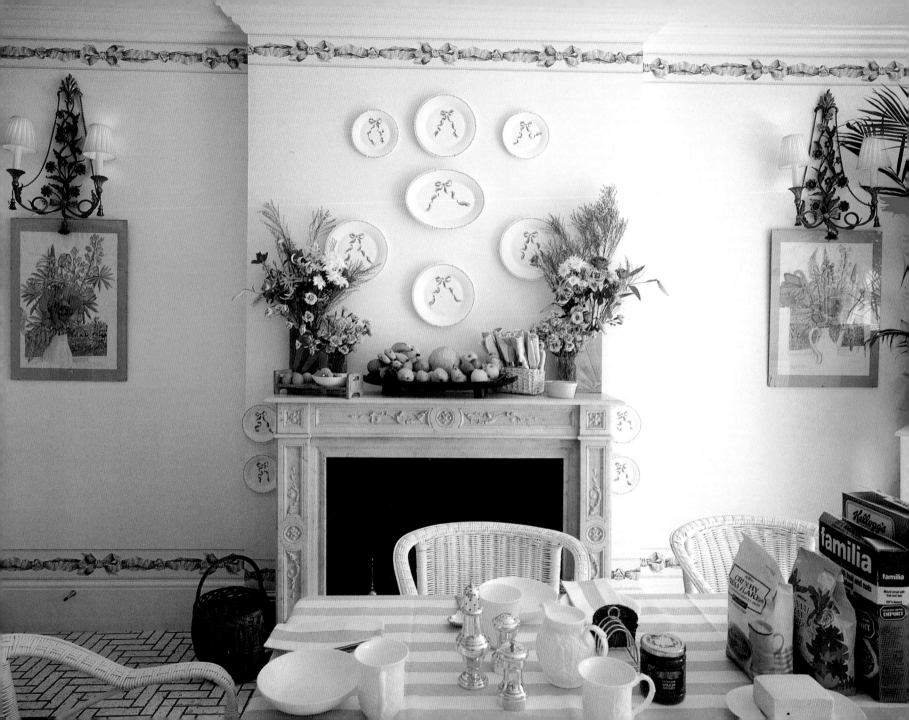

With its ribbon-motif wallpaper borders, cheerful pink-and-white-striped cotton tablecloth, painted rattan chairs, and collection of plates that reprises the border theme, this London basement kitchen has the airy look of a country cottage kitchen. *(Facing page)*

Heinrich Spreti has masterfully converted the stable of his Bavarian schloss into a sleek post-modern kitchen. The arched window is echoed in the curved open shelves. Framed eighteenth-century silver designs on the wall hark back to the schloss's past, as do two period hall chairs, wittily updated with bright green paint and bold, decorative monograms. *(Right)*

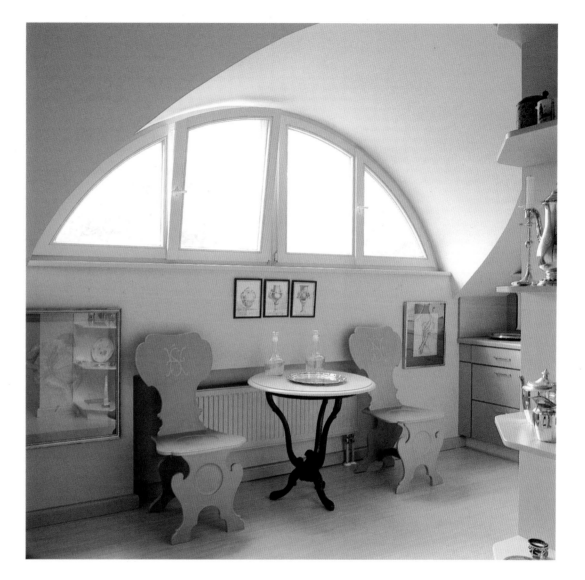

93

In this simply furnished English country kitchen, flowering plants on the windowsill and the table as well as baskets of dried flowers hanging from the ceiling beams provide the main decorative accents. The colorfully tiled countertop is as pretty as it is functional. A woven wine basket, nestled under the table within easy reach, provides a perfect place to store bottles prior to serving them.

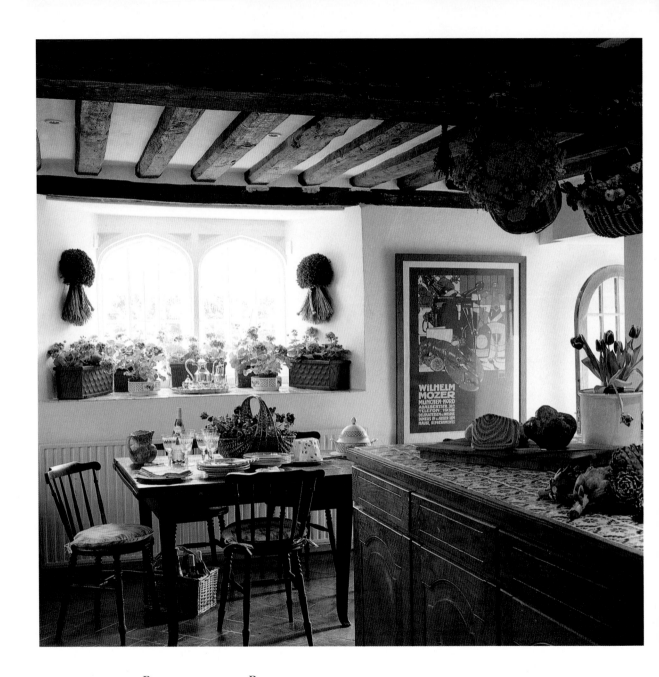

\mathcal{B}OLD SCALE AND SIMPLICITY ARE THE KEYS TO THE BACK-TO-BASICS STYLE OF THIS KITCHEN IN THE SWISS ALPS. A LARGE, UNFRAMED CANVAS OF A BARNYARD SCENE SETS THE RURAL MOOD. A BROAD-PLANKED FARM TABLE PAIRED WITH A SIMPLE BENCH ENHANCE THE RUSTIC FLAVOR OF THE SPACE. HEARTY CHUNKS OF HAM AND CHEESE AND FRESH LOAVES OF BREAD, ILLUMINATED BY AN OVERSIZED HURRICANE LAMP, BRING THE DECORATIVE IMPACT OF GENEROUS SCALE TO THE TABLE.

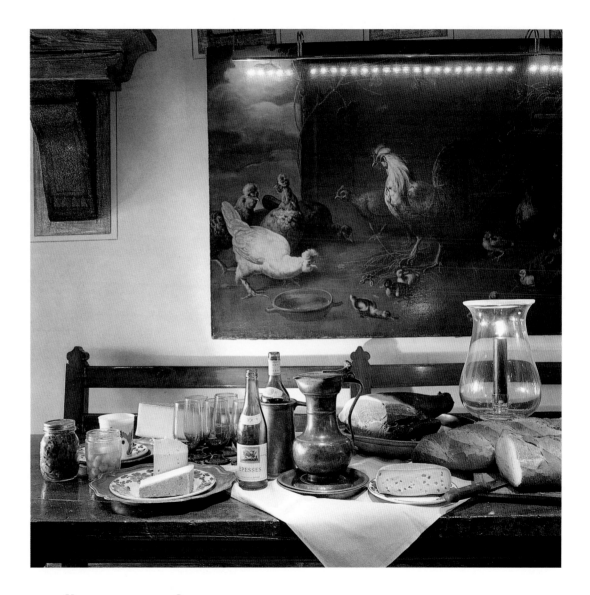

KITCHEN STYLE

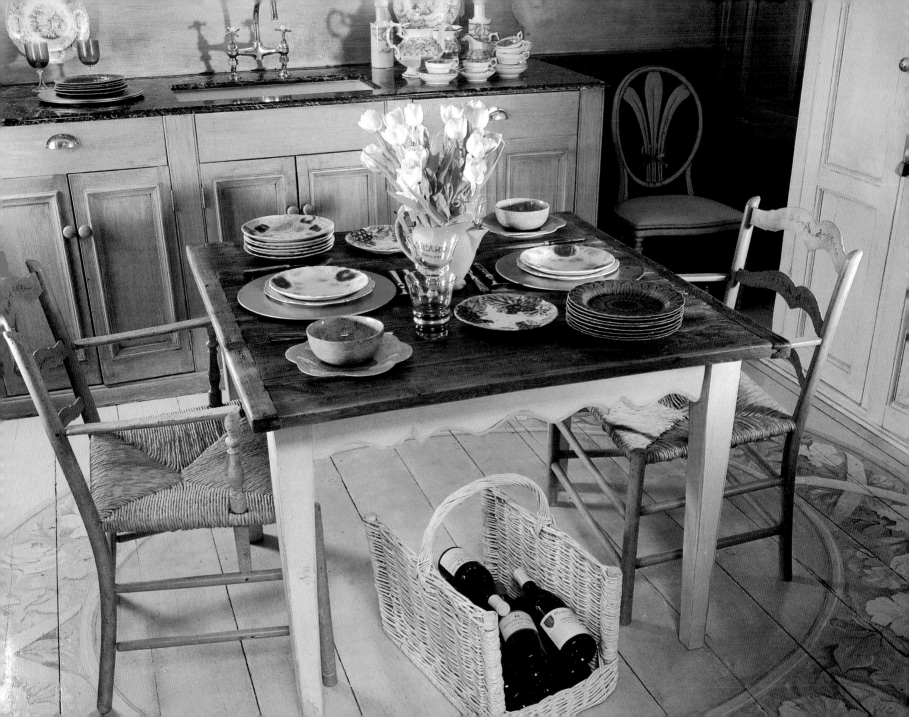

This tiny basement kitchen in London is decorated almost entirely with "found" objects. The floorboards and a nineteenth-century cupboard are from architectural salvage. All of the tableware, including the leaf-motif Wedgwood plates from the 1860s and majolica plates decorated with flowers, was picked up at flea markets. An Aubusson carpet design is painted on the floor. *(Facing page)*

In this small Brussels kitchen, designed by the late Laura Ashley, open white shelving not only allows for the decorative display of kitchen necessities but also creates the illusion of spaciousness. Geometric-patterned curtains and floor tiles also help to open up the room. *(Right)*

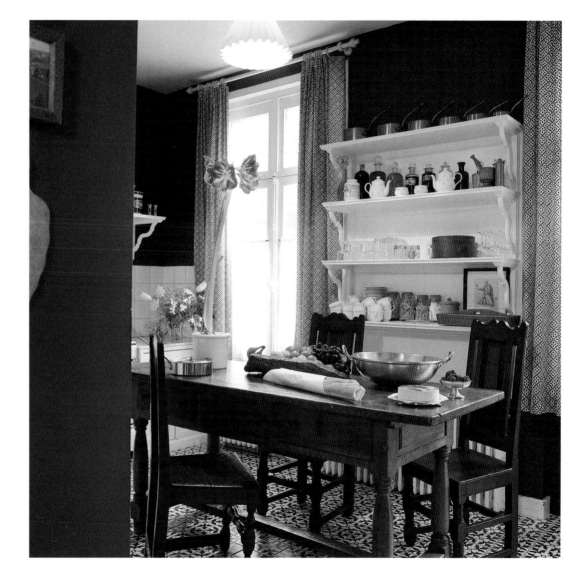

KITCHEN STYLE

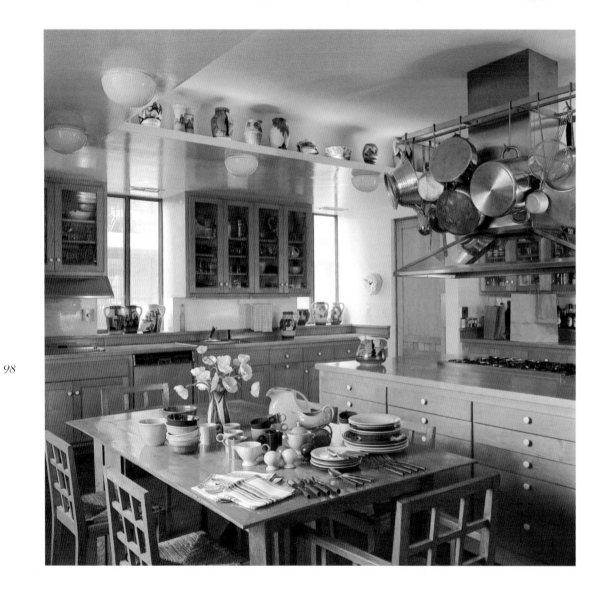

98

The windowsills and a shelf below the ceiling in an Arts and Crafts–inspired New York kitchen are decorated with a collection of Clarice Cliff pottery. A wide assortment of Fiesta ware adds splashes of color to the table. *(Left)*

A whimsical Clarice Cliff tea set contributes a touch of fantasy to this highly efficient kitchen. *(Below)*

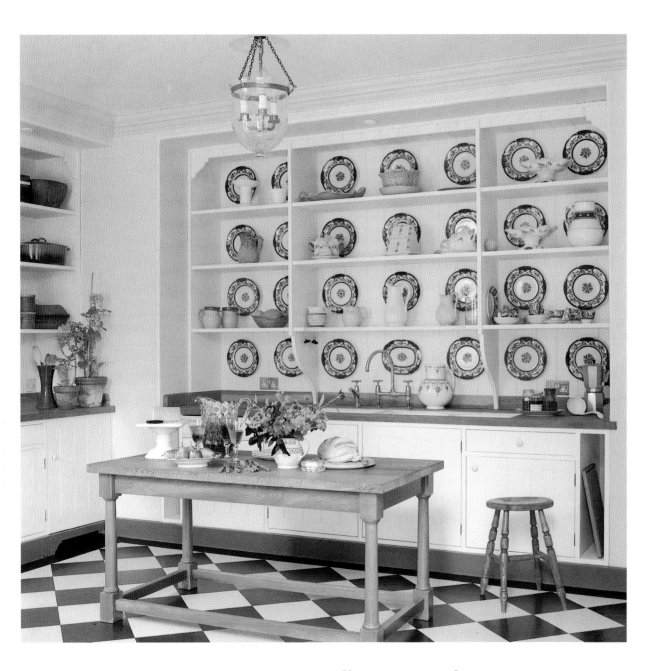

In Antony Little's country kitchen, storage and display are skillfully combined. Built-in shelves showcase his collections of multicolored printed china, jugs, and tureens, while a faux breakfront is fitted with cupboards and drawers, and even houses a sink. Both utilitarian and decorative, this shelf-and-breakfront unit is an ingenious reinterpretation of the traditional nineteenth-century dresser.

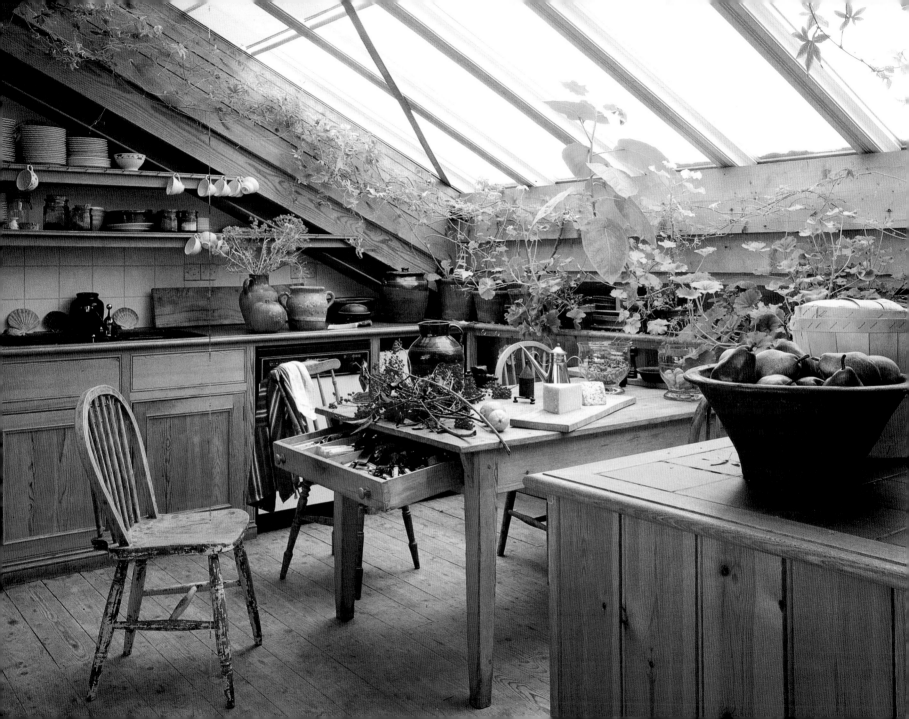

STRIPPED-PINE CABINETS AND SHELVES ENHANCE THE RUSTIC ATMOSPHERE OF THIS KITCHEN IN A CONVERTED LONDON WAREHOUSE. *(Facing page)*

FLORAL DESIGNER KEN TURNER HAS MAXIMIZED THE DECORATIVE POTENTIAL OF USEFUL KITCHEN ITEMS IN THE EATING AREA OF THIS LONDON KITCHEN. A COLLECTION OF NINETEENTH-CENTURY MEAT PLATTERS ADORNS THE WALLS, AND AN HERB GARDEN, ACCENTED WITH TWISTED MAHOGANY CANDLESTICKS, DOUBLES AS AN AROMATIC CENTERPIECE.

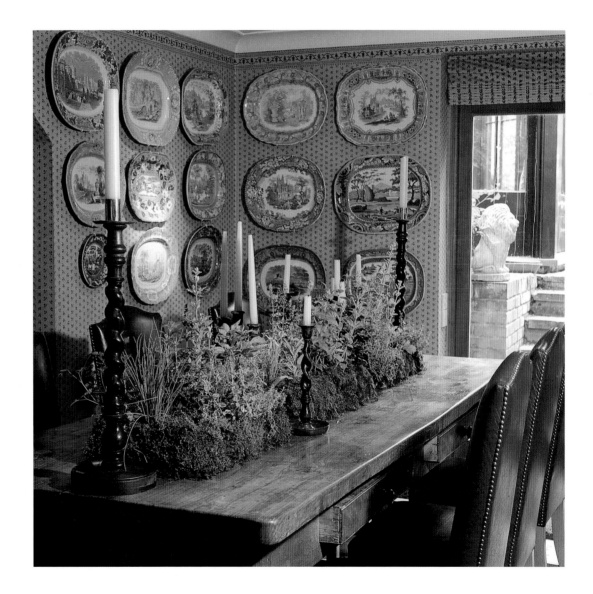

KITCHEN STYLE

THIS NEW YORK KITCHEN COMBINES HIGH-TECH EFFICIENCY WITH PERIOD ELEMENTS TO CREATE A SOPHISTICATED PLACE IN WHICH TO COOK AND DINE. AN INTIMATE TABLE FOR TWO, COVERED WITH A CRISP WHITE LINEN ANTIQUE CLOTH, PAIRED WITH SLIPCOVERED CHAIRS EMBLAZONED WITH BRIGHT RED MONOGRAMS, AND LIT BY AN EDWARDIAN-INSPIRED CANDLE LAMP, IS RIGHT AT HOME WITH THE ARRAY OF PROFESSIONAL-QUALITY POTS AND PANS HANGING ON A RACK SUSPENDED FROM THE CEILING.

102

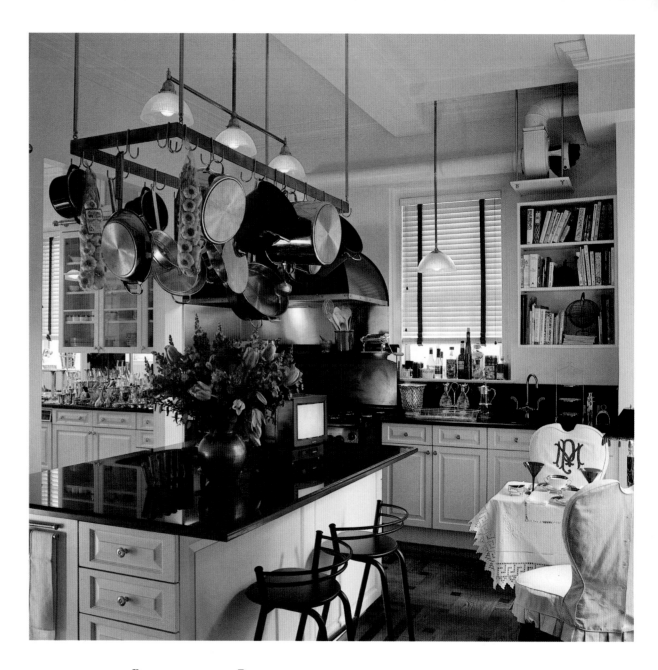

\mathcal{A} PAIR OF SILVER NEOCLASSICAL-STYLE
URNS ECHO THE SOFT CURVES OF THE
CHAIR. WHEN NOT USED FOR SERVING
COFFEE OR TEA THEY MAKE ELEGANT
WINE BUCKETS. *(Above)*

\mathcal{G}LASS-FRONTED CABINETS PROTECT BUT
DO NOT CONCEAL THE SETS OF DINNERWARE
STORED IN THEM. A GLEAMING POTPOURRI
OF DECORATIVE YET UTILITARIAN ANTIQUE
SILVER OBJECTS COVER THE BLACK GRANITE
COUNTERTOP. *(Right)*

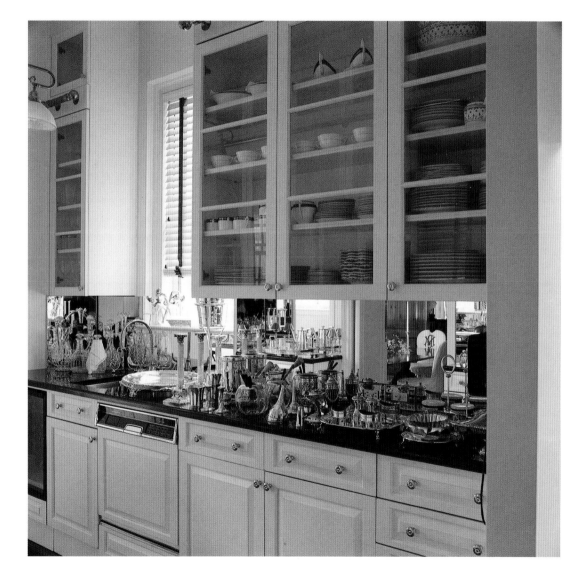

103

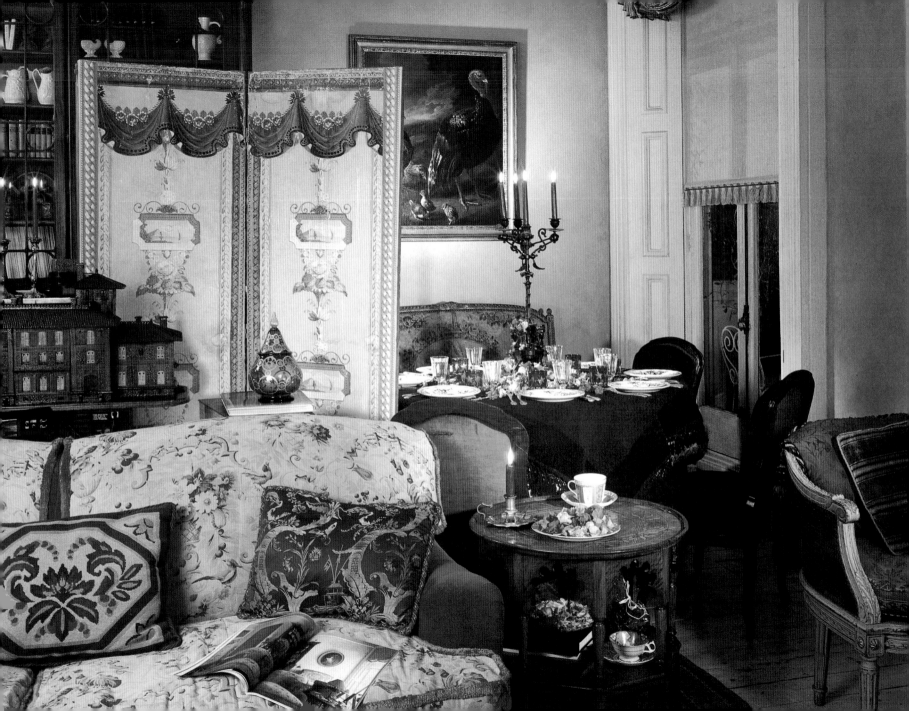

From Library to Salon

A Movable Feast

In a letter to Frederick, Prince of Wales, in 1731, Lord Hervey wrote that Houghton, the English country seat, had "a room for breakfast, another for supper, another for dinner, [and] another for afternooning." The concept of meal taking as a movable feast is as enticing today as it was in the eighteenth century. For a welcome change of pace or mood, virtually any place in your home can become a dining room, if just for an afternoon or evening. Whether we curl up with a good book and a tray on our laps in a sunny window seat on a stair landing, serve dinner for eight in an alcove of the drawing room (facing page), take refuge in bed with a tray straddled across our legs, or gravitate toward a table by the window in a favorite nook or cranny, an assortment of folding tables or trays is the only equipment we need to embark on a movable feast.

One of the most alluring alternative places to set up a table or tray and enjoy a cozy, intimate meal is the library. The combination of shelves lined with leatherbound books and painted deep, rich colors, such as the ruby red of the inviting London library on page 106 or the moody billiard green of the one at Chilston Park (page 6), is irresistibly atmospheric.

With space becoming an increasingly scarce commodity, especially in urban situations, the room in which you dine often serves other purposes as well. Even if you have a separate dining room, it makes sense to give it multiple functions. Furniture with several uses provides lots of flexibility. A Regency mahogany library table, for example, makes a perfect dining table, once piles of books and magazines are moved aside. Cozy armchairs can be pulled up to a round folding table in the drawing room. A banquette can be pressed into service as extra seating when needed, just by drawing a table up to it. In fashion designer Bill Blass's starkly classical library-cum-eating room, everything has a multipurpose life. Crisp slipcovers lend the masculine leather upholstery an airy quality; fluted columns double as decorative props and dining room storage (page 113).

When looking at the rooms on the following pages, consider the hidden places in your house or apartment that might make perfect settings for your own movable feast.

Pages 104 and 105

\mathcal{I}N CHRISTOPHE GOLLUT'S LONDON
DRAWING ROOM, A ROMANTIC TABLE,
LAYERED WITH ANTIQUE TEXTILES AND
STREWN WITH BOUGAINVILLEA PETALS, IS
PARTIALLY CONCEALED FROM THE REST OF
THE ROOM BY AN EARLY NINETEENTH-
CENTURY WALLPAPER SCREEN. AN ANTIQUE
GILDED SETTEE COVERED WITH
NEEDLEWORK AND DELICATE VICTORIAN
CHAIRS UPHOLSTERED IN A RUBY-RED
VELVET PROVIDE THE SEATING. *(Left)* IN
SETTING THE TABLE, GOLLUT HAS UPHELD
THE EIGHTEENTH-CENTURY TRADITION OF
TURNING THE CUTLERY OVER TO REVEAL
ITS DECORATIVE CREST. *(Right)*

106

\mathcal{T}HE WARMTH OF ITS DEEP RED WALLS,
ARTICULATED WOOD PANELING, AND COZY
FIRE MAKE THE LIBRARY IN THIS LONDON
TOWN HOUSE, DESIGNED BY DAVID
MLINARIC, AN EXTREMELY INVITING PLACE
TO DINE. THE ROUND TABLE SERVES AS
BOTH A LIBRARY TABLE AND A
DINING TABLE.

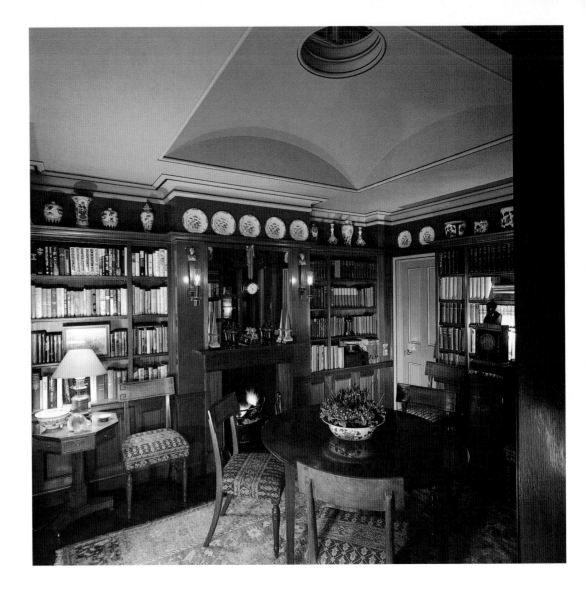

When London art
dealer Stephanie Hoppen
entertains in her New York
apartment, dinner is served
on a mahogany pedestal
table set up at one end of
the drawing room. The
table is set with a
reproduction of Catherine
the Great's ribbon-
bordered dinner service
and a medley of antique
glasses. Twisted candles on
both the dining table and a
side table unite the dining
area with the rest of
the room.

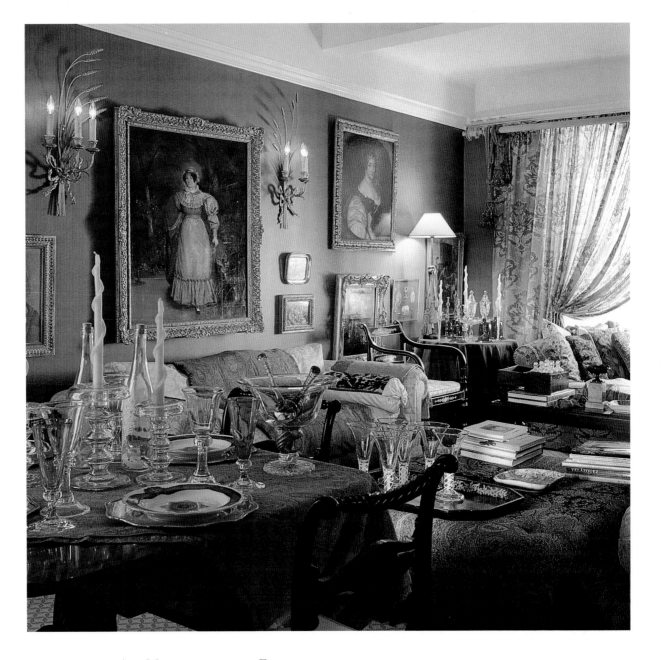

A Movable Feast

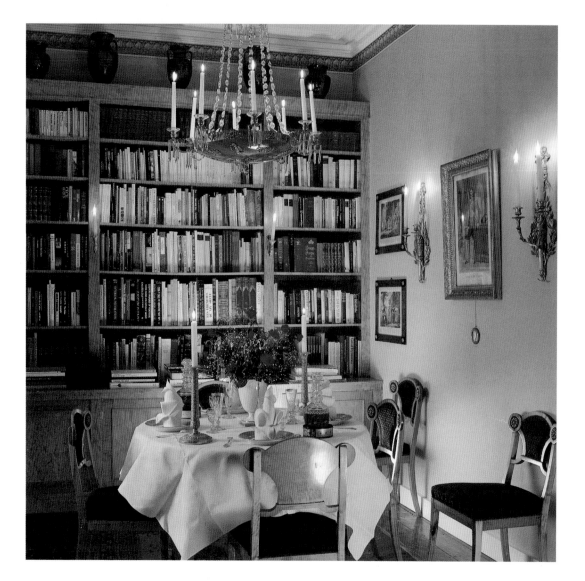

With its cool blue walls and Biedermeier furnishings, Rupert Cavendish's London library provides just the right atmosphere for an intimate dinner. The table, topped with an assortment of Biedermeier-era gilded porcelain, is paired with a set of southern Swedish birchwood chairs, ornamented with sleek black bull's eyes and fanciful rosettes. (*Left*)

An elegant Swedish Empire gilded clock flanked by an imperial pair of lions is the focal point of one wall of the library. A Charles X burr-walnut chest doubles as a sideboard, on which a tray of delicate, lidded *pots de creme* is waiting to be served. (*Below*)

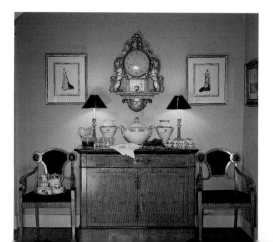

FROM LIBRARY TO SALON

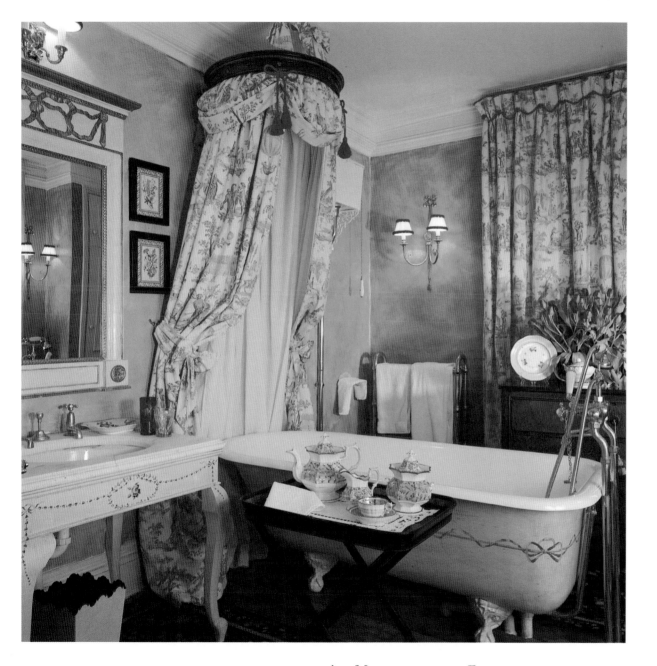

PERHAPS THE ULTIMATE
INDULGENCE IN DINING IS TO
PARTAKE OF AFTERNOON TEA
WHILE LUXURIATING IN THE
BATH. A NINETEENTH-
CENTURY GILDED AND
LACQUERED TRAY, CRISP
ANTIQUE LINENS, AND A
VICTORIAN LUSTERWARE TEA
SERVICE ARE IDEALLY SUITED
TO THIS FOOTED VICTORIAN
BATHTUB.

A MOVABLE FEAST

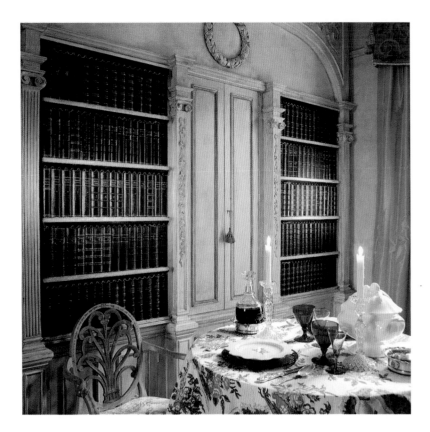

CUPBOARDS CONCEALED BEHIND DOORS MADE OF PERIOD FAUX BOOKS PROVIDE STORAGE FOR CRYSTAL AND FLATWARE. THE ROOM AND THE TABLE ARE DECORATED WITH A POTPOURRI OF INTERESTING OBJECTS, INCLUDING A SCANDINAVIAN CHAIR ORNAMENTED WITH PRINCE OF WALES FEATHERS, RARE EIGHTEENTH-CENTURY PEACOCK-BLUE GLASSES, VICTORIAN PRESSED-GLASS CANDLESTICKS, AND REPRODUCTION CREAMWARE PLATES WITH SCALLOPED BORDERS AND CRESTED MONOGRAMS. THE WREATH ABOVE THE CUPBOARDS IS A PLASTER COPY OF THE ORIGINAL ON THE OPPOSITE WALL. *(Above)*

THE CHARM OF AN EIGHTEENTH-CENTURY FRENCH CHÂTEAU HAS BEEN RE-CREATED IN THIS LONDON LIBRARY BY RECLAIMING A SET OF PERIOD PANELING, PURCHASED AT AN ARCHITECTURAL SALVAGE CENTER, AND FILLING IT IN WHERE NEEDED WITH INEXPENSIVE MEDIUM-DENSITY FIBERBOARD. *(Below)*

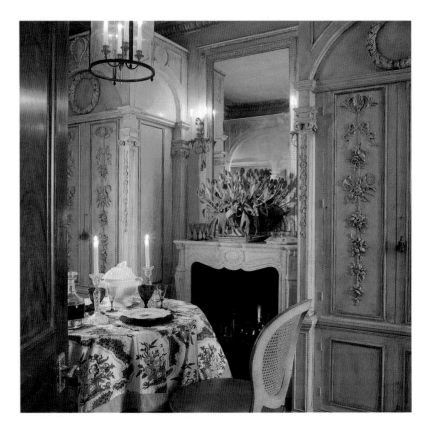

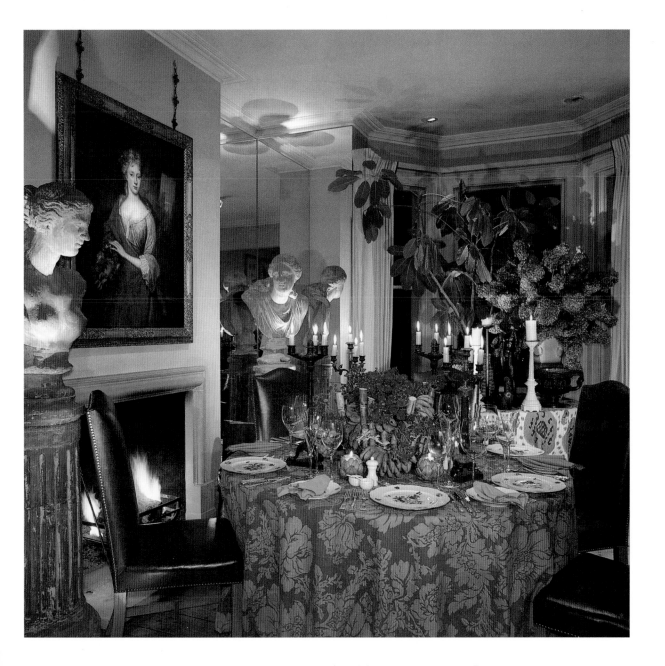

KEN TURNER HAS TURNED
A CORNER OF HIS LONDON
DRAWING ROOM INTO A
THEATRICAL PLACE TO SERVE
DINNER. AN EIGHTEENTH-
CENTURY PORTRAIT AND
DRAMATICALLY LIT CLASSICAL
BUSTS ENHANCE THE DELIBER-
ATELY STAGY ATMOSPHERE.
THE INNOVATIVE TABLE CEN-
TERPIECE COMBINES FLOWERS
WITH GREEN BANANAS AND
BAMBOO STALKS, AND
HOLLOWED-OUT ARTICHOKES
MAKE DECORATIVE CANDLE
HOLDERS.

111

A MOVABLE FEAST

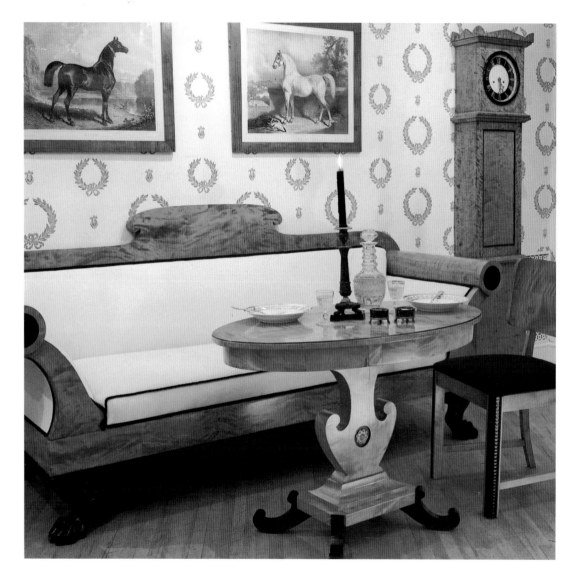

The sleek curves of a Biedermeier sofa and table make this drawing room an irresistible spot for a light meal. Additional seating is provided by an Art Deco chair, whose black cushion and leg decoration complement the striking ebony trim of the other furniture. *(Left)*

This Biedermeier secretary makes a fine setting for dinner for one. Richly gilded Empire porcelain, including a Russian cup depicting Tsar Nicholas I and a plate from an early nineteenth-century French dinner service, sparkle in the glow of the candlelight from an early nineteenth-century Aladdinlike lamp. *(Below)*

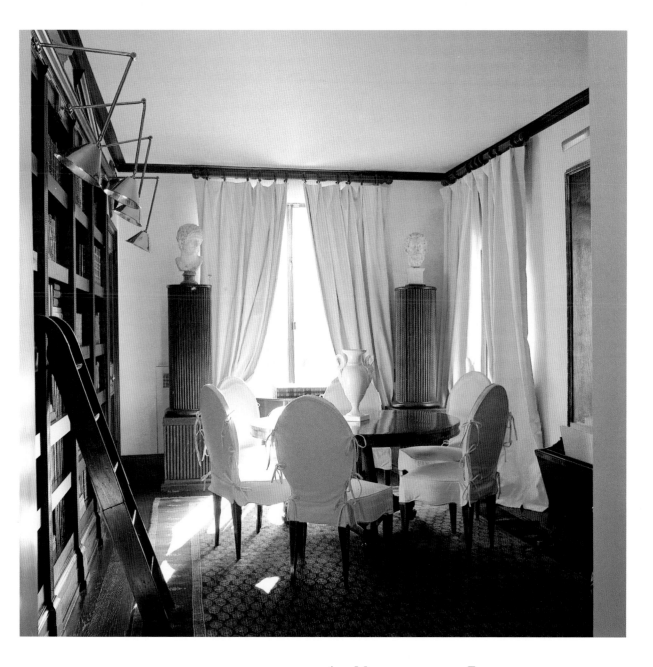

Fashion designer Bill Blass has created an inviting place to dine in this sleekly classical Manhattan library. Leather chairs are given a new look with crisp white cotton slipcovers. A pair of fluted mahogany columns not only serve as striking pedestals for a pair of antique busts but also provide storage space for tableware and other dining essentials.

A Movable Feast

THE TAPESTRY ROOM AT OSTERLEY PARK
IN ENGLAND IS A MAGICAL SETTING FOR
AFTERNOON TEA, HERE SERVED ON ELEGANT
FRENCH PORCELAIN. THE GOBELIN
TAPESTRIES COVERING THE WALLS AND THE
SET OF GILDED FURNITURE UPHOLSTERED IN
A MATCHING FABRIC CREATE AN
ATMOSPHERE OF SOFT GRANDEUR. AN
ANALOGOUS LOOK CAN BE ACHIEVED BY
DRAPING WALLS WITH TAPESTRIES OR
FABRICS, BY USING FABRIC FRAGMENTS AS
PELMETS, OR BY FRAMING THE PAINTED
DESIGNS, OR CARTOONS, OF RUGS OR
TAPESTRIES FROM THE GRAND FRENCH
MANUFACTURERS, SUCH AS AUBUSSON
OR SAVONNERIE.

114

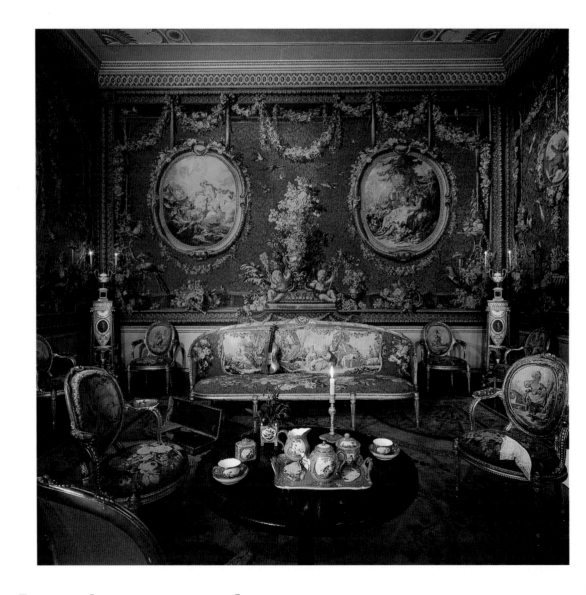

In Christophe Gollut's sitting room, pictures of all shapes and sizes are hung on boldly striped walls in the fashion of a late nineteenth-century artist's studio or salon. An almost unnoticeable seam in the wall is in fact the opening of a pair of doors that conceal a minuscule kitchen, which contains everything necessary to prepare dinner for eight.

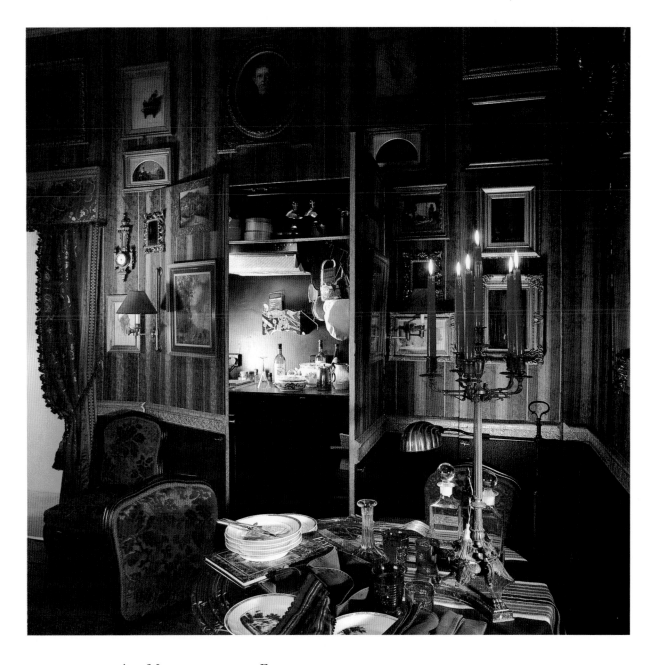

A MOVABLE FEAST

DECORATED AS A PRINT ROOM, THIS LONDON HALLWAY IS A FAVORITE PLACE FOR DINNER FOR TWO. IN THE TRUE SPIRIT OF THE MOVABLE FEAST, A MAHOGANY BUTLER'S TRAY SERVES AS A TABLE THAT CAN BE LIFTED OFF ITS BASE AND CARRIED TO THE KITCHEN FOR CLEANING. THE PRINT-ROOM PRINCIPLE IS CARRIED OUT IN THE TABLEWARE AS WELL AS ON THE WALL: AN EIGHTEENTH-CENTURY TRANSFER-PRINTED CREAMWARE COFFEE POT SPORTS A TEA-DRINKING SCENE; THE PORCELAIN IS ARMORIAL; A PAINTED OVAL TIN CONTAINER USED TO CHILL WINE HAS A DECOUPAGE FESTOON BORDER; AND A JUG DECORATED WITH CUT-OUT FLORAL AND SHELL MOTIFS HOLDS A BUNCH OF SPRING'S FIRST TULIPS.

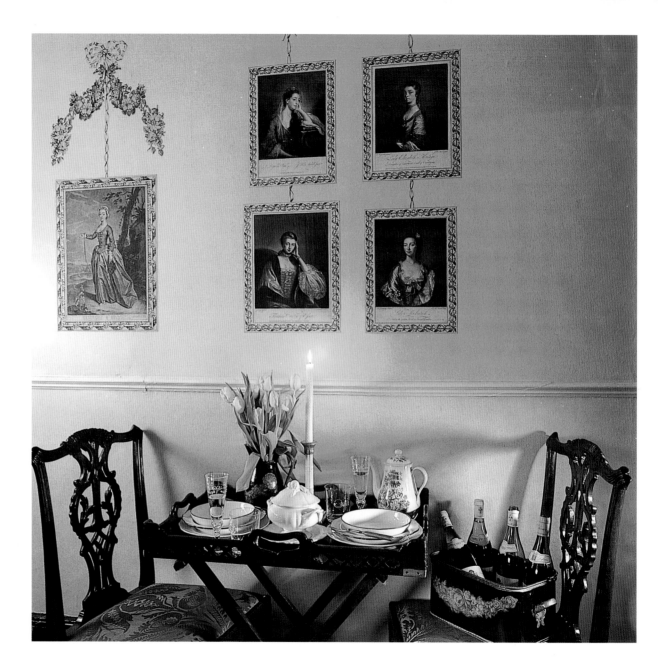

FROM LIBRARY TO SALON

\mathcal{T}HE HALL IN THE STATELY EARLY
EIGHTEENTH-CENTURY ENGLISH HOME OF
LADY VIVIEN GREENOCK, A DESIGNER AT
COLEFAX AND FOWLER, MAKES A BEAUTIFUL
PLACE TO DINE, THANKS TO THE
EXTRAORDINARY PERIOD PLASTERWORK
ORNAMENTING WALLS AND CEILING.
IN CONTRAST TO THE ARCHITECTURAL
GRANDEUR OF THE SPACE ITSELF, THE
TABLE IS CASUALLY SET FOR RELAXED
WEEKEND ENTERTAINING. COVERED WITH
TWO CLOTHS AND SURROUNDED BY
INFORMAL RATTAN CHAIRS, IT SPORTS
UNMATCHED BOTANICAL PLATES AND A
MIXTURE OF GLASSWARE.

(Above and right)

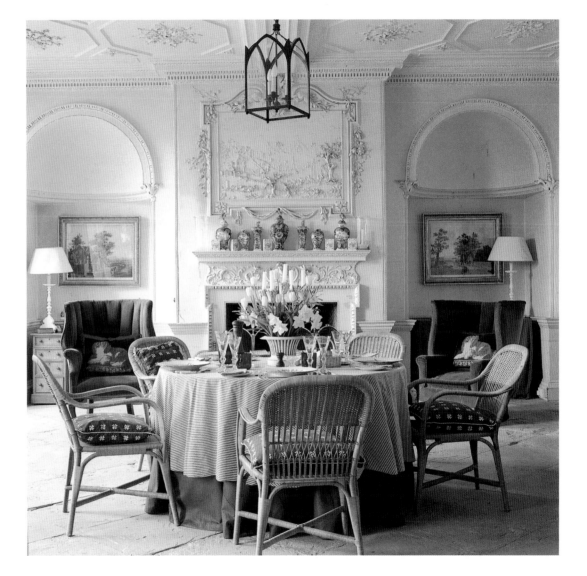

A MOVABLE FEAST

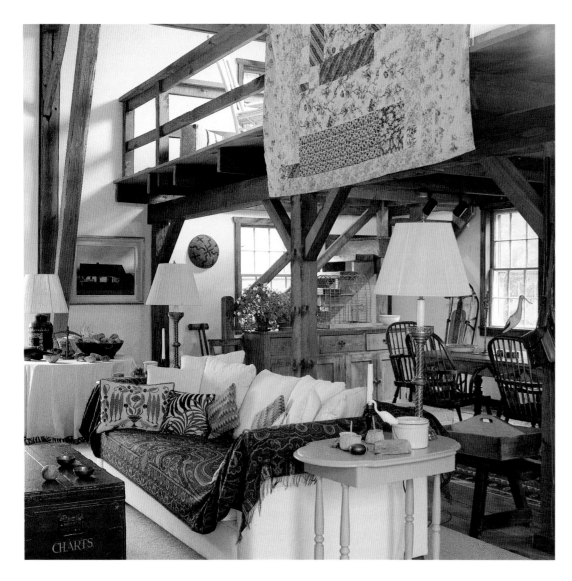

\mathcal{I}N THIS CONNECTICUT COUNTRY HOUSE, THE LIVING IS EASY, AND ENTERTAINING TAKES PLACE IN AN ALL-IN-ONE SITTING-CUM-DINING ROOM. AN ANTIQUE PATCHWORK QUILT HANGING CASUALLY FROM THE RAILING OF THE LOFT ABOVE AND A NINETEENTH-CENTURY PAISLEY SHAWL DRAPED OVER THE SOFA ARE WARM, INVITING DECORATIVE TOUCHES. *(Left)*

\mathcal{T}HIS FITTED ANTIQUE PICNIC BASKET IS THE LAST WORD IN EQUIPMENT FOR A MOVABLE FEAST. CONTAINING IVORY-HANDLED KNIVES, SILVER-LIDDED SERVING DISHES, AND GILT-EDGED CUPS AMONG OTHER NECESSARIES, IT IS USED HERE TO SET A BUFFET TABLE. *(Below)*

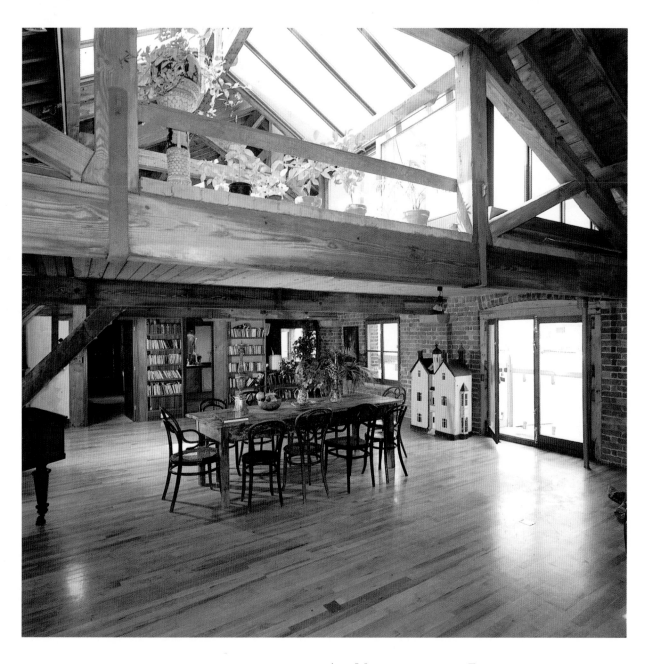

THE DINING TABLE HAS
PRIDE OF PLACE IN THIS
UNCLUTTERED, LIGHT-FILLED
LONDON LOFT, WHOSE
WINDOWS AND GLASS DOORS
AFFORD A SWEEPING VIEW OF
THE THAMES.

A MOVABLE FEAST

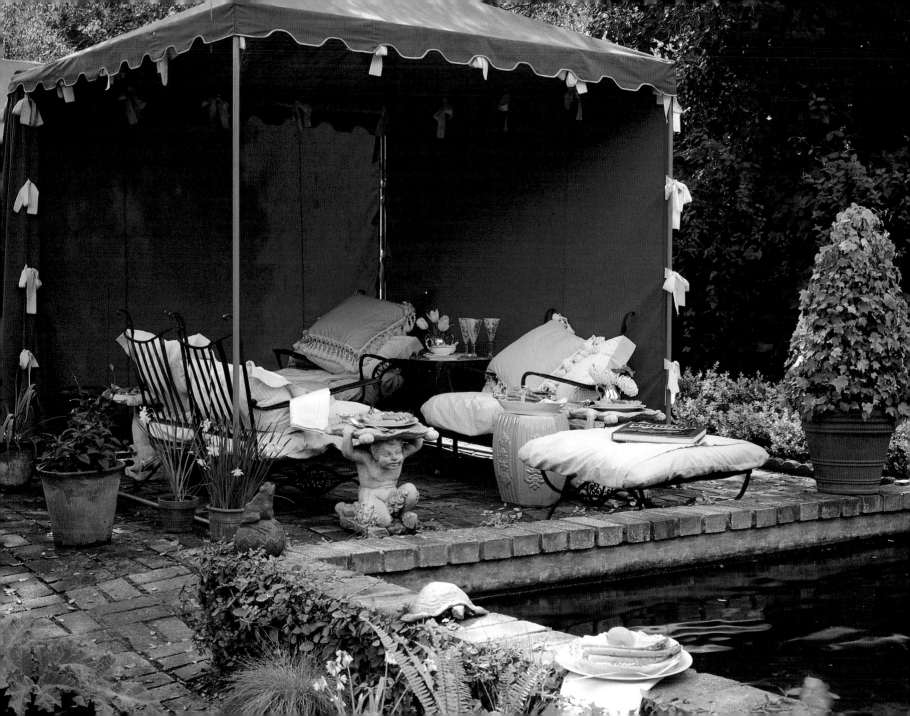

The Great Outdoors

DINING ALFRESCO

At one o'clock we were ready to start, and the little company walked about two or three hundred yards from the house to the lake. At the lakeside was a boathouse, and a kind of chalet or summer-house. . . . The luncheon had been carried down; the tables had been arranged in the same silver and glass and napery as would have been used in the house. The butler and one or two footmen were there to serve. In fact the picnic was no different than an ordinary lunch, except that we ventured a few hundred yards from the mansion, and sat above the boat house. After luncheon and all the suitable wines had been served and coffee drunk, we processed back to the house. The great expedition had taken place.

—Harold Macmillan, *Winds of Change*, c. 1920

Although today's idea of a picnic is far less formal and much more impromptu than the rather curious meal that so impressed Macmillan, the spirit of adventure that prompted it lives on. From the first beautiful day of spring, through the sultry days of summer, and until autumn's last captivating sunset, nature beckons us to pack a picnic basket and perhaps a folding table and venture into the great outdoors.

In the eighteenth century the magic of the garden and the desire to enjoy its charms in any sort of weather generated a craze for follies. These imaginative structures, inspired by a range of classical and exotic architectural designs, were often constructed solely for the purpose of dining or tea drinking. In the nineteenth century the Victorians annexed glass rooms, or conservatories, to the house so they could enjoy the pleasures of dining in a garden setting all year round.

Follies are the ancestors of today's garden gazebos and pavilions. Prefabricated gazebos in a broad range of styles are widely available. Conservatories, whether freestanding or attached to the house (page 127), can be purchased in both period and contemporary styles. Filled with topiary, fruit trees, or flowering plants, they have all the charm of an eternal secret garden. Whether outfitted with Victorian wrought-iron furniture decorated with twig or vine motifs, or with a starkly modern metal table and chairs, whimsical Adirondack-style furniture, or simple rattan, they make superb dining rooms. You can extend the garden theme by setting the table with botanical-motif plates, dishes in the shape of vegetables and flowers, or a cloth with a floral or plant print (page 125).

The settings on these pages, from a courtyard in southern Spain (page 124) to a garden in the Tuscan hills (page 133) to an oceanside patio in California (page 135) to a terrace overlooking the Bosporus in Istanbul (page 136), suggest only a few of the natural venues that provide perfect backdrops for indulging in the joys of dining alfresco.

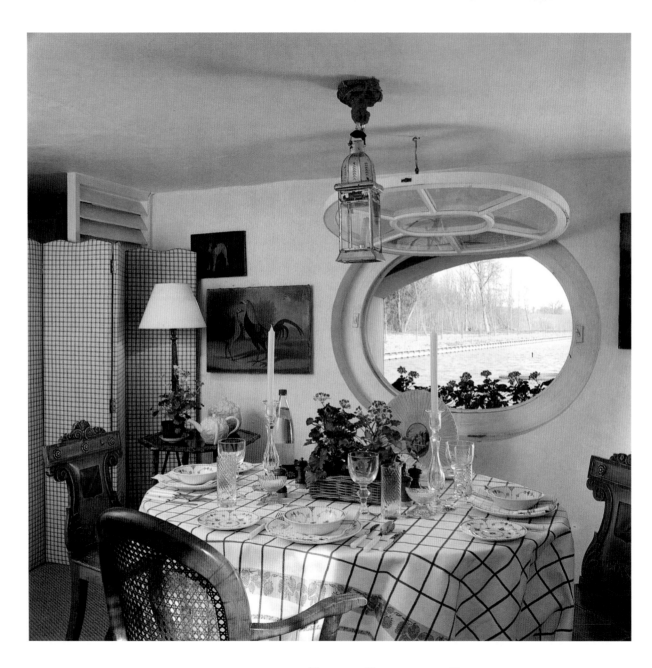

WITH ITS PLUMP-CUSHIONED
GARDEN FURNITURE, THIS
POOLSIDE TENT IN MONTEREY,
CALIFORNIA, IS AN ENTICING
DINING SPOT, ESPECIALLY ON A
HOT SUMMER DAY. STONE
PUTTI MAKE FANCIFUL
INDIVIDUAL TABLES.
(Left and right)

INTERIOR DESIGNER VEERE
GRENNEY OF COLEFAX AND
FOWLER USES THE BASEMENT
OF THE TEMPLE OF THE FOUR
SEASONS, AN EIGHTEENTH-
CENTURY FOLLY, AS A DINING
ROOM, THUS THUS PAYING
TRIBUTE TO THE TRADITIONAL
ROLE OF FOLLIES AS "OUTDOOR"
BANQUETING PAVILIONS. A
BULL'S-EYE WINDOW OPENS IN
PORTHOLE FASHION TO REVEAL
A VIEW OF THE CANAL BEYOND.
THE DECOR, INCLUDING
PRIMITIVE PAINTINGS AND A
GINGHAM-COVERED SCREEN,
GIVES THE ROOM A COUNTRY
FEELING.

THE GREAT OUTDOORS

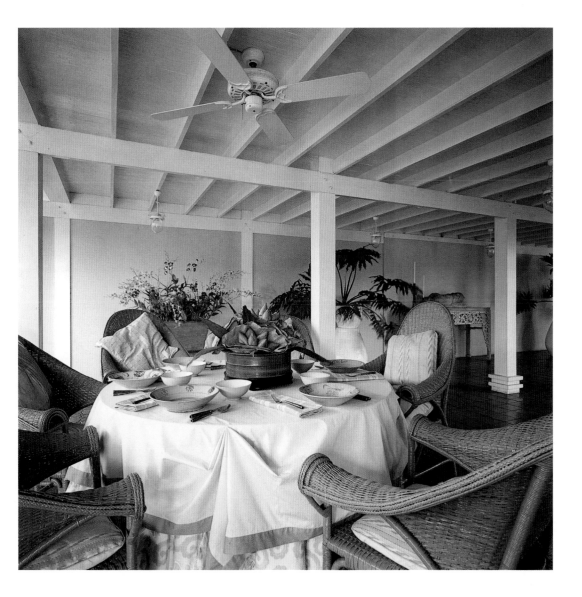

\mathcal{T}HE OPEN-AIR DINING ROOM OF THIS
RIVER HOUSE CONSTRUCTED ON STILTS
PROVIDES A WELCOME RESPITE FROM
THAILAND'S STEAMY SUMMER HEAT. DEEP,
COMFORTABLE RATTAN CHAIRS ARE
PAINTED A COOL GREEN AND A CEILING FAN
GENERATES A REFRESHING BREEZE. THE
CELADON POTTERY AND WOODEN BASKET ON
THE TABLE ARE TYPICAL OF THE THAI
CRAFT TRADITION.

DINING ALFRESCO

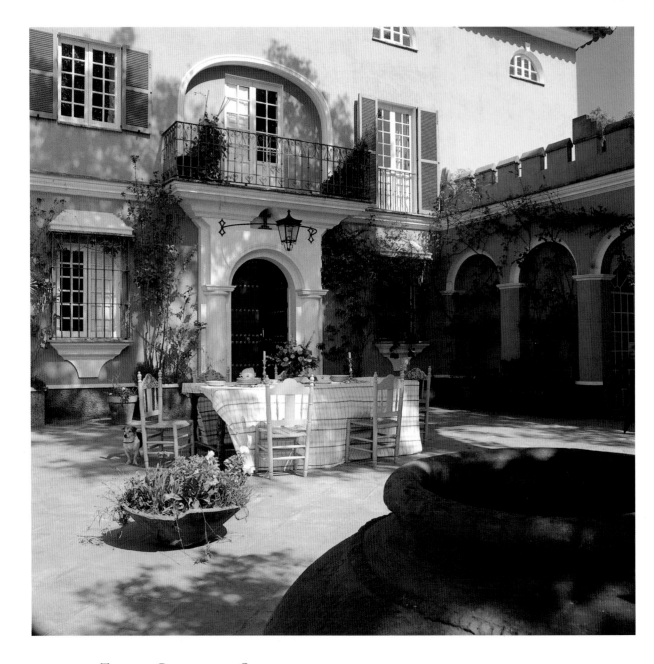

ALL THAT IS NEEDED TO
TRANSFORM THE COURTYARD
OF THIS HOUSE IN SOUTHERN
SPAIN INTO AN IRRESISTIBLE
ALFRESCO DINING SPOT ARE
SOME RUSTIC PROVINCIAL
CHAIRS AND A TABLE COVERED
WITH A SIMPLE COTTON
CLOTH. THE ARCHITECTURE
AND THE NATURAL LIGHT
DO THE REST.

124

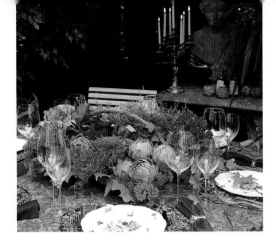

\mathcal{K}EN TURNER HAS TRANSFORMED HIS
CONSERVATORY DINING TABLE INTO A
VERITABLE GARDEN, STARTING FROM THE
LEAF-PRINT TABLECLOTH AND BOTANICAL-
MOTIF PLATES AND CULMINATING IN AN
ORGANIC AND AROMATIC CENTERPIECE OF
VEGETABLES, FLOWERS AND HERBS. *(Above)*

\mathcal{W}EATHER PERMITTING, THIS STONE
COURTYARD IN THE ENGLISH COUNTRYSIDE
IS AN IDYLLIC SETTING FOR BREAKFAST.
COFFEE IS SERVED ON A NINETEENTH-
CENTURY WROUGHT-IRON TABLE, AND
ASSORTED CUSHIONS TURN THE GARDEN
BENCH AND STONE LEDGE INTO
COMFORTABLE SEATING. *(Right)*

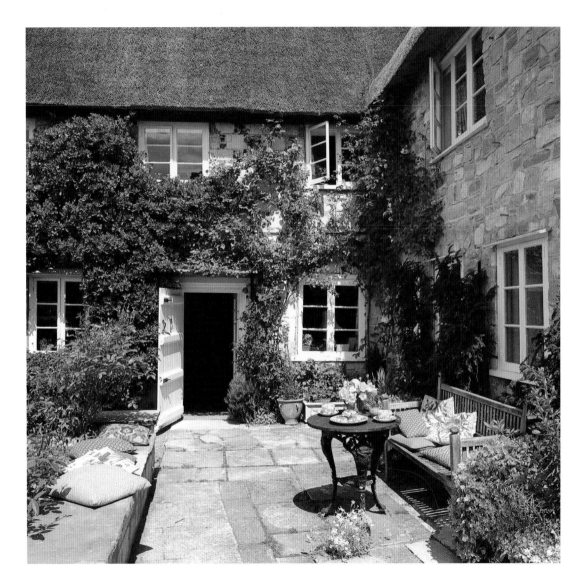

DINING ALFRESCO

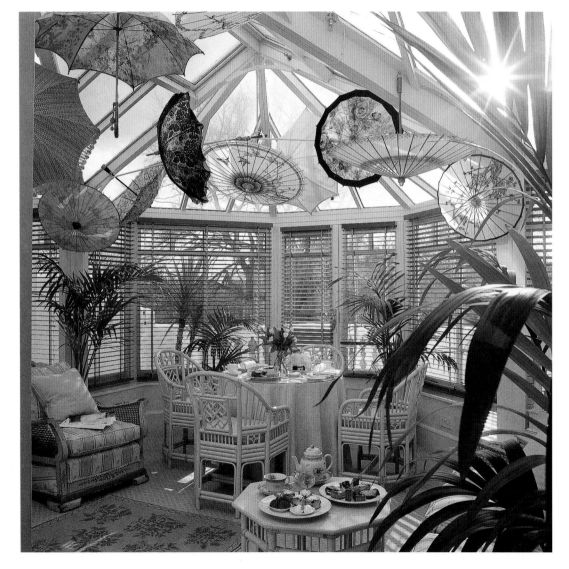

With its bamboo furniture and parasols suspended whimsically from the ceiling, this modern conservatory was inspired by the nineteenth-century penchant for decorating conservatories in an oriental style. The parasols not only reinforce the oriental theme but also filter the sunlight pouring into the room. *(Left)*

In conservatories such as this one, set in an English garden, the pleasures of dining alfresco can be savored all year round. *(Facing page)*

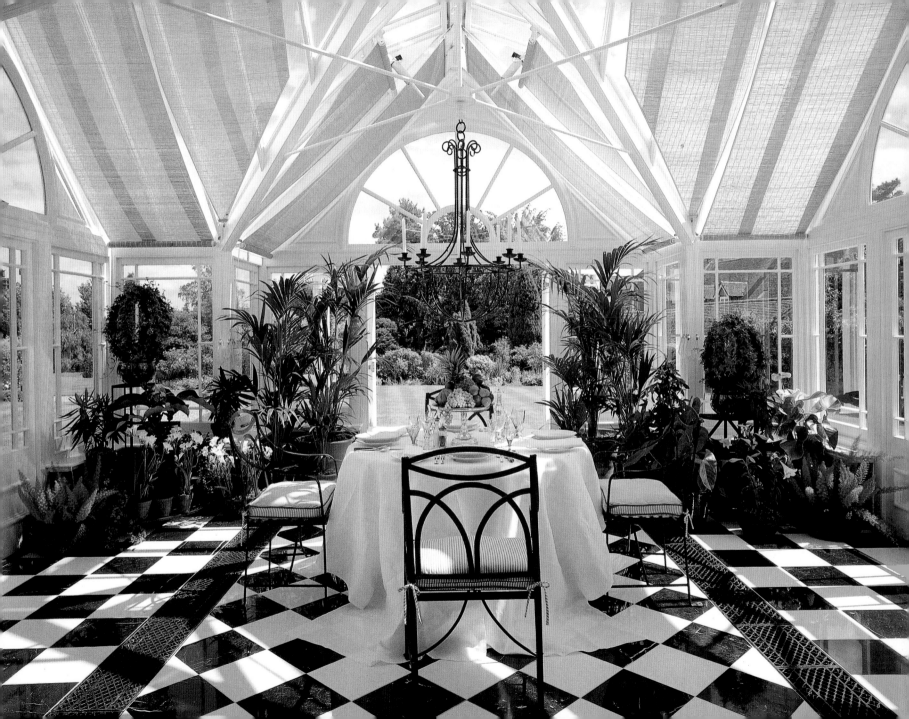

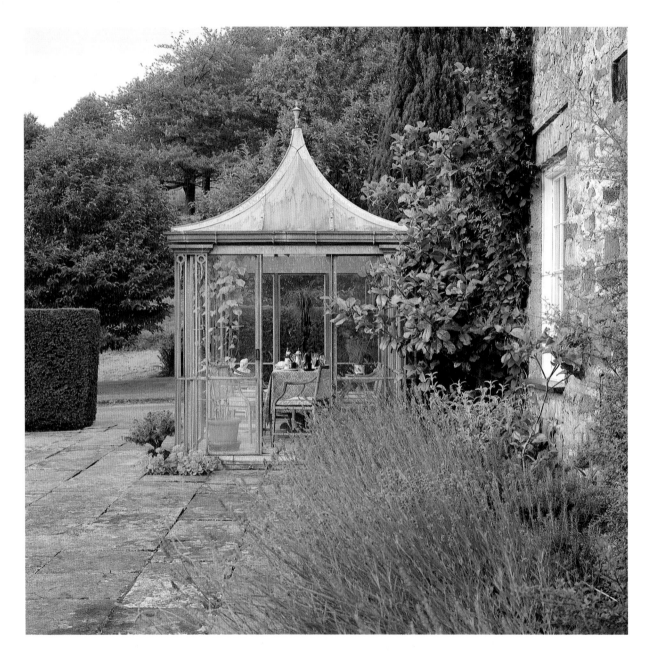

*T*AKING AFTERNOON TEA IN
THIS GARDEN GAZEBO IN THE
*E*NGLISH COUNTRYSIDE, WITH
ITS FANCIFUL PAGODALIKE
ROOF AND THE INTOXICATING
SCENT OF LAVENDER
PERFUMING THE AIR, MUST
BE LIKE TURNING BACK IN TIME
TO THE *E*DWARDIAN ERA.

THE GREAT OUTDOORS

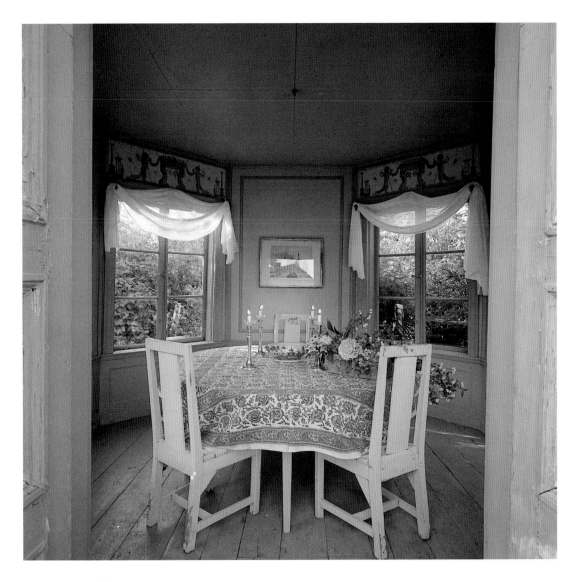

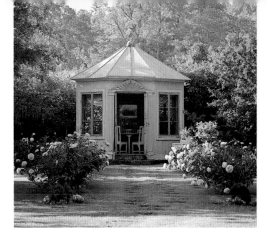

Nestled among trees and peony bushes, this garden pavilion in Sweden has a fairy-tale charm. *(Above)*

The magic of this pavilion lies in its small decorative touches, such as the delightful friezes of cupids above the windows and the simple white curtain swags, which add a softness to the room but do not obstruct the view of the surrounding garden. Reproductions of such period follies can be bought ready to assemble. *(Left)*

129

DINING ALFRESCO

PARTAKING OF NATURE'S
BOUNTY RIGHT IN THE MIDST
OF ITS BEAUTY IS WHAT MAKES
DINING ALFRESCO SO ENTICING,
AS THIS MOUTH-WATERING
PICNIC ALONG A RIVER IN THE
ENGLISH COUNTRYSIDE
ILLUSTRATES.

130

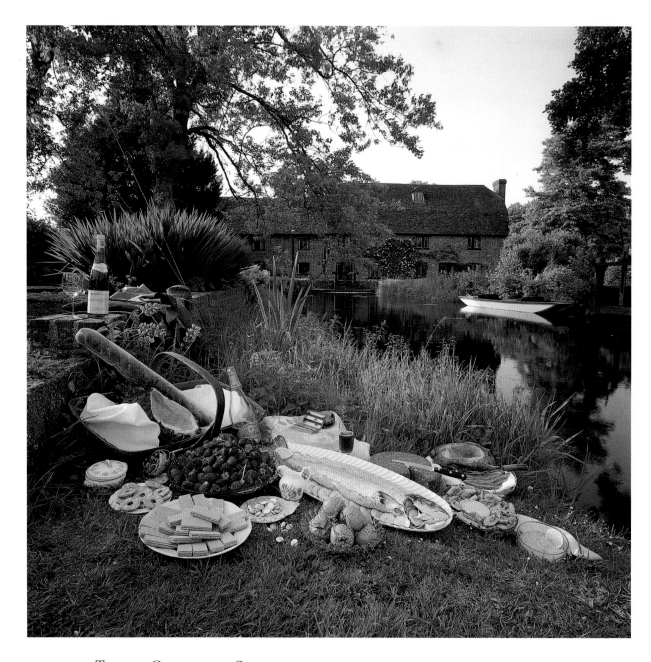

THE GREAT OUTDOORS

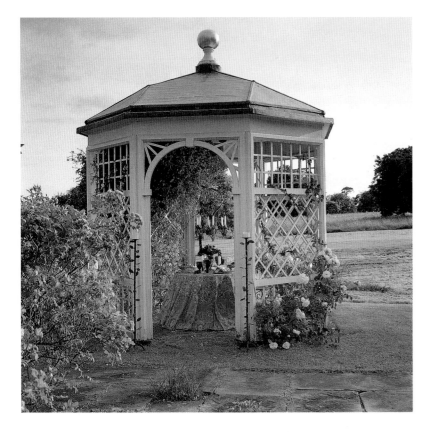

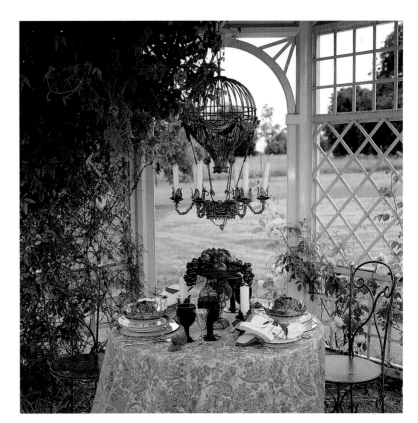

A STEP INSIDE THE GAZEBO'S ARCHED DOORWAY REVEALS A METAL, CANDLE-BURNING CHANDELIER IN THE SHAPE OF A MONTGOLFIER BALLOON. AS THE SOFT AFTERNOON LIGHT FADES INTO DUSK, THE THICK PURPLE GOBLETS AND GILDED PLATES AND BOWLS WILL CATCH NOT ONLY THE SUN'S LAST RAYS BUT ALSO THE GLOW OF CANDLELIGHT. *(Below)*

THIS TRELLISED GAZEBO RISES OUT OF THE OXFORDSHIRE COUNTRYSIDE LIKE A FROTHY CONFECTION. IT IS A MAGICAL SETTING FOR A LAZY SUMMER LUNCHEON FOR TWO. THESE ENCHANTING PAVILIONS ARE AVAILABLE IN PREFABRICATED FORM AND CAN BE ASSEMBLED ANYWHERE, EVEN ON AN URBAN ROOFTOP. *(Above)*

DINING ALFRESCO

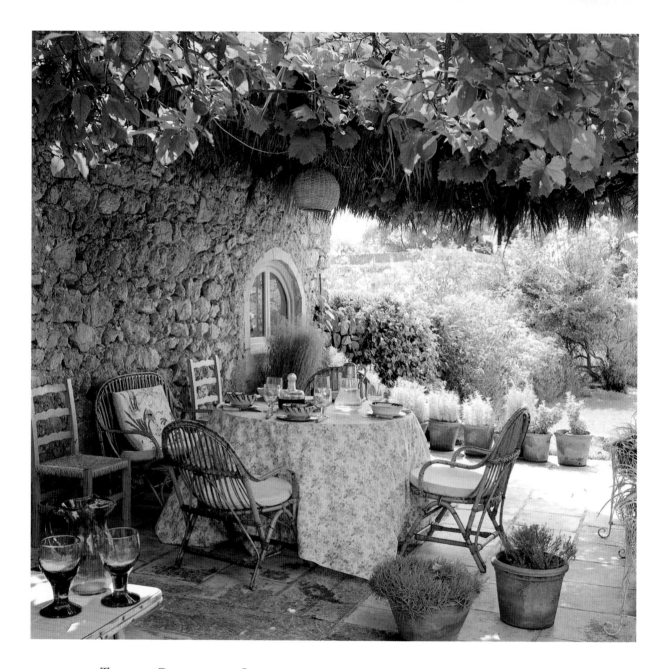

SHIELDED FROM THE
STRONG AFTERNOON SUN BY A
CANOPY OF TWISTED VINES,
THE PATIO OF CHIQUITA
ASTOR'S MALLORCAN FARM-
HOUSE IS A PARTICULARLY
INVITING SETTING FOR CASUAL
SUMMER DINING. THE CHEER-
FUL FLORAL-PRINT COTTON
TABLECLOTH PICKS UP THE
COLORS OF THE SURROUNDING
GARDEN.

132

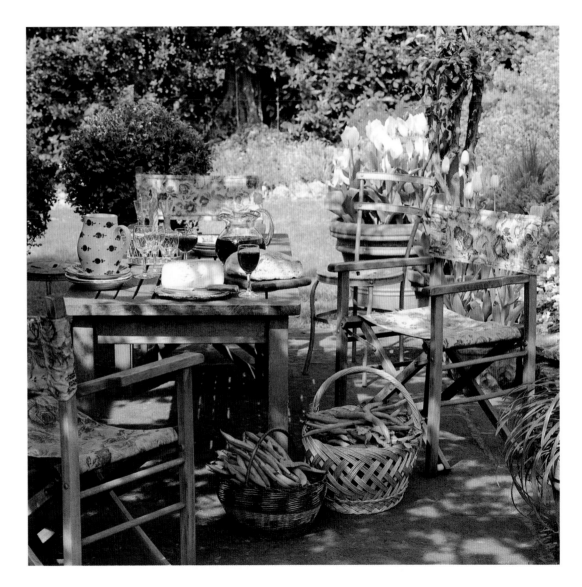

ON HOT SUMMER DAYS, THE OWNERS OF
THIS VINEYARD IN PROVENCE FLEE TO THE
SANCTUARY OF A TINY STONE CHAPEL AT
THE EDGE OF THE PLANTED FIELDS TO
SAVOR THE LOCAL CULINARY DELIGHTS AND
THE FRUITS OF THEIR OWN LABOR, INCLUD-
ING WINE SERVED IN OVERSIZED JUGS, SUCH
AS THE RATTAN-COVERED ONE ON THE
GROUND BESIDE THE TABLE. *(Above)*

ON EMMA BINI'S RUSTIC PATIO IN
TUSCANY, THE WEATHERED WOODEN TABLE
AND CHAIRS SEEM AS NATURAL A PART OF
HER GARDEN AS THE PLUMP GREEN BEANS
PILED HIGH IN WOVEN BASKETS. *(Right)*

DINING ALFRESCO

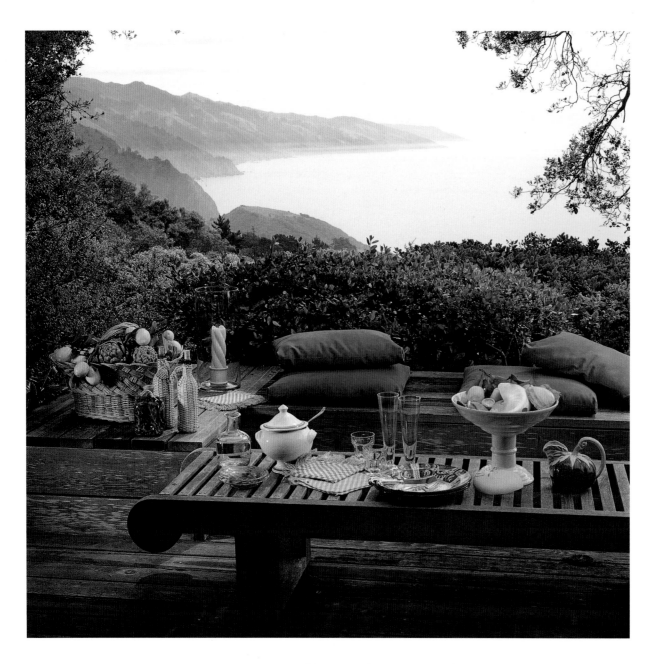

NATURAL-TEAK BENCHES, BUILT ATOP A HILL IN CARMEL WITH A SPECTACULAR VIEW OF THE PACIFIC COAST, PROVIDE A DRAMATIC VENUE FOR SUMMER LUNCHES, CALIFORNIA STYLE. A LOCAL BASKET IS FILLED TO OVERFLOWING WITH VEGETABLES AND FRUITS, AND WINE IS SERVED IN RATTAN-COVERED BOTTLES.

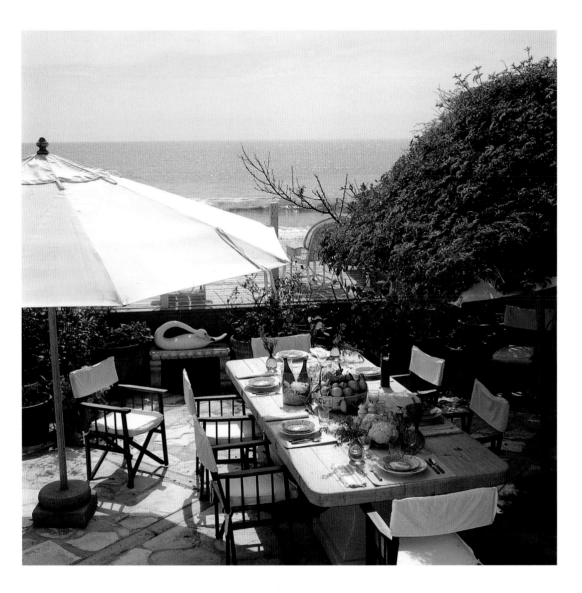

135

\mathcal{W}ITH THE OCEAN AS A BACKDROP, THE
PATIO OF THIS MALIBU BEACH HOUSE IS A
CAPTIVATING SPOT TO DINE EN PLEIN AIR.
A STONE TABLETOP, MADE TO LOOK LIKE
DRIFTWOOD, TAKES ITS INSPIRATION FROM
THE SEA, AS DO THE CERULEAN-BLUE
MINERAL-WATER BOTTLES AND THE HAND-
MADE BLUE-AND-WHITE POTTERY.

DINING ALFRESCO

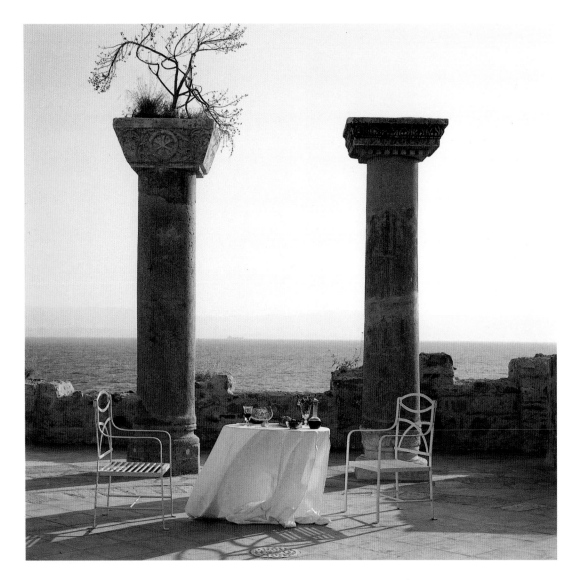

136

OVERLOOKING THE BOSPORUS IN
ISTANBUL, AN ANCIENT STONE TERRACE
BECKONS WITH TIMELESS GRANDEUR. THE
CLASSICAL COLUMNS THAT FRAME THE
WINDSWEPT TABLE SEEM TO HOLD UP THE
SKY ABOVE THIS OPEN-AIR DINING ROOM.
(Left)

THE URBAN SETTING OF THIS LONDON
PENTHOUSE TERRACE, WITH ITS BREATH-
TAKING VIEW OF THE ROYAL NAVAL
COLLEGE, GREENWICH, ACROSS THE
THAMES, HAS BEEN COUNTRIFIED WITH
FILIGREE WROUGHT-IRON FURNITURE FOR
RELAXED DINING FAR FROM THE BUSTLE OF
THE STREET. *(Facing page)*

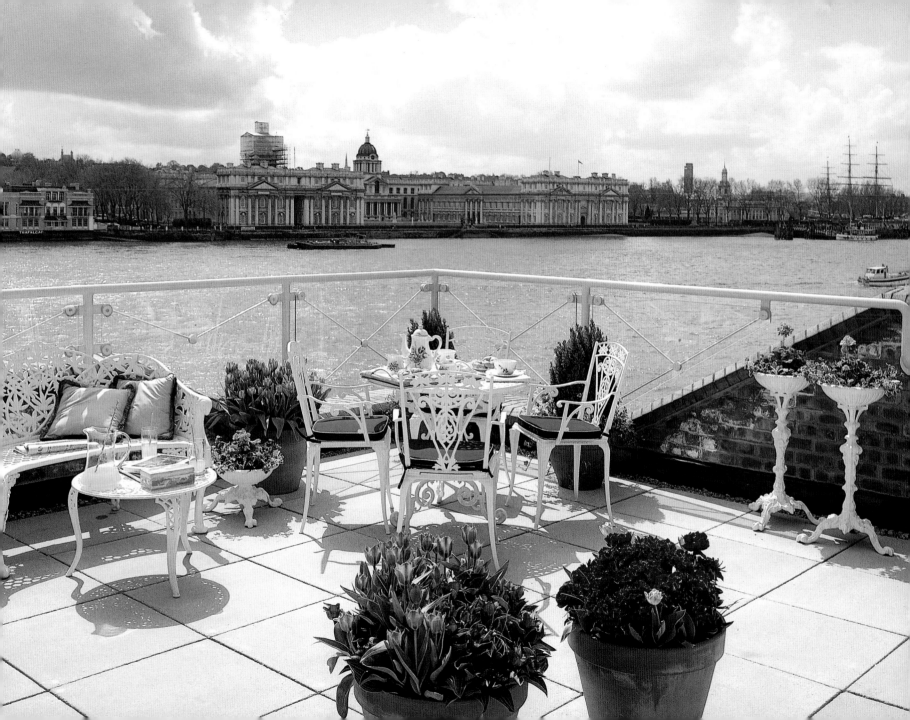

Sources

UNITED STATES

Department-Store/ Tabletop-Store Chains

Bloomingdale's
Bullock's
Conran's
Crate & Barrel
Dillard's
Ikea
I. Magnin
Macy's
Neiman-Marcus
Pottery Barn
Saks Fifth Avenue
Stein Mart
Tiffany & Co.
Williams-Sonoma

NEW YORK

Department Stores/ General Tabletop Stores

ABC Carpet & Home
888 Broadway, NYC

Asprey
725 Fifth Ave., NYC

Barneys Chelsea Passage
106 Seventh Ave., NYC

Bergdorf Goodman
754 Fifth Ave., NYC

Henri Bendel
712 Fifth Ave., NYC

Speciality Stores/Boutiques

Aventura
463 Amsterdam Ave.,
NYC

Baccarat
625 Madison Ave.,
NYC

Bardith, Ltd
1015 Madison Ave.,
NYC

Bernadaud-Limoges
777 Madison Ave.,
NYC

Cardel
621 Madison Ave.,
NYC

Ceralene Inc.
625 Madison Ave.,
NYC

Ceramica Mia II
59 Thompson St., NYC

Charlotte Moss
1027 Lexington Ave.,
NYC

Christofle
680 Madison Ave.,
NYC

Felissimo
10 W. 56th St., NYC

Fishs Eddy
889 Broadway, NYC;
551 Hudson St., NYC

Galeries Lafayette
4 E. 57th St., NYC

Howard Kaplan
Antiques
827 Broadway, NYC

James II Galleries
15 E. 57th St., NYC

John Rosselli
255 E. 72nd St., NYC

Katie Ridder Home
Furnishings
944 Lexington Ave.,
NYC

Keesal & Matthews
1244 Madison Ave.,
NYC

Laura Ashley Home
714 Madison Ave.,
NYC

Manhattan Art and
Antiques Center
1050 Second Ave., NYC

Mayhew-Copley Ltd
507 Park Ave., NYC

The Mediterranean
Shop
780 Madison Ave.,
NYC

Ocino
66 John St., NYC

Pierre Deux
870 Madison Ave.,
NYC;
369 Bleecker St., NYC

Polo Ralph Lauren
867 Madison Ave.,
NYC

Puiforcat Boutique
811 Madison Ave.,
NYC

Royal Copenhagen
Porcelain–Georg
Jensen Silversmiths
683 Madison Ave.,
NYC

Scully & Scully
504 Park Ave., NYC

Simon Pearce
385 Bleecker St., NYC

Slatkin & Co.
131 East 70th St., NYC

Thomas K. Woodward
835 Madison Ave.,
NYC

Treillage
418 East 75th St., NYC

Waterford Wedgwood
713 Madison Ave.,
NYC

The Wicker Garden
1318 Madison Ave.,
NYC

Wolfman, Gold &
Good Company
116 Greene St., NYC

Zona
97 Greene St., NYC

Linens

AD Hoc Softwares
410 W. Broadway, NYC

E. Braun
717 Madison Ave.,
NYC

Descamps
723 Madison Ave.,
NYC

D. Porthault & Co.
18 E. 69th St., NYC

Frette
799 Madison Ave.,
NYC

Leron
750 Madison Ave.,
 NYC

Portico Bed and Bath
Spring St., NYC

Pratesi Linens
829 Madison Ave.,
 NYC

Schweitzer Linens
1132 Madison Ave.,
 NYC

Architectural Salvage

Architectural Artifacts
14 Second Ave., NYC

Lost City Arts
275 Lafayette St., NYC

Urban Archaeology
285 Lafayette St., NYC

O T H E R U . S .
C I T I E S

Tabletop Stores/Boutiques

Abodio
5961 Corson Ave.
Seattle, WA

Affairs
1401 N. Highland
Atlanta, GA

The American Wing
Main Street
Bridgehampton, NY

Ansel Gurney House
403 County Rd.
Marion, MA

A Place in Time
6850 Main St.
Miami Lakes, FL

Assinippi Trading Co.
2053 Washington St.
Hanover, MA

Berings
3900 Bissonnet
Houston, TX

Center Street Gallery
136 Park Ave. South
Winter Park, FL

Chalmers
904 S. Robertson Blvd.
Los Angeles, CA

Charles Willis
465 E. Paces Ferry Rd.
Atlanta, GA

Cherie's Fancy
4923 St. Elmo Ave.
Bethesda, MD

Cloud Tree and Sun
Gresham, OR

Crazy Horse
400 Orchid Springs
Winter Haven, FL

Crowder's Gift Horse
3120 W. Bay to Bay
Tampa, FL

Domus
141 Bellevue Sq.
Bellevue, WA

Events
1966 W. Gray
Houston, TX

The Galleries
100 Indian Rocks Rd.
Belleair Bluffs, FL

Geary's Beverly Hills
351 N. Beverly Dr.
Beverly Hills, CA

Glyn Weakley Ltd.
3489 Northside Pkwy.
Atlanta, GA

The Greenhouse
1235 Cornwall Ave.
Bellingham, WA

Gump's
250 Post St.
San Francisco, CA

Habitat
Anchorage, AK

HK Limited
1829 N.W. 25th
Portland, OR

Hospitality House
Peachtree Battle
 Shopping Center
Atlanta, GA

Jacqueline Adams
 Antiques
2300 Peachtree, N.W.,
 Suite B 110
Atlanta, GA

Kaplans Ben-Hur
2125 Yale
Houston, TX

Kasala
1505 Western Ave.
Seattle, WA

Kitchen Kaboodle
3219 N.W. Guam
Portland, OR

Lawrence
809 Madison St.
Huntsville, AL

Legacy
6333 Camp Bowie Blvd.
Ft. Worth, TX

Mandrake
1655 Wisconsin Ave.,
 N.W.
Washington, D.C.

Martin's of Georgetown
1304 Wisconsin Ave.,
 N.W.
Washington, D.C.

M. L. Jarvis
4200 Paces Ferry Rd.
Atlanta, GA

Norwell Art Complex
25 Washington St.
Norwell, MA

Oltz-Wilson Antiques
24 Franklin St.
Newport, RI

Panhandlers
310 Preston Royal
 Shopping Center
Dallas, TX

The Perfect Setting
6726 Snider Plaza
Dallas, TX

Port O'Call Pasadena at
 Brentwood
11965 San Vicente Blvd.
Los Angeles, CA

P.S. The Letter
5122 Camp Bowie Blvd.
Ft. Worth, TX

Reed and Cross
160 Oakway Rd.
Eugene, OR

Richard Kazarian
70 Charles St.
Boston, MA

Rooms and Gardens
1631 Wisconsin Ave.,
 N.W.
Washington, D.C.

Steve Beverly Hills
9530 Santa Monica
 Blvd.
Beverly Hills, CA

Strawberry Patch
119 Harrison St.
Cocoa Village, FL

Straw Goat
130 Beach Dr., N.E.
St. Petersburg, FL

Sunshine Kitchen
14625 N.E. 20th
Bellevue, WA

Swan Creek
333 North Main St.
Lambertville, NJ

Teigland's
17510 Hwy. 99
Lynnwood, WA

Tiskets n' Taskets
241 Miracle Mile
Coral Gables, FL

Trappings
332 Elm St.
South Dartmouth, MA

LONDON

Department Stores/
General Tabletop Stores

Asprey
165 New Bond St.
London W1

Chinacraft
1 Beauchamp Pl.
London SW3

The Conran Shop
81 Fulham Rd.
London SW3

Fortnum & Mason
181 Piccadilly
London W1

Garrard
112 Regent St.
London W1

General Trading Co.
144 Sloane St.
London SW1

Habitat
206 King's Rd.
London SW3;
196 Tottenham Court
 Rd.
London W1

Harrod's
Knightsbridge
London SW1

Harvey Nichols at
 Home
Knightsbridge
London SW1

Heal's
196 Tottenham Court
 Rd.
London W1

Liberty
Regent St.
London W1

Maison
47 Neal St.
London WC2

Mappin & Webb
106 Regent St.
London W1

Past Times
146 Brompton Rd.
London SW3

Selfridges
Oxford St.
London W1

Thomas Goode
19 S. Audley St.
London W1

Tiffany & Co.
25 Old Bond St.
London W1

Waterford Wedgwood
158 Regent St.
London W1;
266 Regent St.
London W1;
174 Piccadilly
London W1

Specialty Stores/Boutiques

The Antique Textile
 Gallery
100 Portland Rd.
London W11

Baer and Ingram
 (wallpaper)
273 Wandsworth Bridge
 Rd.
London SW6

Britannia (majolica)
Gray's Antiques Market
58 Davies St.
London W1

Christophe Gollut
116 Fulham Rd.
London SW3

Christopher Moore
 (toile de jouy)
40a Ledbury Rd.
London W11

Colefax & Fowler
39 Brook St.
London W1

Comoglio
c/o Pierre Frey
253 Fulham Rd.
London SW3

David Linley
60 Pimlico Rd.
London SW1

David Mellor
4 Sloane Sq.
London SW1

Descamps (linens)
197 Sloane St.
London SW1

Designer's Guild
271 & 277 King's Rd.
London SW3

Designs for Living
c/o Antiquarius
131 King's Rd.
London SW3

The Dining Room Shop
64 White Hart Lane
London SW13

Divertimenti
139–141 Fulham Rd.
London SW3

The French Kitchen
 Shop
42 Westbourne Grove
London W2

Graham & Greene
4 Elgin Crescent
London W11

Jane Churchill Ltd
135 Sloane St.
London SW1

Joanna Wood
8a Pimlico Rd.
London SW1

John Stefanidis
261 Fulham Rd.
London SW3

Laura Ashley
120 King's Rd.
London SW3;
256 Regent St.
London W1;
449 Oxford St.
London W1

Lewis M. Kaplan
 Associates Ltd (Art
 Deco)
50 Fulham Rd.
London SW3

Mark B. West, Cobb
 Antiques
396 High St.,
 Wimbledon
London SW19

Markov & Beedles
c/o Antiquarius
131 King's Rd.
London SW3

Monogrammed Linen
 Shop
168 Walton St.
London SW3

Mrs. Monro
16 Motcomb St.
London SW1

Mulberry Home
 Collection at Harvey
 Nichols
Knightsbridge
London SW1

Museum Quilts
254 Goswell Rd.
London EC1V 7EB

Nicholas Haslam
6 Cale St.
London SW3

Nina Campbell
9 Walton St.
London SW3

Osborne & Little
304 King's Rd.
London SW3

Percy Bass
188 Walton St.
London SW3

Peta Smyth (antique tex-
 tiles)
42 Moreton St.
London SW1

Pierre Frey
253 Fulham Rd.
London SW3

Pryce & Brise (antique
glass)
79 Moore Park Rd.
London SW6

Ralph Lauren Home
Collection at Harvey
Nichols
Knightsbridge
London SW1

Rupert Cavendish
Antiques
610 King's Rd.
London SW6

Shaker Shop
25 Harcourt St.
London W1

Souleiado
171 Fulham Rd.
London SW3

The Study (Christopher
Nevile)
55 Endell St.
London WC2

Veranda
15b Blenheim Crescent
London W11

William Yeoward
(ceramics and acces-
sories)
336 King's Rd.
London SW3

Wilson & Gough (con-
temporary ceramics
and glass)
106 Draycott Ave.
London SW7

X. S. Baggage
c/o Antiquarius
131 King's Rd.
London SW3
Zuber (wallpaper)
42 Pimlico Rd.
London SW1

Antiques Markets

Antiquarius
131 King's Rd.
London SW3

Bermondsey Market
1a Bermondsey Sq.
London SE1

Campden Passage
London N1

Chenil Galleries
Antiques Market
181 King's Rd.
London SW3

Gray's Antiques Market
58 Davies St.
London W1

Portobello Road
London W11

Silver Vaults
Chancery Lane
London WC2

Prints

Norman Blackburn
32 Ledbury Rd.
London W11

Julia Boston
14 Wilby Mews
London W11

Stephanie Hoppen
17 Walton St.
London SW3

Nicola Wingate-Saul
(print rooms)
43 Moreton St.
London SW1

Architectural Salvage

LASSCO (London
Architectural Salvage
and Supply Co.)
St. Michael's Church,
Mark St.
London EC2

Walcott Reclamations
108 Walcott St.
Bath

Westland Company
The Clergy House, Mark
St.
London EC2

*Department Stores/
General Tabletop Stores*

Galeries Lafayette
40 bd Haussmann
75009 Paris

Le Bon Marché
38 rue de Sèvres
75007 Paris

Printemps
64 bd Haussmann
75009 Paris

Specialty Stores/Boutiques

Agnès Comar
7 av Georges V
75008 Paris

André Dubreuil
Galerie Gladys Mougin
30 rue de Lilles
75007 Paris

Atelier de Joy de Rohan-
Chabot
3 av du Square
75016 Paris

Au Bain Marie
8 rue Boissy d'Anglas
75008 Paris

Avant-scène
4 place de l'Odéon
75006 Paris

Boutique Elle
30 rue St.-Sulpice
75006 Paris

Boutique Orient Express
15 rue Boissy d'Anglas
75008 Paris

Boutiques du Palais-
Royal
9 rue de Beaujolais
75001 Paris

Catherine Memmi-La
Maison douce
100 rue de Rennes
75006 Paris

Christian Liaigre
61 rue de Varenne
75007 Paris

Christofle
9 rue Royale
75008 Paris

Colefax and Fowler
19 rue de Mail
75002 Paris

Comoglio-Braquenié
22 rue Jacob
75006 Paris

The Conran Shop
117 rue du Bac
75007 Paris

Daum
4 rue de la Paix
75002 Paris

Descamps/Primrose
Bordier
2 rue Tronchet
75008 Paris

Designers Guild
2 rue de Furstenberg
75006 Paris

Dîner de Gala
8 Villa Lauguier
75017 Paris

Dîners en ville
27 rue de Varenne
75007 Paris

En attendant les Barbares
50 rue Etienne Marcel
75002 Paris

Etat de Siège
29 av de Friedland
75008 Paris;
94 rue du Bac
75007 Paris

Galerie Edifice
27 bis, bd Raspail
75007 Paris

141

Galerie Neotu
25 rue du Renard
75004 Paris

Garouste et Bonetti,
 Robert le Héros,
 Frédérique Morel:
 Objets Pompadour
74 bis, rue de Paris
92190 Meudon

Geneviève Lethu
95 rue de Rennes
75006 Paris

Habitat
17 rue de l'Arriveé
75015 Paris;
45 rue de Rennes
75006 Paris;
12 bd de la Madeleine
75008 Paris

Hermès
24 Fbg St.-Honoré
75008 Paris

Ikéa
202 rue Henri Barbusse
78370 Paris

Inès de la Fressange
81 rue des Saints-Pères
75006 Paris

Kenzo maison
16 bd Raspail
75007 Paris

Kitchen Bazaar
11 av du Maine
75015 Paris

La Chaise longue
30 rue Croix-des-Petits-
 Champs
75001 Paris

La Desserte
57 rue de Commerce
75015 Paris

La Joie de Vivre
43 rue Alain Chartier
75015 Paris

Lalique
11 rue Royale
75008 Paris

La Vie de Chateau
17 rue de Valois
75001 Paris

Le Flore Gourmet
26 rue St.-Benoit
75006 Paris

Les Olivades
1 rue de Tournon
75006 Paris

Manuel Canovas
1 rue Sedillot
75007 Paris

Mariage Frères
30 rue du Bourg-
 Tibourg
75004 Paris

Marie-Pierre Boitard
9 et 11 place du palais
 Bourbon
75007 Paris

Modernisme
16 rue Franklin
75016 Paris

Muriel Grateau
132 galerie de Valois
75001 Paris

Noblesse Oblige
27 bis, rue de
 Bellechasse
75007 Paris

Pier Import
40 av des Champs-
 Elysées
75008 Paris;
124 rue de Rivoli
75004 Paris

Pierre Frey
36 rue des Petits
 Champs
75002 Paris

Pimlico
88 rue de Rennes
75006 Paris

Point à la ligne
25 rue de Varenne
75007 Paris

Porthault
18 av Montaigne
75008 Paris

Puiforcat
2 av Matignon
75008 Paris

Ralph Lauren
2 place de la Madeleine
75008 Paris

Souleiado
7 rue Lobineau
75006 Paris

Un Jardin en plus
27 rue de Cherche-Midi
75006 Paris

VIA (Valorisation de
 l'innovation dans
 l'ameublement)
4 cour du Commerce
 St.-André
75006 Paris

Yves Halard
252 bis, bd Saint-
 Germain
75007 Paris

*Antiques Markets and
Marches aux Puces*

La Cour des Antiquaires
54 rue du Fg St.-Honoré
75008 Paris

Salle Drouot Richelieu
9 rue Drouot
75009 Paris

Le Louvre des
 Antiquaires
2 place du palais Royal
75001 Paris

Les marchés aux Puces
Clingnancourt, St.-Ouen,
Vanves, Montreuil

Marché Didot
Porte de Vanves

Le Village Suisse
54 av de la Motte Piquet
75007 Paris

Le Village Saint-Paul
rue St.-Paul
75004 Paris

Tabletop Stores/Boutiques

Edith Mézard Broderies
Château de l'Ange
04220 Lumières

Francis Guare
23 rue Monclar
13100 Aix-en-Provence

Hervé Baum
rue de la Petite Fusterie
84000 Avignon

Le Jardin de Mougins
place du Vieux-Village
06250 Mougins

Le Mas Cureborg
Route d'Apt
84800 L'Isle-sur-la-
 Sorgue

Michel Biehn
7 avenue des Quatres
 Otages
84400 L'Isle-sur-la-
 Sorgue

Segriès
3 rue de la Petite
 Fusterie
84000 Avignon

Xavier Nicod
9 av des Quatre Otages
84400 L'Isle-sur-la-
 Sorgue

Tabletop Stores/Boutiques

Abacus
Via Cerva, 11
Milan

Alessi
Corso Matteotti, 9
Milan

Area International
Piazza Canova
Milan

Bassetti
Corso Garibaldi, 20
Milan

Becassine
Via Santa Marta, 21
Milan

Beppe Morone
Via Soresina, 7
Milan

Cose Belle
Viale Montenero, 31
Milan

Croff Centro Casa
Piazza Diaz, 2
Milan

Dabbene
Largo Treves, 2
Milan

De Padova
Corso Venezia, 14
Milan

Due Dei Giardini
Via dei Giardini, 2
Milan

Elam
Corso Matteotti, 5
Milan

Ghidoli
Piazza del Duomo
Milan

High-Tech
Piazza XXV Aprile, 12
Milan

Koivu
Via Solferino, 11
Milan

L'Utile e il Dilettevole
Via Spiga, 46
Milan

Manie e Antichità
Via Sassoferrato, 1
Milan

MC Selvini
Via Poerio, 3
Milan

Mirabello
Via Montebello
Milan

Missaglia
Piazza S. Sepolcro, 2
Milan

Penelopi
Piazza San Marco, 1
Milan

Picowa
Galleria San Babila, 4
Milan

Porcellana Bianca
Via Statuto, 11
Milan

Pratesi
Via Montenapoleone
Milan

Richard Ginori
Corso Matteotti, 1
Milan

Rosenthal Italia
Via Rubattino, 4
Milan

Sag Ottanta
Via Boccaccio, 4
Milan

Sogaro
Corso di Porta Romana,
 40
Milan

Tanzi
Corso Monforte, 19
Milan

Venini
Via Montenapoleone, 9
Milan

Vetrerie di Empoli
Via Borgospesso, 5
Milan

*Open-Air Antiques
 Markets*

Bollate (every Sunday)
Brera (second Saturday
 of the month)
Navigli (last Sunday of
 the month)

Australia

Department-Store Chains

Grace Bros.
Myers

Melbourne

*Department
 Stores/General Tabletop
 Stores*

Georges Australia Ltd.
162 Collins Street
Melbourne, 3000

Matchbox Giftware Pty.
 Ltd.
1050 High Street
Armadale, 3143

Specialty Stores/Boutiques

Acorn Antiques
885 High Street
Armadale, 3143

Dining Table
826 Glenferrie Road
Hawthorn, 3122;
325 Chapel Street
Prahran, 3181

Going, Going, Gone
567 Bridge Road
Richmond, 3121

Made in Japan
533 Chapel Street
South Yarra, 3141

Minimax
585 Malvern Road
Toorak, 3142

Scullerymade
1400 High Street
Malvern, 3144

Zyqqurat Bazaar
562 Malvern Road
Prahran, 3181

New
Zealand

Department-Store Chains

J. Ballantyne & Co.
Kirkcaldie & Stains
Smith & Caughey

Japan

Department-Store Chains

Daimaru
Isetan
Parco
Sogo

143

Selected Bibliography

Barwick, Jo Ann, and Norma Skurka. *Scandinavian Country.* New York: Clarkson Potter, 1991.

Batkin, Maureen. *Wedgwood Ceramics.* London: Richard Dennis, 1982.

Beard, Geoffrey. *The National Trust Book of the English House Interior.* London: Viking, 1990.

————. *Craftsmen and Interior Decoration in England, 1660–1820.* London: John Bartholomew and Son, 1981; London: Bloomsbury Books, 1986.

Beeton, Isabella. *Mrs. Beeton's Victorian Cookbook.* Edited by Simon Rigge. Topsfield, Mass.: Salem House Publishers, 1987.

Belden, Louise Conway. *The Festive Tradition: Table Decoration and Desserts in America, 1650–1900.* New York: W. W. Norton in association with the Winterthur Museum, 1983.

Bickerton, L. M. *Eighteenth-Century English Drinking Glasses.* Woodbridge, Suffolk, England: Antique Collectors Club, 1991.

Brown, Peter. *Pyramids of Pleasure: Eating and Drinking in Eighteenth-Century England.* York, England: York Civic Trust, 1990.

Carson, Barbara G. *Ambitious Appetites: Dining, Behaviour, and Patterns of Consumption in Federal Washington.* Washington, D.C.: American Institute of Architects Press, 1990.

Chartier, Roger, et al., eds. *A History of Private Life.* Vol 3, *Passions of the Renaissance.* Translated by Arthur Goldhammer. Cambridge, Mass., and London: Harvard University Press, Belknap Press, 1989.

Chippendale, Thomas. *The Gentleman and Cabinet-Maker's Director.* Reprint of 3d ed., 1762. New York: Dover Publications, 1966.

Charleston, Robert J., ed. *World Ceramics: An Illustrated History.* New York: McGraw-Hill, 1968.

Cornforth, John, and John Fowler. *English Decoration in the Eighteenth Century.* London: Barrie and Jenkins, 1986.

Cruikshank, Dan, and Neil Burton. *Life in the Georgian City.* London: Viking, 1990.

Davidson, Caroline. *Women's Worlds: The Art and Life of Mary Ellen Best, 1809–1891.* Foreword by Howard Rutkowski. New York: Crown Publishers, 1985.

Davis, John D. *English Silver at Williamsburg.* Williamsburg, Va.: Colonial Williamsburg Foundation, 1976.

Douglas, Mary T., and Baron Isherwood. *The World of Goods.* New York: Basic Books, 1979.

Duby, Georges, et al., eds. *A History of Private Life.* Vol 2, *Revelations of the Medieval World.* Translated by Arthur Goldhammer. Cambridge, Mass., and London: Harvard University Press, Belknap Press, 1988.

English Conversation Pieces of the Eighteenth Century. Detroit: Detroit Institute of Arts, 1948.

English Pictures for the Country House: An Exhibition of Eighteenth and Early Nineteenth Century Conversation Pieces, Portraits, and Sporting Pictures in Period Rooms. London: Leger Galleries, 1986.

Finer, Anne, and George Savage. *The Selected Letters of Josiah Wedgwood.* London: Cory, Adams and Mackay, 1965.

Garrett, Elisabeth Donaghy. *At Home: The American Family, 1750–1870.* New York: Harry N. Abrams, 1990.

Gere, Charlotte. *Nineteenth-Century Decoration: The Art of the Interior.* London: Weidenfeld and Nicolson, 1989.

Gilliam, Jan Kirsten, and Betty Crowe Leviner. *Furnishing Williamsburg's Historic Buildings.* Williamsburg, Va.: Colonial Williamsburg Foundation, 1991.

Girouard, Mark. *A Country House Companion.* New Haven and London: Yale University Press, 1987.

————. *Life in the English Country House.* New Haven and London: Yale University Press, 1978; Harmondsworth, Middlesex, England, and New York: Penguin Books, 1980.

Glanville, Philippa. *Silver in England.* London: Unwin Hyman, 1987; Winchester, Mass.: Allen and Unwin, 1987.

Godden, Geoffrey A. *English China.* London: Barrie and Jenkins, 1985.

Groth, Håkan. *Neoclassicism in the North: Swedish Furniture and Interiors, 1770–1800.* London: Thames and Hudson, 1990.

Grover, Kathryn, ed. *Dining in America, 1850–1900.* Amherst: University of Massachusetts Press in association with the Margaret Woodbury Strong Museum, 1987.

Hajdamach, Charles R. *British Glass, 1800–1914.* Woodbridge, Suffolk, England: Antique Collectors Club, 1991.

Henrywood, R. K., and A. W. Coysh. *The Directory of Blue and White Printed Pottery, 1780–1880.* Vol. 3. Woodbridge, Suffolk, England: Antique Collectors Club, 1982.

Hepplewhite, George. *The Cabinet-Maker and Upholsterer's Guide.* Introduction by Joseph Aronson. Reprint of 3d ed., 1794. New York: Dover Publications, 1969.

Heskett, John. *Industrial Design.* New York and Toronto: Oxford University Press, 1980.

Holmes, Michael, ed. *The Country House Described: An Index to the Country Houses of Great Britain and Ireland.* Winchester, England: St. Paul's Bibliographies in association with the Victoria and Albert Museum, 1986.

Jones, Chester. *Colefax and Fowler.* London: Barrie and Jenkins, 1989.

A King's Feast: The Goldsmith's Art and Royal Banqueting in the Eighteenth Century. London: Kensington Palace, 1991.

McKendrick, Neil, John Brewer, and J. H. Plumb. *The Birth of a Consumer Society: The Commercialization of Eighteenth-Century England.* Bloomington: Indiana University Press, 1982.

Mennell, Stephen. *All Manners of Food: Eating and Taste in England and France from the Middle Ages to the Present.* Oxford, England: Basil Blackwell, 1985.

Montgomery, Florence. *Textiles in America.* New York: W. W. Norton and Co., 1984.

Mott, George, and Sally Sample Aall. *Follies and Pleasure Pavilions.* Introduction by Gervase Jackson-Stops. London: Pavilion Books, 1989.

Nylander, Richard C., Elizabeth Redmond, and Penny J. Sander. *Wallpaper in New England.* Boston: Society for the Preservation of New England Antiquities, 1986.

Parissien, Steven. *Adam Style.* London: Phaidon Press, 1992.

———. *Regency Style.* London: Phaidon Press, 1992.

Praz, Mario. *An Illustrated History of Furnishing from the Renaissance to the Twentieth Century.* Translated by William Weaver. New York: George Braziller, 1964.

———. *An Illustrated History of Interior Decoration from Pompeii to Art Nouveau.* London: Thames and Hudson, 1964.

Reilly, Robin. *Josiah Wedgwood.* London: Macmillan London, 1992.

Reilly, R., and G. Savage. *The Directory of Wedgwood.* Woodbridge, Suffolk, England: Antique Collectors Club, 1991.

Rosomon, Treve. *London Wallpapers: Their Manufacture and Use, 1690–1840.* London: English Heritage, 1992.

Roth, Rodris. *Floor Coverings in Eighteenth-Century America.* United States National Museum Bulletin 250. Contributions from the Museum of History and Technology, Paper 59. Washington, D.C.: Smithsonian Press, 1967.

———. *Tea Drinking in Eighteenth-Century America: Its Etiquette and Equipage.* United States National Museum Bulletin 225. Contributions from the Museum of History and Technology, Paper 14. Washington, D.C.: Smithsonian Press, 1967.

Rybczynski, Witold. *Home: A Short History of an Idea.* New York: Viking Penguin, 1986.

Schama, Simon. *The Embarrassment of Riches: An Interpretation of Dutch Culture in the Golden Age.* New York: Alfred A. Knopf, 1987.

Sheraton, Thomas. *The Cabinet-Maker and Upholsterer's Drawing-Book.* Introduction by Joseph Aronson. Reprint of various early eds., 1793–1802. New York: Dover Publications, 1972.

Shoeser, Mary, and Celia Rufy. *English and American Textiles.* London: Thames and Hudson, 1989.

Spours, Judy. *Art Deco Tableware.* London: Studio Vista, 1988.

Stewart, Martha. *Martha Stewart's New Old House.* New York: Clarkson Potter, 1992.

Thornton, Peter. *Authentic Decor: The Domestic Interior, 1620–1920.* New York: Viking, 1984.

———. *Seventeenth-Century Interior Decoration in England, France and Holland.* New Haven and London: Yale University Press, 1978.

Veyne, Paul, et al., eds. *A History of Private Life.* Vol 1, *From Pagan Rome to Byzantium.* Translated by Arthur Goldhammer. Cambridge, Mass., and London: Harvard University Press, Belknap Press, 1987.

Visser, Margaret. *The Rituals of Dining.* London: Viking, 1991.

———. *Much Depends on Dinner.* Toronto: McClelland and Stewart, 1986.

Wakefield, H. *Nineteenth-Century British Glass.* New York: Yoseloff, 1962.

Watkins, Susan. *Jane Austen's Town and Country Style.* London: Thames and Hudson, 1990; New York: Rizzoli, 1990.

Wenger, Mark R. "The Dining Room in Early Virginia." In *Perspectives in Vernacular Architecture,* edited by Thomas Carter and Bernard L. Herman, vol. 3. Columbia: University of Missouri Press, 1989.

White, Elizabeth. *Pictorial Dictionary of British Eighteenth-Century Furniture Design.* Woodbridge, Suffolk, England: Antique Collectors Club, 1990.

Wilke, Angus. *Biedermeier.* New York: Abbeville Press, 1987.

Williams, Susan. *Savory Suppers and Fashionable Feasts: Dining in Victorian America.* New York: Pantheon Books in association with the Margaret Woodbury Strong Museum, 1985.

Williams-Wood, Cyril. *English Transfer-Printed Pottery and Porcelain.* London and Boston: Faber and Faber, 1981.

Acknowledgments

First I would like to express my sincerest thanks to everyone at Abbeville whose enthusiasm, support, and imagination made this project a wonderful and richly rewarding experience, especially Mark Magowan for his great vision in helping to structure the project initially, his constant encouragement, and his unerringly delightful sense of humor throughout; Jacqueline Decter, my editor, not only for introducing me to the world of editing but for her sensitive, perceptive, and incisive contributions to the text, its structure and language, all delivered with great humor and enormous spirit despite the demands of transcending transatlantic time zones; Molly Shields, the designer, for creating a superb visual presentation of the photographs; and Jennifer Pierson for her great enthusiasm. I would also like to thank Marike Gauthier in the Paris office for her valuable contributions, and Fritz von der Schulenburg and Karen Howes, not only for their invaluable collaboration but for making the photographic shoots a delightful experience, full of good times shared.

In addition, I would like to thank all those who generously shared their personal insights and philosophies on what the dining room should be, including Roger Banks-Pye, Lady Vivien Greenock, Veere Grenney, and Tom Parr, all of Colefax and Fowler; Bill Blass; Rupert Cavendish; Joanne di Guardiola of Parish-Hadley; David Easton; Christophe Gollut; Anne Hardy; Nicholas Haslam; David Hicks; David Mlinaric; Christopher Nevile; and John Stefanidis.

I would also like to thank Trudi Ballard of Colefax and Fowler, Elizabeth Brooks, Linda Costamagna, Lisa Eastman, Mary Hermann and Martin Puris, Isabella Invernizzi, Jill Keyte, Amicia de Mowbray, Judy Nyquist, Christopher Payne at Mrs. Monro, Jane Rappaport of Past Times, Peter Ayers Tarantino, and Susan Tinsley.

Index

147